Baltic Triennial 14: The Endless Frontier (A Reader)

Contents

Commissioner's Foreword

The Baltic Triennial is the only international project held at the Contemporary Art Centre (CAC), Vilnius, that has survived the four decades of its existence. The Triennial launched in 1979 during the Soviet regime as a group exhibition of young Lithuanian, Latvian, and Estonian artists aiming to present the most current tendencies of visual art in the Baltic states. After the restoration of independence, the Triennial gradually turned into the largest and most ambitious international project organized by the CAC and is now integrated into the European biennial circuit as the strongest northern European showcase event.

The 14th edition of the Baltic Triennial, curated by João Laia of Portugal and ex-CAC team member Valentinas Klimašauskas, is special for a few reasons. First is the curators' choice of topic, or rather their field of research, which this year focused on the arts of Eastern and Central Europe while at the same time questioning the very definition of this region. For various political and economic reasons, the countries in question had little contact with one another for many years after their liberation from Communist oppression. Studies, publications, and exhibitions on the region took place on the Western side of the continent, while the dynamics of mutual exchange in the East remained rather apathetic. Therefore, this attempt to present both historically important names and phenomena and the most recent concerns in the art of this region within the framework of a single Vilnius-based project is a valuable and well-appreciated initiative.

Second, this triennial will be long remembered by visitors
for its geography and the design of the exhibition spaces. With
their skillful use of unconventional materials and technical
solutions, the solid duo of young architects Ona Lozuraitytė
and Petras Išora transformed the exhibition and auxiliary
spaces of the CAC building (such as technical warehouses and
artwork storage) to such an extent that even the institution's
long-standing employees sometimes struggled to find their way
around. Anyone who had known the CAC building as a mod-
ernist and highly transparent architectural structure suddenly
found themselves in an intricate maze that relentlessly decon-
structed the building with many unexpected exits to ever-new
areas of artistic action.

Thanks to a preestablished dialogue with independent Vilnius
art project spaces and new partners, the geography of the
14th Triennial expanded to five additional smaller outer islands.
Special projects were presented in the spaces of Autarkia,
Atlektika, Editorial, Rupert, and Swallow, while part of the
Triennial's main exhibition was unexpectedly placed in the
Lithuanian Artists' Association Gallery. All of this was woven
back into one seamless fabric by Nerijus Rimkus's elegant
graphic design for the project and, naturally, the contours of
Laia and Klimašauskas's curatorial concept, ultimately entitled
The Endless Frontier.

My most sincere thanks go to the Triennial team and all our
sponsors, friends, and partners, who managed, under the ex-
traordinary conditions of a global pandemic, to focus their cre-
ative drive and achieve a surprisingly ambitious result—a truly
spectacular and remarkable manifestation of contemporary art.

Kęstutis Kuizinas
CAC director

João Laia

The Endless Frontier
(A Few Notes on the Recent Past and Present Future)

The 14th edition of the Baltic Triennial focused on the geopolitical area surrounding the Baltic countries. We chose to engage with the definition of Central and Eastern Europe (CEE) as an attempt to question established notions of the region. As stated by Lithuanian sociology professor and researcher Eglė Rindzevičiūtė, Eastern Europe (EE) as a "concept is politically charged and should not be approached as a neutral geographical designation."[1] The definition of EE connects with both the near and the distant past, being a result of recent ideological and political divisions operating during the Cold War and materialized by the Iron Curtain, while finding its roots in the eighteenth-century Enlightenment. Using Edward Said's *Orientalism* (1978) as a reference, Larry Wolf has analyzed how the self-defined Western Europe (WE) invented EE in a dynamic relationship of "complementary divergence."[2] While engaging with Wolf's historical reading, which stresses externalized dynamics, our use of CEE also connects with positions underlining the region's intrinsic specificity by highlighting shared elements. In "Eastern European Coloniality

11

without Colonies" (2022), curator and professor Joanna Warsza and social theorist and researcher Jan Sowa signal serfdom as a possible distinguishing factor between WE and EE; with the exception of Macedonia and Serbia and Montenegro, in all states currently categorized as part of CEE, serfdom was still an operating social mechanism in the 1800s. This comes in opposition to WE, where with the exception of Germany, the practice had been abolished by then.[3] The particularity of Germany in this case is relevant given the country's recent division, split in half via the Iron Curtain and thus embodying a fractured Europe. More recently other definitions have been revived. While Wolff highlights that "the advocates of Central Europe today are committed to shattering intellectually the oppressive idea of Eastern Europe," Rindzevičiūtė signals the constant negotiation of the term, noting how "the United Nations has classified the Baltic states as Northern Europe since 2017, although the notion of Nordic countries remains reserved for Denmark, Iceland, Sweden, Norway and Finland and does not include the Baltic states."[4]

While dissenting from crystallized readings of the area as Eastern, we did not wish to silence important historical moments of the region, in particular the recent Cold War period, whose impacts are still felt today and whose gravitational pull has recently witnessed a revival. At the same time we also wanted to emphasize how even during this period of binary opposition, national self-identities were more complex than they might have appeared. We also chose to experiment with a larger symbolic geography and include territories that at times or as a norm are not included in CEE such as the Balkans, the Caucasus, and Finland. The Balkans' rich ethno-cultural constitution and autonomous identity during the Cold War make them a special case. Through their inclusion we aimed at signaling continuities and ruptures with more established notions, specifically by underlining the different experiences of communism across the Eastern Bloc but also looking into the ongoing integration of the region's states into the West and particularly into the European Union.

The inclusion of the Caucasus was another gesture preventing a monolithic understanding of CEE. Structured through a manifold identity in light of its geographical location and bridging of a number of cultures, the presence of the Caucasus here underlines historical ties with the West, namely with the Italian states of the fourteenth and fifteenth centuries, as well as current challenges radiating from their strategic position of proximity to Russia and, more generally, as a crossroads between East and West, as evidenced by their inclusion in the ongoing development of China's new Silk Road. Lastly, the inclusion of Finland, consistently classified as a Nordic Western country, might arguably be considered the most eccentric position. We intended to revive the memory of the process of "Finlandization"[5] as well as the country's cultural and linguistic affinities to Estonia while underlining Finland's lesser-known Eastern heritage. We hope that with the incorporation of these three cases, the overlaps and disruptions between the states included in our understanding of CEE are brought to the fore, countering stable conceptions of the region as well as underlining its composite constitution which, as most geopolitical bodies, experiences constant shift, balancing between the difficulty and perhaps even impossibility of a conclusive and unanimous definition.

The process of defining CEE as the employed geopolitical term was preceded by a decision to focus on the territory geographically and symbolically surrounding the Baltic states, a novelty for the Triennial. While analyzing the exhibition history of the Baltic Triennial, two main strategies clearly emerged, echoing the paradigmatic shift endured by CEE as a consequence of the USSR's dissolution. At its inception, the Triennial had a regional focus, presenting mainly if not exclusively artists from the three Baltic States, whereas from the early 1990s onward, and coinciding with the independence of Lithuania, it forged a different mission, namely presenting key international voices in dialogue with local agents. We wanted to strengthen the international standing of the Triennial and, at the same time, highlight the

vitality of the Baltic and Eastern European scene. As an outcome of our early conversations the possibility to work exclusively with artists from the region started to materialize. As our research progressed, this option gained further traction, emerging as the strongest statement we could offer both locally and internationally. It seemed particularly relevant to engage with authors such as Ivan Krastev and Stephen Holmes, whose powerful analysis thoroughly articulated the complexity and urgency of the region's present and recent past. In parallel to our interest in questioning long-held "orientalizing" ideas of the region as Eastern, we were also concerned with overcoming naturalized readings of it as lagging behind. We began to identify an opposite tendency through which CEE has been a place of experimentation. Certain abrupt shifts endured by the region during the long twentieth century— early experiments with democracy, right-wing dictatorial regimes, the long communist period, and the more recent fast-track adoption of neoliberal policies—countered readings of the region as backward, rather highlighting CEE's vital ability to change and develop.

14

In addition to our interest in the region's malleable structure, adopting starkly different and at times opposite social models, we also recognized the activation and emergence of particular actors, positions, and narratives that introduced rather than mimicked developments that later took place in other parts of the globe. Four ongoing processes were of particular importance to this reading and were mapped thoroughly in the exhibition: ecological and industrial disasters, disinformation and populism, the reemergence of nativist nationalisms, and the oppression of nonnormative identities. The global ecological emergency can be viewed from a standpoint with CEE at its core when considering Chernobyl as one of the first globally circulated industrial catastrophes. Arguably introduced in the USSR, disinformation strategies gained a revived strength in recent times, materializing for example in Russia's supposed intervention in Western societies' elections (as in Brexit) and its complex relationship with posi-

tions emerging during the pandemic. Likewise, Vladimir Putin and later Jarosław Kaczyński were early manifestations of the return of populism, a development that later also manifested in the West as seen in figures such as Donald Trump and Jair Bolsonaro, who mentioned figures such as Viktor Orbán as references. Both in CEE and globally, the renewed contemporary status of right-wing positions places nativist nationalism at its core, distributing narratives opposing multicultural strategies developed in the recent past and identifying migration and refugee dynamics as prime targets, in a process that quickly expands to include the oppression of queer identities. In this sense, these four areas can be identified as having found a space of emergence inside CEE and later circulating throughout the world.

Such shifts from a territory mimicking to one introducing global dynamics connects with Ivan Krastev and Stephen Holmes's reading of how "the ultimate revenge of the CEE populists against Western liberalism is not merely to reject the initially welcomed Imitation Imperative, but to invert it." "We are the real Europeans," Orban and Kaczynski repeatedly claim, and "if the West will save itself, it will have to imitate the East." "We believed that Europe was our future, today we feel that we are the future of Europe." Krastev and Holmes define such development as follows: "Instead of the West spreading its influence eastward, the East brags of spreading its influence westward. . . Illiberal populism everywhere, including in the US, seems to be taking a page from Orban's illiberal playbook."[6] Progressively we realized that addressing the local was a means to also question the global, an exercise that strengthened our decision to focus on the region.

The artistic practices included in the Triennial echo this complex network of questions, and in particular embody the sometimes paradoxical shape-shifting features of the territory as well as its position as a symbolic space of anticipation. In tandem with the historical and sociological approach described, our research on the rich artistic scene of the region led us to identify a revived interest in dreamlike or surrealist strategies. We found

that a productive form of engaging with this tendency was to read it both as a reaction to the abrupt changes taking place in CEE and the world at large but also, more importantly, as a gesture of refusal to passively accept the current context. Indeed, it is a proposition to imagine other worlds—a highly politically charged stance. As a defiant statement we associated such revival of oneiric strategies as a form of queering, and adopted an expanded understanding of "queer" that departed from questions related to gender and identity to embrace a larger frame in connection to futurity. Queer was embraced not only as an approach that would echo the unfixed status of the region, but also, and equally importantly, as a gesture that, while deeply embedded in the present and conscious of the past, is nevertheless able to look toward the future. As stated by José Esteban Muñoz, "Queerness, if it is to have any political resonance, needs to be more than an identitarian marker and to articulate a forward-dawning futurity."[7]

Our engagement with queer was also a support gesture to all sorts of nonconforming identities suffering the oppressive weight of governments in the region, including Lithuania, where repeated attempts to legalize same-sex marriage have yet to prevail. In this sense, *The Endless Frontier* was not only an echo of ongoing frictions and conflicts, but also a proposal to keep brushing against the grain, to keep striving against definitions and limits toward wider possibilities—a cry for a communal horizon of freedom in an ever more constricted world.

1 Eglė Rindzevičiūtė, "Transforming Cultural Policy in Eastern Europe: The Endless Frontier," *International Journal of Cultural Policy* 27, no. 2 (2021), 149.

2 Larry Wolff, Inventing Eastern Europe: The Map of Civilization on the Mind of the Enlightenment (Stanford, CA: Stanford University Press, 1994), 8.

3 Joanna Warsza and Jan Sowa, "Eastern European Coloniality without Colonies," Post. Moma.org, January 19, 2022, https://post.moma.org/eastern-european-coloniality-without-colonies/.

4 Wolff, *Inventing Eastern Europe*, 15; Rindzevičiūtė, "Transforming Cultural Policy in Eastern Europe," International Journal of Cultural Policy, 27:2, 149-162, 152.

5 Jason Horowitz, "Finns Don't Wish 'Finlandization' on Ukraine (or Anyone)," *New York Times*, February 9, 2022, https://www.nytimes.com/2022/02/09/world/europe/finlandization-ukraine-russia-nato.html.

6 Ivan Krastev and Stephen Holmes, *The Light That Failed: A Reckoning* (London: Penguin, 2020), 45, 47.

7 José Esteban Muñoz, *Cruising Utopia: The Then and There of Queer Futurity*, New York and London: New York University Press, 2009), 87.

Valentinas Klimašauskas

Kaleidoscopic Carcasses of Permanent Exploitation in the Infinity Mirror

The moment has come when all the crises—economic, ecological, migration, informational and political—are intertwined, and nobody can entirely figure out where they originated and how to address them but many declare to have "the solution."

> —Marta Barandiy, "Policy Paper: A Look Inside the Russian Information War against the West," 2019

If everything is a matter of perspective, then it's time to talk about this new position we find ourselves in today: of exploited and abandoned ideological carcasses posing as narcissistic subjects in the infinity mirror. I'm talking about this new type of subject we most often meet online, possessing ever-changing and often bizarre assemblages of characteristics, something like a hybrid of provoked, projected,

or programmed avatars. They are amateurish experts on everything, radicalized self-righteous moralists, someone's puppets, (un)conscious trolls, emphatic preachers, deep-dreamed optimists, and many more. The list is endless and is growing as I type.

Many seemingly contradictory forces are dictating this presence, every nano-moment of it. One of its vectors is separation and contraposition, followed by the other one, which may be described as dissuasion, disinformation, and polarization. It constantly bombards and atomizes society into individuals, and individuals into radicalized defragmentations of radicalized choices, ideologies, views. Its second vector permanently recruits and reconnects the new atomized and defragmented subjects into new temporary structures and transactions that are again meant to be regrouped, precipitated, and atomized. Numerous global, regional, and local powers, as well as surveillance capitalism, institutions, discourses, and projects, may stand for or inspire the aforementioned forces, which may be equally contradictory in their aims.

Suddenly, everything around us became extremely political. Most probably even you and I would strongly disagree about something very casual like food, family status, or operational systems. Discussing capitalism, pandemics, global warming, gender, or migration at the family table poses a definite danger of spoiling the meal. For this new subject, nothing is final or objective. Everything may be reviewed, reconstructed, renegotiated.

How did we end up here? In numerous nonlinear and equally contradictory ways.

What Happens to Democracy in Times of Surveillance Capitalism

We may start from something we wake up every morning with: surveillance capitalism. In her book *The Age of Surveillance Capitalism* (2019), Shoshana Zuboff offers a disturbing picture of how corporations are mining users' information to predict and shape their behaviours.[1] According to Zuboff, "Surveillance capitalists now develop 'economies of action' as they learn to tune, herd, and condition our behaviour with subtle and subliminal cues, rewards, and punishments that shunt us toward their most profitable outcomes."[2] Zuboff further explains how surveillance capitalism modifies our behaviour and corrupts democracy, and why this model takes the future from us. The future and human agency are ripped away because this new kind of capitalism does not just predict the future, but also shapes it:

> Surveillance capitalism's "means of behavioural modification" at scale erodes democracy from within because, without autonomy in action and in thought, we have little capacity for the moral judgment and critical thinking necessary for a democratic society. Democracy is also eroded from without, as surveillance capitalism represents an unprecedented concentration of knowledge and the power that accrues to such knowledge. They know everything about us, but we know little about them. They predict our futures, but for the sake of others' gain. Their knowledge extends far

beyond the compilation of the information we gave them. It's the knowledge that they have produced from that information that constitutes their competitive advantage, and they will never give that up. These knowledge asymmetries introduce wholly new axes of social inequality and injustice.[3]

According to Zuboff, the idea that in this new kind of capitalism we became products is not just cliché, but also false. According to her, we are not products—we are the abandoned, exploited carcasses. The product, according to her, is the surplus that is being ripped from our lives.

There Is No Shared Sky in Nonlinear Warfare

Let's turn our focus back to Central and Eastern Europe. Around the time the Crimea crisis (2014) shook the world, there were multiple articles about the parallels between the philosophy of French postmodernist Jean-François Lyotard and the so-called architect of Putin's system — Vladislav Surkov.

Just to remind you, the best known of Lyotard's books, *The Postmodern Condition: A Report on Knowledge* (1979), was declaring an end to grand or meta-narratives and recognizing the subsequent atomization of thought and society. This postmodern condition, according to Lyotard, is characterized by multiple perspectives and micro-narratives. In this diffuse situation, the dominance of information is power:

> Knowledge in the form of an informational com-
> modity indispensable to productive power is al-
> ready, and will continue to be, a major—perhaps
> *the* major—stake in the worldwide competition
> for power. It is conceivable that the nation-states
> will one day fight for control of information just
> as they battled in the past for control over terri-
> tory, and afterwards for control of access to and
> exploitation of raw materials and cheap labour.
> A new field is opened for industrial and commer-
> cial strategies on the one hand, and political and
> military strategies on the other.[4]

Questioning the heritage of postmodernism in Eastern Europe, one may stumble on a critique of it by the Lithuanian phi- losopher Arūnas Sverdiolas. In his book *On Spectral Being* (2006) he ponders that post-Soviet postmodernism was a rather unusual version.[5] Because of the accelerated road that Eastern Europe took, it could not refer to what constituted the so-called Western way. For example, Easterners did not have the construct of an independent and responsible person who could independently make decisions with integrity. How does one deconstruct something that does not exist?

Yet even if one would not agree with the aforementioned differences between former Eastern and Western Europeans, today there seem to be an abundance of this self-confident subject, maybe even globally, who feels that they finally received a chance to have their voice amplified and heard, if not by the larger society, then by surveillance capitalism or autocrats, for different ends and means. The question is, then: How authentic is this voice of the carcasses of exploited subjects? Before answering, now is the right time to introduce

23

Vladislav Surkov, who is often seen as applying Lyotard's ideas practically, and is the author of concepts like "nonlinear war" and "sovereign democracy." He is also a former aide to the president of the Russian Federation, a "political technologist," the "gray cardinal," or a "puppet master." It's he who published the short story "Without Sky" under a pseudonym and at the same time "curated" an invasion into Ukraine in 2014. In "Without Sky" he writes:

> In the primitive wars of the 19th and 20th centuries, it was common for just two sides to fight. Two countries. Two groups of allies. Now four coalitions collided. Not two against two, or three against one. No. All against all. . . . The goals of those in the conflict were quite varied. Each had his own, so to speak: the seizing of disputed pieces of territory; the forced establishment of a new religion; higher ratings or rates; the testing of new military rays and airships; the final ban on separating people into male and female, since sexual differentiation undermines the unity of the nation; and so forth.[6]

In this context, do you see why today's cultural wars about the family institution, gender, traditional values, et cetera may be interpreted as the direct results of nonlinear information wars?

Have you heard what happened to Lyudmila Savchuk? Around 2015, this investigative journalist and internet disinformation activist went undercover to expose the Russian troll factory Internet Research Agency (IRA), located in Saint Petersburg. The agency employs fake accounts registered on major social networking sites, comment sections, discussion boards, online newspaper sites, and video hosting services to promote the Kremlin's interests. The point is to weave propaganda seamlessly into what appear to be the nonpolitical musings of everyday people. She worked there for two and a half months:

> One could say that the trolls' main task is to give what they write a human touch—write it so there seems to be a genuine politically engaged person sitting at the screen. For example, I was told at the start that I should write something like "I was in my kitchen baking, and I was thinking how Putin is doing a really good job." . . . You might write from a fake profile as an ordinary woman that "I would like to meet a good man, someone like Sergei Shoigu"—and then mention how great it was that he had just ordered new fighter planes.[7]

After she anonymously gave material about the troll farm to newspapers, the trolls wrote that "no troll factories exist" and "that they are all fabrications by paid-journalists." Savchuk then went public and gave dozens of interviews and talks across the world. The trolls turned on her. According

to Peter Pomerantsev in *This Is Not Propaganda: Adventures in the War against Reality* (2019), "There were comments and posts claiming she was a sexual deviant, a spy, a traitor. There were phone calls to her relatives saying that people were often killed for what she had done." But among the general public,

> instead of an outcry she found that many people, including fellow activists, just shrugged at the revelations. This horrified her even more. . . . At one point she began to get anxiety attacks and . . . went to see a psychotherapist. The psychotherapist listened to her patiently, nodded and then inquired why she wanted to fight the state this way— was she some kind of paid-for traitor? Lyudmilla, perturbed, visited another doctor. They said the same thing again. She felt as if the mindset promoted by the troll factory had literally penetrated into the country's subconscious. She had left the confines of the farm—only to find she was enveloped by it everywhere.[8]

The story is scary on many registers. This is a surrealist Borgesian tale of someone who reveals the truth about some fictional post-truth world, which backfires while fictionalizing its discloser. The story is also Kafkaesque. The main character has only the best of intentions but falls to an inescapable inner logic: the world knows it is fictional and deceitful but seems to enjoy its fake ideology and detests someone who refuses to play by its rules. It's also an Orwellian story, in that apparently nothing can be done to change its dark cynicism. Literary illusions aside, this is also

a story of how the contemporary world is being created 24/7 by ideological and capitalist mechanists and, although its secrets are revealed and widely known, nothing really changes. The troll factories are still producing perspectives seemingly created by a genuinely politically engaged person sitting at the screen.

I mention Surkov and the troll factory in Russia not just because the Russian government is responsible for many atrocities that recently took place in Central and Eastern Europe, including wars in Georgia (2008) and Ukraine (2014–ongoing). It stands behind the shooting down of a Malaysian airplane in Ukraine in 2014, is the only supporter in Europe of Belarusian dictator Alexander Lukashenko. It secretly supports the extreme-right and -left and troll factories in various countries around the world. These narratives are well researched and proven. However, it seems that this model of Putin's Russia is also influencing how other nations reorganize their democracies, including Hungary, Poland, and many more, and, most probably, on different levels, also yours. There are indications, and sometimes proof, that the troll factories function(ed) not just in Russia but also in Hungary, Poland, Ukraine, the UK, and the United States.

The Kaleidoscope: Multiple Pasts, Converging Presents, Alternative Futures

Multiple pasts, converging presents, alternative futures. Numerous kaleidoscopic, multifaceted entry points, continually shifting from one set of relations to another.

According to this model, everything is collected data, which is then projected into an outcome, a part of a probabilistic framework, programmed to bring back profit and/or political results. What one may recently call a descriptive reality is transformed into computational, speculated, projected, encrypted, blockchain, trolled, and various other realities.

Partly because of the click economy, partly because of (Twitter) bots, partly because of surveillance capitalism, partly because of the atomization of thought in society, partly because of propaganda and troll factories, partly because of acceleration, this society is moving into the dystopic capitalist future, partly because the now and the future aren't equally distributed, partly because . . . So how do we reclaim the present and the future under these conditions? How may we use political and other technologies to bring back power to democracy and human agency to individuals? What is the role of the artist in this new, toxic, radicalized environment of surveillance capitalism and sovereign democracy? The 14th Baltic Triennial proposed that this kaleidoscopic division of reality, democracy, and society itself could also bring positive outcomes. Our ultimate hope was that this atomized, broken, kaleidoscopic landscape of historical and contemporary survey would help us to construct new, more democratic visions.

Have we succeeded? Nothing seems to be final or objective. Everything may be reviewed, reconstructed, and renegotiated. Look at it as a possibility, a promise of the new multiple beginnings.

1 Arūnas Sverdiolas, *Apie pamėklinę būtį* (Vilnius: Baltos lankos, 2006).

2 Natan Dubovitsky, "Without Sky". Retrieved from: http://www.bewilderingstories.com/issue582/with out_sky.html

3 Lyudmila Savchuk, "My Life as a Troll: Lyudmila Savchuk's Story," 2017, available at https://www.diis.dk/en/my-life-as-a-troll-lyudmila-savchuk-s-story.

4 Peter Pomerantsev, *This Is Not Propaganda: Adventures in the War against Reality* (London: Faber and Faber, 2019), 37.

5 Arūnas Sverdiolas, *Apie pamėklinę būtį* (Vilnius: Baltos lankos, 2006).

6 Natan Dubovitsky, "Without Sky". Retrieved from: http://www.bewilderingstories.com/issue582/without_sky.html

7 Lyudmila Savchuk, "My Life as a Troll: Lyudmila Savchuk's Story," 2017, available at https://www.diis.dk/en/my-life-as-a-troll-lyudmila-savchuk-s-story.

8 Peter Pomerantsev, *This Is Not Propaganda: Adventures in the War against Reality* (London: Faber and Faber, 2019), 37.

Michal Novotný

Orient

The landscape of their country—a sprawl of snowy hills and ugly roads, paints a lonely picture, and suggests that there is no one to see them.
 —Laura McLean-Ferris[1]

Farewell, Poland, farewell, empty wasteland, forever covered in snow and ice. . . Barbaric people, arrogant and fickle, braggarts, blabberers, having nothing but language, who, day and night shut up in a heated room, amuse themselves with a glass for every pleasure, snore at the table and sleep on the ground.
 —Philippe Desportes[2]

What Was There Before?
A Waiting Room

I was born in 1985.[3] When the so-called Velvet Revolution arrived at the TV in our housing estate flat in November 1989, I was with my mother. My father was in Germany, for the

first time authorized to visit his sister, who had emigrated in the early 1970s. In case they steamrolled us again like in '68, my mother said, we had a chestnut-colored gym bag for emergency departure via our chestnut Škoda 105, to follow the rest of the family to Germany, ready in our living room. Most probably for educative reasons I was allowed to put in that bag only one of the two small Lego Formula 1 cars I owned. "Either the red or the yellow, you have to choose," said my mother.[4]

My memories from my early years are cast in a sort of heavy, anxious, brutal ugliness. It still puts a dark shadow on everything from this time. I could never enjoy the celebrated stop-motion movies of Jan Švankmajer, even if I rationally understand their quality. We can't help our emotions. It explains the militant aggression that led to the demolishment in 2019 of the Transgas building in Prague, the Brutalist 1978 spaceship pearl designed by architect Václav Aulický. "It is as if my child died," said the seventy-seven-year-old architect while witnessing the destruction in real time. I remember once having a discussion with Anna Daučíková about how I divide an artist's persona from their work. "If you live in Stalinist Russia and an artist sends your family to their deaths, you won't," she replied.

While the main topic in Czech art from the first half of the 1980s seems to have been the anxious human figure against an eroding background, art from the second half quickly moved into mythology and fantasy. Jaroslav Róna, Stanislav Judl, or Stefan Milkov could easily exhibit their ancient crypt gates, T-shaped crosses with teardrops, and alien-like figures alongside works by my twentysomething students. I am not sure it signifies that we escapists also live and wait for the end of a certain era, but I see that many

older teachers have some emotionally based prejudices when it comes to these students' work.

1990s: All Dressed Up and Nowhere to Go

"1968 is over. 1983 is over. The future is between your legs," says some graffiti that Dušan Mandić, a member of NSK/Irwin, painted in the Upper Šiška Youth Center in 1984. It seems that in Ljubljana they already knew that sex had to be freed not only from the petit-bourgeois morality of the Communist Party but also from the supposed liberation that successfully commodified it. Even my father ordered five suddenly available VHS porn cassettes and hid them behind some home-recorded tapes, with their carefully typewritten movie titles.

I live just a couple of hundred meters from Discoland Sylvie, a legendary celebrity/mafia nightclub of the 1990s.[5] Hard to imagine nowadays how it was ever legendary, as it's just a random two-story house in the still-shabby gray outskirts. Ivan Jonák used to promote the club riding naked in his large American cabriolet in Prague's city center, with naked club dancers and blaring music. In one famous photo he is posing seated and half-naked with suspenders over his large belly, cradling his newborn son in one hand and a gun in the other. Jonák served eighteen years for ordering the killing of his wife, who ran a vegetable kiosk in Petrovice, another housing block on the outskirts that I passed almost every day as a kid. He died in 2016, on the 666th day after his release from prison, in a small apartment above his former

club.[6] "At least one person in this country was always stand-
ing for freedom," commented someone under his obituary.

Prague's first McDonald's opened on March 20, 1992,
on Vodičkova street.[7] It took me a long time to find the news-
paper photograph where, at the beginning of the queue of
its very first customers, stand Milan Salák and Jan Kadlec,
then art students. Salák later became a German flying ace—
only in a computer game, but still among the world's top
ten players. As he didn't have any money to travel, he hired
himself out as a tourist guide to finally get to see the spot
in some empty fields in central France where "his" plane was
shot down in 1917. In his studio, he staged a room with
painted cutout identification numbers like trophies from
crashed World War I planes, drawings of himself posing
in German uniform leaning against the wing of his biplane
so as to resemble other flying aces, black-and-white photo-
graphs, and other re-created memorabilia. Kadlec later quit
art completely to focus on set design for TV commercials.
But some works of his can still be found as documentation.
One of them, *McBed* (1995), is an actual-size child's bed
supported on both sides by the McDonald's golden arches logo.

After the Millennium:
Carpathian Digital Meadows

In 1991, Jiří Černický was still an operative at a surface coal
mine in Předlice, where he conceived one of his first perfor-
mances. Squatting naked in one of the excavator holes in
this windy, wounded, open landscape, he inserted into his
anus a peg connected to a kite. Holding the kite only with

the power of his anal muscles, his body heated up and a temperature-sensitive emulsion he'd previously applied all over himself turned red. He lighted the safety fuse attached to the kite rope, and the kite overhead burst into flames. The performance was over. When he and I watched the original video while preparing for a retrospective exhibition, the burning kite was not captured. While Černický was sweating with the kite in his anus, the TV student he had hired to document the performance, standing above on a crane, hadn't entirely understood the work and was seemingly fascinated by the scenery, capturing long TV-news-like shots of diggers, transporting belts, and loaders.

In 2003 we protested "against globalization"; the art initiative tranzit.cz published a Czech translation of Hakim Bey's *Temporary Autonomous Zone* (1991); and the CzechTek free techno festival attracted forty thousand visitors and 120 sound systems.[8] One big lightning and pulsing city spread over the hill. I walked all night long and never danced at the same place twice. NEW HUMAN ERA! said an old Communist banner with yellow letters on a red background that one of the sound systems hung over the usual machinic-tribal iconography.

In summer 2005, the police shut down CzechTek on a populist political order, and the media was full of images showing half-naked dancers fighting with full-gear officers. But surprisingly, the newspaper headlines were all about "dancing children" rather than illegally occupied land.[9] One year later and after much political turmoil, CzechTek was organized in a military sector with the assistance of the police and army and welcomed fifty thousand people. Shortly after it ended, the coordinators announced on the official CzechTek website that the festival had been discontinued.

A common statement mentioning the abolition of thoughts of freetekno and the parasitic behavior of many visitors was signed by fifty-eight sound systems. On this list, among the technology-enchanted names like Format C:\, Direct Drive, Reset, and Kernel Panic, and Communism-ironizing names such as Swazarm[10] or Jednota[11], stood the appropriated name of the Japanese construction and mining machine manufacturer Komatsu.

Present Times:
The Devil in the Machine

Four years ago, I took part in a discussion on the occasion of *Facing the Future: Art in Europe 1945–1968* at the Pushkin State Museum in Moscow. The exhibition project had previously premiered at ZKM Karlsruhe, Germany, and BOZAR, Brussels, and the Moscow iteration included more than 150 artists, showing similar art developments on both sides of the Iron Curtain. But only two of the exhibited artists were female, and during the discussion I pointed out this very dramatic gender imbalance. A strong reaction from the Russian representatives followed, accusing me of applying culturally imported, "foreign" values. With several years' distance I finally get their point, at least theoretically. The emancipation process often seems related to economic development and cultural imperialism. In supposedly developing countries, not only the economy but also mainstream values often seem outdated. Similarly, lack of art infrastructure is often equated to a lack of art quality. This overlap of hard and soft data situates most of the world as needing to

catch up in both respects—or if not economically, then at least culturally—with high-GDP, high-income economies.

"The art got spoiled when women entered it." Milan Grygar, a ninety-four-year-old legend of Czech sound art, told me openly while sitting next to his wife, Květa Pacovská, ninety-two years old and also a legendary painter, who in response only smiled impishly. Working with older, sometimes very old artists, I sometimes find intergenerational dialogue impossible. Indeed, part of the mechanism of progress is to simply discredit the previous generation in power. But then I thought, maybe in the context of their world, the context they still live in, he is the most progressive, respectful, gentle guy.

We all helped to put in motion the wheel of modernity, which has since accelerated so much, we have trouble just running along with it. Not only energy but also time investments are necessary to keep pace. Understandably, most of us at some point give up and freeze in a certain time and context.[12]

Shadows of the Past Futures

Sometimes I think of Ciprian Muresan's pencil drawing *Romanian Blood* (2004), a first-person view of two hands where the right one has just cut the left wrist with a razor. The flying blood takes the shape and color of the Romanian flag.

A young-looking couple faces the camera, the man embracing the woman's waist with his right arm and hand. Behind them are a huddle of discussing, gesticulating people, the Old Town Tower of Charles Bridge, and cobble-

stones slightly covered with snow. The man is mid-stride, one hand in his pocket and face turned slightly aside, eyes narrowed with courage. The girl has one foot a bit above the ground as if uncertain whether to make a step further, gloved hand in front of her mouth in a gesture of fright. She wears an outmoded headscarf, large glasses, and a baggy beige coat. He is tall and well-built, with high-top sneakers, black jeans, a "Sport"-labeled beanie, and a moustache. The photo is by Magnum photographer John Vink, taken in Prague in November 1989. Although it doesn't get any further from the stereotypical depiction of inhabitants of former Communist countries, I like this picture. I know it is a photographically constructed cliché, but the emotions are real for me.[13]

In all the images Vink took, in the eyes there is always this mix of fear and resolution. All these badly dressed people, with their naive but pure expressions, so sidelined and suddenly so determined.[14]

1 Laura McLean-Ferris, "New Artist Focus: Laura McLean-Ferris on Deimantas Narkevicius,"*Lux*, June 16, 2014, https://lux.org.uk/writing-new-artist-focus-laura-mclean-ferris-deimantas-narkevicius.

2 Philippe Desportes, "Adieu à la Pologne," 1574, translated into English in Rory Finnin, "Philippe Desportes's 'Adieu à la Pologne' and Jan Kochanowski's 'Gallo Crocitanti,'" *Comparative Literature Studies* 44, no. 4 (2007), 461.

3 This text draws its title, some text and work fragments, and its chronological chapter structure from my exhibition *Orient*, which showed at Kim? Contemporary Art Centre, Riga, Latvia; BOZAR, Brussels; and Bunkier Sztuki, Krakow, in 2018 and was followed by *Orient2* at Kunsthalle Bratislava, Slovakia, and *Orient V* at Prague City Gallery in 2019. "What Was There Before? A Waiting Room" draws from Natalija Vujosevic's installation *The Winner* (2014).

4 "My context is a country that was built on a social and political Utopia. But I grew up in the period when nobody really believed in it. The fall of the Soviet Union was at a time when people had other Utopias. These were liberal Utopias, about freedom to do what you do. These kinds of Utopia were also an illusion, and lasted only for a few years. People grew disillusioned very quickly. What kind of Utopias can be created on a human scale? That is the question and I don't have an answer." Hans Ulrich Obrist, "Deimantas Narkevicius," *Flash Art*, July–September 2008, available at https://flash—art.com/article/deimantas-narkevicius/.

5 Ivan Jonák's seven-hundred-page unpublished memoir includes the following: "In my cabaret there were no eight-year-old girls. But girls of age, long-legged—imitations of angels. Instead of wings, they spread their long legs, which was as beautiful as if it were angel wings. Guests liked it more than any show of an illusionist, and their faces followed the open genitals with fascination, like the praying bodies of Muslims follow Mecca. To make the show more interesting, girls were making different special effects. One for example put in her vagina a blinking plastic ring with diode. When after she got naked, spread her legs, all her c**t was lightened through visibly. And the ring was not at all visible. Then once she started to pee, it looked like the famous light fountain in Fučíkárna. . . . Another specialty were the glass eyes used for the mutilated bodies from car crashes. The amazed 'ooh' of the Germans floated in the bar, when a girl spread her legs and there was a 'magic eye' looking at the amazed guests! It even winked when she alternately closed and open her legs. It was unbelievable illusion of a living eye, right in the anus. You must admit, that real angels, even with their wings, would never be able to reach that effect!" (my translation).

6 666 is also the number on a bank waiting ticket, a readymade "satanistic/capitalistic relic," by the group Guma Guar, made in 2015.

7 The philosopher Václav Bělohradský introduced the term "McDonaldization" to Czech discourse in the 1990s, although the economic processes at this stage were more linked to a basic economic transformation from planned to market economy. He mostly avoided the word "capitalism," as it overemphasized Communist Party rhetoric.

8 "Our emotional state of choice is Ecstasy. Our nourishment of choice is Love. Our addiction of choice is technology. Our religion of choice is music. Our currency of choice is knowledge. Our politics of choice is none. Our society of choice is utopian though we know it will never be." From Shockraver Manifesto, available at https://www.urbandictionary.com/define.php?term=ravers%20manifesto.

9 The image of police beating children has been a strong political symbol in the Czech Republic since the student demonstrations of 1939 and 1989.

10 From Svazarm – Union for Cooperation with the Army, a Communist Czech sport-military organization.

11 Jednota was the largest network of grocery store cooperatives in pre-1989 Czechoslovakia.

12 "Back when I was at the art academy, I think it was my 1st or maybe 2nd year, I once read an interview in the newspaper or magazine with a 'contemporary' artist from ex-Yugoslavia. I don't remember exactly where was he from, nor his name, but what stayed with me from this interview is a statement he made at one point, saying something like: If I were to live in France or Norway . . . I, as well, would like to or would make works that analyse or study the relationship between 'line' and 'circle.' But look at me and look where I live, I can't just stand with my arms crossed, I have to make art that is socially engaged, art that reacts to the situation that I am in. Today, when I moved from Bosnia to France, I decided to use the naivety of this statement." From Ibro Hasanovic, *Circle and Line* (2000). This wall text accompanied the large drawing of a line and a circle on a wall, the circle illuminated with a spotlight.

13 Compare with Chantal Akerman, *D'Est* (1993).

14 "A clever dog knows how to survive and what price to pay for survival. He knows when to crouch and when to dodge and when to bite, it's in his tongue. It's a tongue that was to have been destroyed, and its time has yet to come; now

it never will. Invented by versifiers, spoken by coachmen and maids, and that's in it too, it evolved its own loops and holes and the wildness of a serpent's young. It's a tongue that often had to be spoken in whispers. It's tender and cruel, and has some good old words of love, I think, it's a swift and agile tongue, and it's always happening. Not even the Avars could get this tongue of mine, not tanks or burning borders or the most repulsive human species of all: cowardly teachers. What will eventually get it is cash in a shrinking world. But I still have time." Jáchym Topol, *City Sister Silver*, trans. Alex Zucker (North Haven, CT: Catbird, 2000), 34.

Zane Onckule

Vaguely Baltic, Nearly Sisters: By Way of "New East," "New North," and "New (Queer) Beyond"

Understanding and framing the Baltic region is certainly problematic. Quoting the curator and writer Valentinas Klimašauskas: "The Baltic as a psycho-geographical term is a phenomenon in its lack of direction and definition. This incoherence can apply to politics, economics, infrastructure and mentalities. You can and can't be Baltic simultaneously, but also you can be more or less Baltic."[1] As a geopolitical term used to describe the northeastern region of Europe containing Estonia, Latvia, and Lithuania, all of which are located along the eastern coast of the Baltic Sea, "the Baltics" is not conventionally used in the contexts of culture, national identity, or language. Nor does it comprise a political union. Rather, the three countries in question engage in what can be described as intergovernmental and parliamentary cooperation.

As an (un)clearly demarcated (cultural) territory, "the Baltics" also functions across the arts, from the per-

spective of the Global West, as an opaque realm. Since the 1990s and well into the 2010s, this opaqueness, frequently addressed through and supported by metaphors such as fog[2] and mood[3], has designated a certain cultural, intellectual, and more widely dispersed condition of unclarity, simultaneity, and (post-)postmodernity. Even though this inertia and the tendency shared by colleagues from the region to decidedly accept and occupy a position of the Other[4] (never, though, as part of the Third World) might be overplayed, the region does still appear to an extent *wild* and *exotic*: hermetic, dis-tanced, and problematically patriotic. In light of the resur-gence of transnational and supranational economic, political, social, and cultural processes—from the naive, pastiche-like treatment of the "national" throughout centennial celebra-tions in the Baltics[5] to the far-right patriotisms haunting Poland and Germany (and widespread across present-day Europe and the world at large)—this essay is an attempt to imagine, depict, and narrate three simultaneous avenues of (self-)presentation that currently prevail across the Baltics: the "New North," the "New East," and the "New (Queer) Beyond."

Whereas the "vaguely"[6] in my title denotes a selective take on both collective and individual imaginaries (at times interchanging and overlapping, and at times barely *touching*), the "sisters" part is supported by visuals that should be viewed not only in terms of their original meanings and contexts but also in a more speculative, pan-Baltic way to show how immanently *relational* as well as unattached to any singular position the region is.

44

New North

"As the creative psyche of this seashore is discernibly feminine, and the regional moniker unfamiliar at large, The Baltic Sisters, with its allusion to a familial bond, is a pretty fair marker for the creative force that lies within," states the editorial team (Giedrė Stabingytė, Andrius Skalandis, and Denis Bondar) of the Vilnius-based magazine *N WIND*. A free publication that has been distributed across the region since 2014, *N WIND* is a platform for "exchanges of creative Northern energy" within geopolitical strategy, business, and visual expression, transforming it into what is understood as the "New North."[7]

As a concept that originated in the Baltics, the "New North" or "New Nordic" is a willful embodiment of shared thinking and values across the realms of culture, business, and behavior. For example, the sensibility is less about a distinguishable aesthetic and more about a certain northern breeze in which non-colors (black, white, and gray) reign, standing for peacefulness and quiet wisdom. All in all, the idea of the New North sells the subtle, the quiet, the peaceful.

The cover of *N WIND*'s April–May 2016 issue helps to illustrate and contextualize these values in a way that is in sync with the aforementioned quote. A composite photograph by Linas Masiokas capturing fresh-faced Lithuanian model Ieva Palionytė in three different poses unmistakably conjures the three contemporary New North "Baltic sisters."[8] While the metaphor of the Baltic sisters is not exclusive to the New North, it does resonate with its stance especially closely.

To understand this claim, one should know that in Estonia, Lithuania, and Latvia, the term "Baltic sisters" is commonly used and readily understood.[9] Harking back to the nation-woman and nation-mother allegories popular throughout Europe during the first part of the nineteenth century, the term was first invoked in the early 1920s, just after the three "sisters" formed as three independent republics (each was founded in 1918). Further into the twentieth century, in 1940, when the three republics joined the new Soviet Union, whose ideological and artistic propaganda based on Marxist-Leninist ideology was used to promote the Communist Party line, they became "little sisters" to the Soviet "sisters" already being exploited. By the end of the twentieth century, and speculatively, with the exhaustion of each of individual Soviet sister (as well as of the Soviet regime itself, which was decomposing), the term "Baltic sisters" reentered the spotlight, now as part of the so-called third awakening (ca. 1987–91) and largely in relation to the Baltic Way and "Singing Revolution."[10]

N WIND's use of the term "Baltic sisters" raises questions about the relationship between national identity and gender identity. Framed within the call for a certain geopolitical, cultural, and creative unity, this decidedly feminine anthropomorphism invites readers to reflect on gender identity in the same way they do national identity.[11]

If in the 1990s, attempts to restore the traditional values of nation, homeland, and family to the nation-state/s prevented female emancipation across the post-Soviet realm, perhaps the current Baltic sisters could be seen as new (social) subjects who, responding to the gaze directed at them, at once enact, perform, and play out their supposedly fragile, vulnerable femininity—more so, or even especially, given

the current socioeconomic, political, and ecological crises that surround the mid-nineteenth to early twentieth-century male-built nation-state concept, particularly across Europe.

Furthermore, the idea of the North is attractive in the Baltics largely because it was once the imagined North. The Baltics dreamt of being Northern—that is, until particular historical and sociopolitical circumstances actually made it possible to *become* Northern. The resolution of this longing was vividly expressed on January 8, 2017, when upon learning of the United Nations' decision to classify the Baltic states as Northern European countries, Artis Pabriks, the Latvian member of the European Parliament and former foreign and defense minister, tweeted, "This is where we belong."[12] Whether as New North or "near North" or "nearly North," the classification functions as a promise that carries with it certain notions of reinvention and rebirth. The stance of the New North also embodies a coping mechanism based on healing processes and tactics developed in attempting to move away from the transgenerational traumatic past usually associated with life under Soviet Union rule.[13]

While the New North never existed before, it is understood that the Baltic mentality is a natural part of Nordic thinking and therefore should be treated as integral to it. Sentiment and nostalgia are absent from this relatively untapped territory. Seen as an attempt to mechanically scratch off the complicated past, this operation works and speaks to the demographic of thirty- to forty-year-olds who constitute the last generation born under the Soviet regime and currently occupy leading positions in the fields of creative commerce and science—design, advertising, architecture, fashion, sustainability, and so on—across neoliberal capital markets.[14]

The New North, therefore, strives for a qualitatively different future and introduces behaviors, thinking, and argumentation rooted less in "modernist poetic devices" such as irony, the grotesque, ambiguity, and subjectivity.[15] Defense mechanisms in the realms of language and speech were practiced among individuals during the Soviet period as a form of silent resistance wherever and whenever an actual action was simply not possible. Now, facing and embracing other realities, Baltic society/ies (at least partly, and among those of active working age) appear to invest themselves in more constructive, pragmatic, capital-generating discussions and actions.

The emergence of the New North also cements and supports the need for further discussion of various perspectives internal to the Western art world—or, in this case, the Eurocentric art world—leaving open the question of where its claimed center resides. More directly, in its relation to the global art world, the New North reflects on shared aspects of the "poor" Baltics and "rich" Scandinavia, and on being assigned to a position in the margins of that world, which further contributes to the (self-)provincialization of being situated at the periphery.[16]

New East

Referring to what is currently being observed, theorized, stylized, and monetized as the new aesthetics of the "New East," the Baltics joins in talks about otherness that are projected onto a place that is not actually a place (post-Soviet realm), and onto a political map (again, post-Soviet realm)

that is no longer relevant, to contribute to the massive and visually aggressive penetration of the so-called post-Soviet aesthetics connecting East and West in a way that politics never did.[17]

By the end of 2017, the New East had become a phenomenon that was hard to ignore. According to Metahaven, an Amsterdam-based research and design studio, the idea of a New East borrows from a Western understanding of the vast landmass east of Europe, a *unit* that embodies versatile orientalist tropes such as "risk, fate, wastelands, ruins, rawness, residual and unkept extra space, an unprocessed past, visceral experience, delirium, repositories of the imagination."[18]

While the "New North" is understood as Estonia, Latvia, and Lithuania's new position within the geopolitical/socioeconomic and aesthetic entity known as (Europe's) North, the "New East" covers a much larger political map, one that includes Eastern Europe, Russia, the Balkans, and Central Asia.

With its opacity and categorical complexities, the New East is a rich field for inquiry, where parallels and links may be drawn between the once-Soviet republics.[19] The New East takes distinct past social and political conditions—those prevailing across alternative, unofficial (nonconformist) scenes before 1989—and finds their continuation in the present through the younger (than Jesus) generation coming of age in an era of ever-changing paradigms and worldviews. Across the fields of visual and mass culture, art, design, music, and street-meets-high-fashion, the New East has become a code of a global subculture way beyond the once-post-Soviet area itself.

With its acclaimed deadpan humor, irony, and jokes—at times supported by a darker, more cynical tone and an

underdog mentality, amid layers of contradictions and cross-cultural codes—the New East resonates widely and visibly while largely functioning as a void, a container, or a foil, with numerous absences serving as its momentum. At once tangible and intangible, rude and emotional, it speaks to a known or unknown, or imagined, past.

Estonian-born Tomas Tammemets (b. 1991), aka Tommy Cash, also known by the self-assigned moniker Kanye East and as the inventor of sinister-meets-sexy post-Soviet rap, is a cult personality in the making and a fitting example here.[20] Thoroughly exploiting the New East, and crafting his stage persona by adopting a specific Slavic-Russian accent, he aims as much to grow his already ample social media presence as simply to "delight in his own absurdity."[21]

With only a vague memory of the transformative 1990s, Cash and other millennials went through childhood sandwiched between the ruins of the Soviet era and the new, stagnant conservatism. However distant it may seem to their generation, the Soviet collapse and the trauma-meets-nostalgia associated with it continues to be experienced through memories and stories told by or picked up from earlier generations—or absorbed from visual culture, or their grandparents' decor.

It is not surprising, therefore, that while finding their place in an increasingly digital and global world, New East millennials not only consume culture, but also increasingly drive and direct it. This generation is the market for and the force behind the reverberations and aftereffects of the post-Soviet signs that increasingly turn up in television, music, fashion, and mass culture, framing *our* post-post-Soviet present anew. Cash's song lyrics, music videos, interviews, and garments, which he designs, are full of riddles and double meanings:

50

Soviet imagery, at times enriched with a more specific aesthetic and the codes of Baltic-ness, insider jokes within insider jokes (meta-jokes), and lots and lots of irony. With a claim to be there for a reason, and following recurrent references to the Chilean surrealist filmmaker Alejandro Jodorowsky, Cash's work functions as an outer layer or a mask that, though it can do little to change the inner structure, is celebrated as surface itself.

Whereas in earlier works (for instance the music videos "Euroz Dollaz Yeniz" [2014], "Leave Me Alone" [2014], and "Surf" [2017]), Cash more aggressively and straightforwardly exploited aspects of a certain "Eastern European *chav*" or, more accurately, *gopnik,*[22] driving a BMW through poor suburban areas and engaging in highly sexualized, choreographed acts alongside numerous extras and dancers, in more recent works, beyond built-in shock value, he shows a more distinct interest in addressing, or *playing* on, undercurrents such as gender, body image, and race.[23]

Toying with post-Soviet-era materials (ephemera, other artworks, and goods from everyday life) reveals internal and external misuse in an approach whereby the object-picture-symbol is simply reduced to its face value, and the context or content is dismissed and/or misinterpreted. Theorists and curators from the region refer to this as "almost colonial," for exoticism is the key factor making Cash and his peers globally visible and viable in the context of the (West's) endless desire for the new. While curious, likable, and ready to appropriate, this "new" remains to an extent ungraspable.[24]

One last note: this very outsider gaze counts among the problems of the New East. The exceptionally West-oriented New East would not have emerged or been able to maintain and disseminate its values without the West radiating

an ongoing fascination with crumbling Communist mono-
liths. Moreover, the New East echoes the prevailing view and
criticism of the (self-)understanding of the East (that is, the
former East), as "repressive infantilization of the societies
that have liberated themselves from the Soviet is the post-So-
viet condition."[25]

52

And yet, at the end of the day, what stands at the fore-
front of researching, writing, and promoting the concept of
the New East can be recapped by quoting Anastasiia Fedorova
of the *Calvert Journal*: "Paradoxically, the post-Soviet aesthetic
can act as a gateway that allows these youths to admit, analyze
and ultimately rid themselves of this outsider gaze. This is the
last frontier between the centre and periphery. And as every-
one knows, the centre cannot hold."[26]

New (Queer) Beyond

Identity politics are relevant in considering the transition,
fluidity, and movement involved in breaking away from
established binary ways of thinking to occupy a queered point
of view, one that draws attention to political and cultural
walls as both physical and mental. Relative to body, gender,
and status within social and transcultural parameters, this
last segment, self-coined as "New (Queer) Beyond," intends
to support observations on deconstruction of established
identity/ies and of the normative by establishing new
rules and a disinterest in culturalism, essentialism, and
ethno(pluralism).

Whereas the New North and New East deal with cer-
tain vague-ish notions of identity and identification/s across

the Baltics and dip into the history/ies and trauma/s, the experienced and the imaginative, the "Queer" from "New (Queer) Beyond" is embraced mostly as a signifier outside the binary worldview: that which is otherwise known as The East/The West/The North, Soviet/post-Soviet, poor/rich, center/periphery.

Rooted in politics, "queer" speaks to emotional labor and self-care, mental health, and, importantly, the power to define oneself, to be specific and demanding toward details, and to be in charge of one's reality. While queerness is usually at odds with a fixed place, it is nonetheless about creating safe spaces, as much for individuals—queer or not— as for the cultures they represent or come from. At first it appears problematic to draw any/a link between the Baltics and queer culture,[27] but the region does share an unexpected affinity with what "queer" stands for.

In what has been a time of rapidly changing social and transcultural parameters, and in advocating for liberation from fixed binary constructs, the postcolonial Baltic body is particularly in sync with queer values, notably in its struggle for self-empowerment and a (political) voice, and the right and occasion to "outloud," or name itself, in (new) ways that it desires.

For example, "Naming is a recurrent issue."[28] Dorota Gawęda (b. 1986) and Eglė Kulbokaitė (b. 1987) of the queer collective Young Girl Reading Group point out that prominent Western curators and members of the media have decidedly avoided pronouncing their names. Blaming the difficulty of language, Westerners instead address the artists as Young Girl Reading Group or YGRG as opposed to by their specific monikers, which are, respectively, Polish and Lithuanian. Yet from the very beginning of their collab-

53

orative practice, the duo have been specific in articulating YGRG as a project of an artist collective—not of individuals.

Established in 2013 in Berlin and named after Tiqqun's seminal text *Preliminary Materials for a Theory of the Young-Girl* (2001), this performative entity developed from the duo's formulation of a paradigmatically centered identity and their interest in the spheres of identity politics, self-determination, and economy of presence. Theirs is an ongoing, serial project that "examines the relationships between reading, affect, distraction, togetherness and dis-unity, bodily and virtual presence, live action and documentation."[29]

The outlouding of words is at the center of their practice, which began as a queer-enthusiast book club and expanded to include performative installations in which they stage and investigate the act of reading as an experience that is not only intimate, but has the potential to become public performance. The art venues hosting the work often become settings in which materials with varying connotations and histories—tiles, curtains, carpets, light sources, dirt or clay, fragrance—are combined, breaking down boundaries between the intimate and the public, and becoming sites for readings of YGRG's manifesto.[30]

Linked to their manifesto, their avoidance of their personal names could be seen as either an attempt to please/comfort audiences in contexts where the idea of YGRG is considered catchy or cool, or as a form of discrimination and "an embarrassing/ly public display of US-American imperialism within the art world."[31]

Arguably, since YGRG is the name they have given themselves, it could equally be seen as their own creative/subversive/conciliatory move for grappling with the issue of a lan-

guage barrier; by providing an English alternative, they and their work are more accessible to the global, neoliberal art scene. But what to make of this? Are these readings therefore contradictory? While subjective and personal, they do indicate a wider problem associated with location and with societies on the margins of the art world's central axis. The situation also reveals the ways in which the contemporary art world eradicates an identification with otherness, since we *all* participate in what is supposedly a single and united global art market. This market has unwritten rules that apply to everyone, regardless of background, race, gender, or abilities, and which, upon closer inspection, reveal hidden layers of historically well-rehearsed hierarchies.

What the singular case of YGRG shows is that sometimes taking an uncomfortable position (pose/es of their performances) to read or write down words in the space, sometimes on one another, can complicate the relations of the readers/viewers/observers and the conception of the text itself, acting as a stimulus to move further into an area that questions identities, breaks down historical constructs, and builds a new type of body—the body that resists being called or referred to as "difficult."

Conclusion

In place of a conclusion, this text articulates an outloud-ed wish to *deal* with the Baltics in a way that is beyond the "North," the "East," and the "Queer," and incorporates 'em all. This essay was commissioned by Moma Post and was published on October 9, 2019 https://post.moma.org/vaguely-baltic-nearly-sisters-by-way-of-new-east-new-north-and-new-queer-beyond

1 Valentinas Klimašauskas, blurb for Raimundas
Malašauskas, "Baltxploitation," 2005, available at http://
www.generalpublic.de/archive/eventsarchive/article/15/
originalfassung-issue-37-baltxploitation.html.

2 The notion of fog originated in Arunas Sverdiolas,
"The Sieve and the Honeycomb: Features of Contemporary
Lithuanian Time and Space," in *Baltic Postcolonialism*, ed.
Violeta Kelertas (Amsterdam and New York: Rodopi, 2006).
Referring to systematic changes after the collapse of the
Soviet Union, Sverdiolas describes the situation as follows:
"Therefore, these new (to us) things constitute a weightless
medium—a shapeless fog does not allow us to orient ourselves
according to named landmarks that are at least relatively
stable, does not allow us to establish identities and differences.
There can be no consideration of archaeology or genealogy
in a fog, as here there are no layers, no relation to a legacy or
an inheritance" (244–45).

3 In her review of *oO*, the Lithuanian Pavilion at the
55th Venice Biennale, Claire Bishop inquired whether it was
enough for curators to create "moods rather than arguments."
This question followed her navigating through the nonlinear
exhibition curated by Raimundas Malašauskas, which had
no clear path to approach it, many guides, and a few empty,
action-less rooms that only came to life during special events
that this critic missed. Bishop otherwise perceived the
exhibition as "an unforgettably atmospheric non-pavilion"
or "an obfuscating haze of fictions without any core or sub-
stance." Claire Bishop, "Now You See It," *Artforum* 52, no. 1
(September 2013): 319.

4 Here, "Other" speaks to the West's unspoken request
of the Baltics that it not be an "Other"—that is, that it con-
form to Western models—and at the same time be an "Other"
and fight against cultural imperialism. This leads to new
trauma, specifically the feeling of being backward, subaltern,
and still "othered."

5 Estonia, Latvia, and Lithuania declared independ-
ence in 1918.

6 "Vaguely" here is an expression borrowed from
the New York–based collective CFGNY (Concept Foreign
Garments New York, whose bootleg name is Cute Fucking Gay
New York). Founded in 2016 by Tin Nguyen (born in the
United States to a Vietnamese family) and Daniel Chew
(born in the United States to a Burmese-Chinese family),
CFGNY explores the intersections of fashion, race, identity,
and sexuality, and contentiously returns to the term "vaguely
Asian," which carries an understanding of race as a specific
cultural experience combined with an understanding of what

it feels like to be perceived as Asian. See the CFGNY website, http://www.cfgny.us/info/.

7 See https://issuu.com/n_wind. Note that there are numerous other organizations and groupings of states, regions, and nationalities across the world that are self-united, or ascribed to the category of "New North" or "New Nordic." This essay examines the North-iness/Nordic-ness of the Baltics in particular.

8 See https://issuu.com/n_wind/docs/ nwind09_2016_april-may.

9 In some sources, the "Baltic sisters" include Finland, Sweden, Denmark, Germany, and Poland, corresponding to the area around the Baltic Sea. Subsequently, there are "Baltic Sea sisters," or eight Finno-Ugric, Baltic, Scandinavian sisters of the North. Russia (present through the Kaliningrad region) is never part of the group.

10 The Baltic Way was a peaceful political demonstration that took place on August 23, 1989, when approximately two million people joined hands, forming a six-hundred-kilometer-long human chain through the Baltic countries, demonstrating unity in their efforts toward freedom. The "Singing Revolution" is a phrase coined by Estonian activist and artist Heinz Valk a week after the spontaneous mass night-singing demonstrations at the Tallinn Song Festival on June 10 and 11, 1988. It grounded the bloodless Velvet Revolutions that took place between 1987 and 1991 and led to the restoration of Estonian, Latvian, and Lithuanian independence.

11 For more on this subject see Audronė Žukauskaitė, "Vanishing Identities in Contemporary Lithuanian Art," *Filosofija. Sociologija*, nos. 3/4 (2006): 37–41.

12 The "original" North as the more successful formation shares ties with the Baltics, whose small and open economies are the beneficiaries of direct Nordic investment, leading to direct dependency on it. The Baltic and Nordic people don't have historical complexes about one another, and their politicians regularly cooperate, network, and share seats in various international organizations, such as the Nordic-Baltic seats in the International Monetary Fund and the World Bank. Both are shareholders in the Nordic Investment Bank and members of the Nordic Battlegroup. Differences are nonetheless evident, particularly in terms of standard of living, welfare protections, consensus democracy, Euroscepticism, gender equality, minority rights, and views on geopolitical threats.

13 Trans-generational trauma is defined as the transfer of trauma from immediate trauma survivors to second and later generations. In the post-Soviet Baltics, this type of trauma has influenced the beliefs, values, and cultural identity of large groups of citizens. My thanks to artist and art therapist Julia Volonts for bringing this term to my attention. For more, see writings by Bessel van der Kolk, D. W. Winnicott, Murray Bowen, Mark Wolynn, Esther Rashkin, Jacek Debiec, and Regina Marie Sullivan, among other family counselors, psychologists, and psychiatrists.

14 While to my knowledge there is no survey or statistics-based research to support this claim, a cursory view of the individuals or groups behind contemporary cultural activities, creative businesses, and even environmental and architectural entities evidences it.

15 Benedikts Kalnačs, *20th Century Baltic Drama: Postcolonial Narratives, Decolonial Options* (Bielefeld, Germany: Aisthesis Verlag, 2016), 30.

16 For more on the overlooked "Northern" semi-peripheral perspective in the art world as opposite to the more known "Southern" perspective see Anne Ring Petersen, "Global Art History: A View from the North," *Journal of Aesthetics and Culture* 7, no. 1 (2015): https://www.tandfonline.com/doi/full/10.3402/jac.v7.28154?scroll=top&needAccess=true. My thanks to Alise Tīfentāle for bringing this text to my attention.

17 *The Guardian* was one of the first media outlets to promote the New East through its now-defunct New East Network (NEN), launched in 2014.

18 Anastasia Fedorova, "The New Aesthetic" (conversation with Metahaven), in *PSYOP: An Anthology*, ed. Karen Archey (Amsterdam: Stedelijk Museum, 2018), 45.

19 Since 2016, the twenty-fifth anniversary of the dismantling of the Soviet Union, it has been successfully argued that the "post-Soviet" period is over. As Kirill Kobrin writes: "The personalities and processes of the previous period are no longer relevant. The old post-Soviet project, once relevant back in 1991, is over. It has achieved its aims. The post-Soviet project began with a public gesture of rejection of Soviet ideology. It ended when it drowned in the pseudo-ideological swamp of conservatism." Kirill Kobrin, "The Death of the Post-Soviet Project in Russia," *openDemocracy*, October 19, 2016, https://www.opendemocracy.net/en/odr/death-of-post-soviet-project-in-russia/.

20 My thanks to Anton Ginzburg for our conversation about the New East and for bringing Tommy Cash to my attention.

21 Whitney Wei, "Meet 'Kanye East,' the Estonian Rapper Who Spoofs American Pop Culture," *Vogue*, January 24, 2018, https://www.vogue.com/article/tommy-cash-kanye-east-west-estonia-rapper-pussy-money-weed-merch-yeezy-off-white-virgil-abloh-vetements-life-of-pablo-pavel. Tommy Cash is of mixed background, and his first language is Estonian.

22 *Chav* is an epithet used in the United Kingdom to describe a particular kind of antisocial youth dressed in a tracksuit, while *gopnik* refers to a member of the marginalized working classes across Eastern Europe, notorious for antisocial behavior, substance abuse, and quality-of-life crimes, as well as for wearing tracksuits. See Olaf Jablonski, "Chavs and Gopniks Comparing Subcultures," *Medium*, February 25, 2019, https://medium.com/@olafvontjchavs-and-gopniks-comparing-subcultures-70cbf3ab00a8.

23 On May 2, 2019, *Tommy Cash and Rick Owens: The Pure and the Damned*, an exhibition curated by Kati Ilves, opened at the Art Museum of Estonia (KUMU) in Tallinn. Exploring the desire to populate, blend in with, and mock US popular culture via well-crafted post-post-Soviet imagery, this project was a take on a distorted body image and supports Tommy Cash's nonbinary approach, apparent throughout his oeuvre, which stands in a dialogue with the postapocalyptic chic of the US fashion designer Rick Owens.

24 My thanks to Kati Ilves for providing information about Tommy Cash's practice. Ilves, email correspondence with author, June 5–15, 2019.

25 Boris Buden, "Art and Theory of Post-1989 Central and Eastern Europe: A Critical Anthology," C-MAP roundtable, Museum of Modern Art, New York, September 28, 2018, https://www.youtube.com/watch?v=mOylRġjLDrk.

26 Anastasiia Fedorova, "Post-Soviet Fashion: Identity, History and the Trend that Changed the Industry," *Calvert Journal*, February 23, 2018, https://www.calvertjournal.com/features/show/9685/post-soviet-visions-fashion-aesthetics-gosha-demna-lotta-vetements. My thanks to freelance writer and curator Fedorova for providing information on issues surrounding the New East via email correspondence and Skype communications, May–June 2019.

27 For example, in 2015, Latvia became the first country in the territory of the former Soviet Union to host EuroPride, which—together with the first queer-themed contemporary art

59

exhibition, *Slash: In Between the Normative and the Fantasy*, which opened June 18, 2015, at Kim? Contemporary Art Centre in Riga—drew a lot of attention and an aggressive response from the general public, the media, and local politicians. It is noteworthy that Kim? was asked to eliminate any reference to the Culture Ministry of Latvia—otherwise a regular supporter of its activities—as the project supposedly went against the "family values" promoted and supported by culture minister Dace Melbārde's party, Nacionālā apvienī-ba "Visu Latvijai!"—"Tēvzemei un Brīvībai/LNNK" ("For Fatherland and Freedom/LNNK").

28 Dorota Gawęda and Eglė Kulbokaitė, email correspondence with author, June 1–8, 2019.

29 Gawęda and Kulbokaitė, email correspondence with author, June 1–8, 2019.

30 Other readings have been copresented—usually by using iPhones—throughout the course of their practice by such authors as Paul B. Preciado, Nina Power, Ursula K. Le Guin, Richard Sennett, and Donna Haraway. See Federico Sargentone, Young Girl Reading Group," *Kaleidoscope*, November 27, 2018, https://www.cellprojects.org/press/ young-girl-reading-group-kaleidoscope.

31 Gawęda and Kulbokaitė, email correspondence with author, June 1–8, 2

Borbála Soós

From the Cracks of Human Infrastructure Flowering Resilience Shall Arise

The invasive ragweed flourishes in disturbed soils alongside road networks; the fast-growing red stems of flame willow spread like wildfire along train lines; the "aggressive" giant hogweed, with its dangerous phototoxic sap, outcompetes other vegetation along canals;[1] storks cease their migrations as they find an ever-replenishing food source in open waste fields;[2] emerald ash borers and longhorn beetles travel as stowaways in wood pallets used for industrial shipping;[3] valuable autumn-smelling matsutake mushrooms grow underground in their preferred habitat of recently cut and disturbed forests;[4] bacteria abundantly multiply in the water and sediment associated with hydroelectric dams. While undeniably a very large number of species have been pushed out, reduced in numbers, or lost altogether as a result of major infrastructure projects, human-induced disturbances, and climate crises, a few others have found ways to survive and thrive in the cracks. While some of the species listed above can be desirable, like the highly priced matsutake mushrooms, many more have been marked with terms such as

"invasive," "alien," or "pests," and deemed unwanted
or even dangerous due to their allergy-inducing or
toxic qualities.

In certain cases, such as the noxious giant hogweed,
creating an enemy goes even further: the plant, which orig-
inates from the Western Caucasus, features in the British
rock band Genesis's 1971 song as a Russian agent in the sha-
dow of the Cold War.[5] Despite considerable efforts, the giant
hogweed continues to evade eradication through the agency
of certain "feral qualities."[6] While these resilient and wild
strategies can be regarded negatively, they make crucial con-
tributions to local ecologies, alternative economies, and
planetary survival. Cultural anthropologist Bettina Stoetzer
has described the development of "ruderal" botany—that
is, ecologies that spontaneously emerged in disturbed en-
vironments such as wastelands or rubble, or alongside
train tracks or roads—in Berlin at the end of World War II.[7]
Stoetzer's research draws on fieldwork with immigrant and
refugee communities and ecologists. With a focus on life
in the ruins and in the cracks of infrastructures, we can find
emerging ecologies, as well as social justice, in an era of
inhospitable environments, she writes.

Relationships between technology, nature, and society
have shifted considerably due to industrialization and the
conditions created by large-scale infrastructure projects start-
ing before the eighteenth century and continuing to inten-
sify in the twenty-first, including but not limited to energy
projects, monocrop farming, forest management, factory
production, waste repositories, mining, and transportation
technologies. These enterprises go hand in hand with state
and capitalist interests to rationalize and standardize social
relations, as well as to manage and simplify complex and

entangled ecologies into more measurable, legible natural resources and all-around more convenient formats. To equip ourselves with agency in the face of ecological and climate crisis, it is important to examine how the concept of nature was shaped by the compulsion of power in modernity, techno-scientific development, and growth structures.[8] Our relationships with nature and related cultural practices continue to change due to these imaginaries. Top-down management policies together with the so-called shifting baseline syndrome—when each new generation perceives the environmental conditions in which they grow up as "normal"— means that standards for acceptable environmental conditions steadily decline. People forget far too quickly what used to constitute the by-now exploited landscapes scarred with mines, burns, floods, waste repositories, and deserts.[9]

In recent centuries, fossil fuels have underpinned a growth-oriented economic paradigm in a range of countries and political spectrums, from libertarian capitalism to Soviet-style communism. Energy dependency as a dynamic has become inextricably fused with social imaginaries, political affiliations, and ecological consequences in terms of the climate crisis. As John Szabo explains, energy infrastructures and gas coming from Russia have played a prominent role in encoding how production, social, political, and ecological relations are constituted in Central and Eastern Europe.[10]

Regularly experiencing abrupt shifts and tensions, Central and Eastern Europe are often seen as laboratories for ideological, sociopolitical, cultural, economic, and ecological experiments, for instance the emergence of heavy industry, human-made industrial disasters, and collective farming. Since 1989, environmental resources have become

a key battleground between local and international stake-
holders, from communities to corporations and states, as
each seeks to formulate and secure their needs, access, and
dominium.[11] In the past three decades, re-territorialization
and privatization have swept through the region. Lately, new
phenomena such as the emergence of xenophobic nation-
alism, eco-fascism/right wing-ecologism, the oppression of
non-normative identities, and illiberal populism have gener-
ated attention and models for many nations.[12]

 For states to get a better idea of their subjects and
resources, it has been crucial to streamline and simplify
complex and hard-to-understand systems and relations.
Standardization was a monumental undertaking all over the
world, as exemplified by a fundamental problem, namely
measurement systems. Particular customs of measurement
have been culturally, situationally, temporarily, and geo-
graphically bound, often embedded in the activity itself, and
only as precise as the activity requires (think of words such
as "handful" or "basketful"; descriptions of how certain seeds
should be planted "two hand widths" apart; or how the
next village is "two rice cooks away").[13] Moreover, value has
often been defined in a barter economy. But these are
useless measures for understanding patterns and capacities
at a state level, or indeed at a capitalist level, where cate-
gories of people, land, and assets must be interchangeable
regardless of their lifeworld entanglements.[14] The overwriting
of these and other, more widely associated ideas have also
contributed to the fading of many local customs and peasant
cultures, and ultimately a certain understanding of land.

 Standardization aids not only precise measurements
but also quick and efficient taxation and resource extraction.
For example, in a standardized monoculture forest with no

undergrowth, trees of equal age planted in a regular grid are much easier to control and cut than those in an unruly ecosystem. The species-rich forest commons that were home to so many, and which local villagers would have used for food, firewood, medicine, and other materials, become enclosed and then disappear. The monocrop system might be efficient, but it is clearly not sustainable: Soil becomes depleted in just one or two generations. The large and heavy machines used to extract the trees quickly and efficiently leave deep scars, contributing to soil loss. Opportunities for animals and other companion species disappear. And communication and nutrition support systems between trees weaken, resulting in low resilience to diseases, infestations, drought, and high winds, which might easily wipe out the majority of the forest (as with the 2014 wind calamity that destroyed twelve thousand hectares of mostly spruce but also broadleaf forests in the Slovak Tatras). The only way such a monoculture system can somewhat drag out its demise is through artificial fertilizers, insecticides, pesticides, and fungicides; reintroduction of specific plants and animals (such as houses for useful birds that lost their natural habitats); or actual inefficiencies in the system, in which life stands a chance to survive on the fringes. Weeds may emerge despite the adverse conditions. Hedge growth remaining at the borders of the otherwise monocrop farms provide slim opportunities for survival of diverse birds, insects, and other species.

Political scientist and anthropologist James C. Scott's seminal book *Seeing Like a State* (1998) treats Soviet collectivization as paradigmatic of failed schemes to improve the human condition via the standardization of society and nature. The aims of the highly modernized agriculture system were actually similar to and paralleled high modernism in

the United States and elsewhere. The USSR and the United States frequently shared experiences at professional agriculture conferences and exhibitions, and connections were not completely severed even during the Cold War.

Collectivization provided an instrument that achieved appropriation and political control—both traditional aims of statecraft. As philosopher Manuel De Landa points out in his book *A Thousand Years on Nonlinear History* (1997), energy conversion between rural and urban ecosystems is essential to sustain cities.[15] This happens by shortening the food chain, and by redirecting the flow of biomass toward the top of the hierarchy through simplified ecosystems. This is one of the drivers of colonization, as well as dekulakization and collectivization of Soviet farms. The largely urban political movement of the Bolsheviks needed to bring affordable food to workers in the cities. The new landscape of large, state-managed farms and industrial agriculture was meant to be modern and electric, with cropping patterns and procurement quotas centrally managed. In reality, they never achieved a high level of mechanization, and even where they did, yields were the same as or inferior to those before the Revolution in the 1920s. The devised system served for nearly sixty years as a mechanism of control at a massive cost in stagnation, waste, demoralization, and ecological failure.[16] The fact that collectivized agriculture persisted for so long was less due to the efficient plan of the state, and rather to improvisation, gray or illegal markets, networks of favors, bartering, alternative practices such as mushroom picking, and other ingenuities that grew out of scarcity and redirected the huge waste and inefficiencies built into the system. The same alternative channels had to be used to get hold of counterculture items, or to publish samizdat magazines.

Life in the cracks compensated for the state's failures. Looking more closely at the Soviet era, certain behaviors were able to survive not only despite but precisely because of faults in the infrastructure. The resilient strategies associated with taking advantage of the system's shortcomings and opportunities became crucial conditions for survival during the Cold War. These qualities encoded in the resistance and resilience of people created rich entanglements between ecology, economy, and cultural production.

An ongoing example of such a system is Cuban society, euphemistically also called "people of scarce resources." Embargoed by the United States since 1960 and isolated from sympathetic states, Cuba had to learn self-sufficiency to survive. In the years following the breakdown of the Soviet Union, which eliminated Cuba's preferential market for sugarcane, and also the harvest failing, the country was left in increasingly poor economic conditions. Under such circumstances, necessity generated domestic and self-made production that substituted for large-scale industry. This was more than ever the case in the years of the Special Period, officially declared in 1991. In the 1990s, the government prioritized food production and focused on supporting small farmers. Eventually, starting in 1994, it allowed farmers to sell their surplus product directly to the population as a move to lift the state's monopoly on food distribution. Due to shortages in artificial fertilizers and pesticides, Cuba's agricultural sector largely turned organic, with the urban agriculture of *organopónicos* playing an important role in the transition.[17] Scarcity had a direct effect not only on farming, crops, and biodiversity, but also on culture in numerous respects. DIY, makeshift and recycled products, mended cars, and other odd and eccentric objects visually

characterize the period, revealing many parallels with the former Eastern Bloc.

Without trying to overly romanticize the feral qualities that arise in the cracks of such simplified infrastructure systems as detailed above, I want to acknowledge their importance and the resilience they represent for both ecology and human society. If the desire to completely streamline human infrastructures systems could be fully realized without any failures and cracks, the simplified skeletal and supposedly highly efficient structures would ensure the elimination of most biological and cultural diversity and quickly lead to catastrophic failure. It is in this context that I want to point out that feral qualities are a fundamental underlying ability of life, without which survival would simply not be possible.

Sociologist Jason Moore writes about capitalism's aims to make nature cheap by turning the work of living and nonliving beings, including humans, into commodities that can be transformed and transferred to make more money, wrecking ecological communities in an active and often purposeful process of ruination.[18] While statecraft may aim to better conditions by administrative tools and infrastructures, and by employing a high-modernist ideology of scientific progress, through the coercion of power it often fails and in fact produces similar effects to the problems of capitalism. Feral qualities and wildness offer hope through positive disturbances in this system. The disruption, disobedience, and ungovernability associated with being wild allow for not only the survival of certain species, but the cultural and political practices of resistance. In queer theorist Jack Halberstam's explanation, while the wild may conjure a place of ruination, destitution, anarchy, and despair, it is also an actively anti-hegemonic space from whence new alternative political imaginaries can arise.[19]

1 See Ingela Ihrman's solo exhibition *Giant Hogweed (Heracleum mantegazzianum)* Karlin Studios, Prague (2021), which I curated: http://futuraprague.com/en/karlin-studios/event/489-ingela-ihrman-the-giant-hogweed.

2 Lucy Cooke, *The Unexpected Truth about Animals: A Menagerie of the Misunderstood* (Doubleday, 2017), 187–213.

3 See the online exhibition (feralatlas.org) and catalogue *Feral Atlas: The More-Than-Human Anthropocene*, ed. Anna L. Tsing, Jennifer Deger, Alder Keleman Saxena, and Feifei Zhou.

4 Anna L. Tsing, *The Mushroom at the End of the World: On the Possibility of Life in Capitalist Ruins* (Princeton: Princeton University Press, 2015).

5 The song "The Return of the Giant Hogweed" appears on *Nursery Cryme* (1971), the band's third studio album.

6 "Feral qualities" in this sense are described in *Feral Atlas*: feralatlas.org.

7 Bettina Stoetzer, "Ruderal Ecologies: Rethinking Nature, Migration, and the Urban Landscape in Berlin," *Cultural Anthropology* 33, no. 2 (2018), 295–323.

8 Rita Süveges, "Beyond the Postcard: An Ecocritical Inquiry on Images of Nature," Mezosfera.org, October 2020, http://mezosfera.org/beyond-the-postcard:-an-ecocritical-inquiry-on-images-of-nature.

9 In Hungary, more than fifteen thousand landscape scars have resulted from mining and other forms of anthropogenic intervention in the landscape, as quoted in Süveges, "Beyond the Postcard." See also Magyar Bányászati és Földtani Szolgálat [Hungarian Mining and Geological Service], "Bezárt bányászati hulladékkezelők" [Closed Mining Waste Treatment Plants], https://mbfsz.gov.hu/hatosagi-ugyek/nyilvantartasok/bezart-banyaszati-hulladekkezelok.

10 John Szabo, "Between Two Giants: Materialism and the Social Imaginary in the Energy (Transitions) of Hungary," mezosfera.org, October 2020, http://mezosfera.org/between-two-giants:-materialism-and-the-social-imaginary-in-the-energy-(transitions)-of-hungary/.

11 See Eszter Krasznai Kovács, ed., *Politics and the Environment in Eastern Europe* (Open Book Publishers, 2021).

12 For more see Valentinas Klimašauskas and João Laia, eds., *Baltic Triennial 14: The Endless Frontier* (Vilnius: CAC Vilnius, 2021).

13 James C. Scott, *Seeing Like a State: How Certain Schemes to Improve the Human Condition Have Failed* (New Haven, CT: Yale University Press, 1998).

14 See Tsing, *The Mushroom at the End of the World*, 5.

15 Manuel De Landa, *A Thousand Years on Nonlinear History* (New York: Zone, 1997).

16 See Scott, *Seeing Like a State*.

17 Roger Atwood, "Organic or Starve: Can Cuba's New Farming Model Provide Food Security?," *The Guardian*, October 28, 2017, https://www.theguardian.com/environment/2017/oct/28/organic-or-starve-can-cubas-new-farming-model-provide-food-security.

18 Jason Moore, *Capitalism and the Web of Life: Ecology and the Accumulation of Capital* (New York: Verso, 2015), referenced in *Feral Atlas*'s article on capitalism: https://feralatlas.supdigital.org/world/acceleration?cd=true&bdtext=steffen-acceleration&rr=true&cdex=true&text=ad-capital&ttype=essay.

19 Jack Halberstam, "Wilderness," Visual Cultures Lecture Series, Gorvy Lecture Theatre, Royal College of Art, London, December 12, 2017.

Michał Grzegorzek

The Thrill of the Open Road: The Body in Movement and at Rest in Central and Eastern Europe

In historical politics, everything seems to orbit around maps, much as how in most men's lives, everything orbits around their penis. In either case, comparing sizes always leads to catastrophe, or at the very least to conflict. So it has been and so it remains, making it easy to strike analogies between the symbolic value of a map (travel, discovery, colonialism, knowledge, et cetera) and what the penis signifies (desire, sex, colonialism, violence).

In today's Central-Eastern Europe, governments have been taken over by ultraconservative parties and other groups whose policies reflect an adoration of maps and penises alike. Space, in a material and symbolic sense, acquires enormous significance—it becomes the subject of conflict, and a guarantor of existence. In Poland we hear that "Poland is for the Poles"[1] or that a region is "an LGBT-free zone."[2] Another map to appropriate and divide becomes the body—particularly the bodies of women, queer people,

illness sufferers, and children. The bitter notions of biopower and biopolitics are making a comeback, making us see that they never went away, only the masks changed over the decades; for a moment they were slumbering, now they've returned in new guises, or as farces.

The limits of our freedom go far beyond the contours of our bodies and politically determined state borders. They do not mind the charts of atlases; they negotiate, they revise. Shamed by hatred and cruelty, they want to return to being a blank spot. And later, having democratically acknowledged the history and presence of one and all, they want to rewrite. This would be the map of Central-Eastern Europe if it recognized queer stories.

This article has neither the ambition nor the capacity to consider all the stories. It is rather a fraction of a guide that blends travel with cruising. It roams across the Baltic shorelines and the balconies of the former Yugoslavia, from warm apartments and beds to streets and city washrooms, from the private to the public.

Homoviators

Let's say that this journey begins in 1975. A young Ryszard Kisiel is traveling with a friend to East Germany. He has yet to become the creator of one of Central-Eastern Europe's first homozines, *Filo*, which he would go on to publish for years out of his own pocket. Nor had the brutal Operation Hyacinth yet taken place—a roundup of homosexuals across Poland, organized by the Civic Militia.[3] Communism had not collapsed, nor the Berlin Wall, nor had morale been crushed by Western-imported candies.

But let's stay on track—Kisiel, a twenty-seven-year-old inhabitant of Gdańsk, is traveling with a friend to East Germany, where he visits Schoppenstube. Since 1961 this bar has operated as place for homosexual trysts.[4] Secret body language, tender glances, and stolen kisses, all under the watchful eye and ear of the German secret police, the Stasi (at least until 1968, when homosexual contact ceased to be outlawed in East Germany). It may have been Berlin's carefree way of life, the breeze in his hair, or *Spartacus International Gay Guide* magazine (founded in 1970) that made Kisiel yearn for the road, but from the late 1970s onward, he began traveling through the cities of the Socialist Eastern Bloc, large and small, in search of signs of gay life and sexual escapades. He found them in the cafés of Prague, the bathhouses of Budapest, the Golden Sands of Bulgaria, the parks of Bucharest.

Kisiel's travels, preceded by in-depth research and dependent on acquaintances and unbending train timetables, were not one long vacation. The aim, apart from the obvious entertainment value, was to collect information on homosexual cruising culture in the Eastern Bloc. The result was *Polish Gay Guide on the europeans socialists countries* [*sic*], a large, handwritten book featuring detailed practical information on cruising spots. City by city, the guide included addresses of venues and times where you could be sure to get laid, sometimes with descriptions of the crowd, and in some cases even specific prices. Apart from the dry statistics, the author sometimes rated a venue or offered the potential reader a bit of good advice. Sometimes he added a mysterious name or the initials of a local guide. Over time, the descriptions came to be illustrated with photographs of pick-up spots, from opera houses and theaters to park statues, urinals,

building facades, and café signs. In all of these places, men met to have gay sex.

The amateur artist's book, situated somewhere in between a publishing project and the romantic conceptual art of the 1970s, was the only queer undertaking of its kind in the Eastern Bloc. Kisiel's discipline and care means we are still able to locate some of the sites, whose gay past, incredibly enough, is still visible in the present. The places that have vanished in the capitalist changes remain in the book, as in a labyrinthine tomb, but can no longer be found. It is impossible to overstate the value of this initiative, if only in terms of its culture-fostering potential. As an employee at a Gdańsk printing house, the artist could replicate the book and distribute it to friends and acquaintances, men who would make practical use of the information and follow the "guidebook to lust" on their vacations and business trips. Today we can interpret the piece as affective mail art, but also as an erotic delegated performance! We must bear in mind that all this was taking place in a thoroughly communist and heterosexual (and less officially, Catholic) Poland, where family was the main value, and though art had begun to have a gender (Natalia LL), it was still far from having a sexual orientation. Kisiel's foreign trips were preceded by journeys around Poland (which was closer, cheaper, and linguistically easier to get around). The geographical scope is impressive, to say the least: alongside large cities such as Warsaw and Krakow, he visited smaller towns like Kutno and Zakopane.[5]

Among the unofficial meeting places for homosexuals in postwar Poland, few stoke the imagination quite like the Baltic beaches. This is, in fact, where Kisiel's path began in the 1960s—his indoctrination into cruising and his first

efforts to document gay societies. Far from AIDS (and yet so very close), from political oppression, from shame, and from the daily normative performance, gay beachgoers could submit to a different and ever so liberating choreography. Amateur "way-bent"[6] sessions, camp dance routines, and a lazy celebration of nature and freedom transport the figures in Kisiel's photographs beyond time and space to a queer utopia, to the hereafter, to a blank spot on the map.

In these melancholy photographs, the sea melts into the sky, blurring the figures' identities—these men could be mermaids, exotic dancers, or sexual treasure hunters. The work of Kisiel, a scrupulous queer archivist in a Communist queer reality, could be juxtaposed with that of Jack Smith or Nan Goldin, whose artistic strategies allowed excluded people to take over physical and metaphorical space. In Sobieszewo, in Stogi, and later in Lubiewo in private homes, in nowhere-places that were invitation only—ruins, parking lots—queer geographies transcend physical borders and time itself, in enigmatic gestures and gazes, in intimacy and a carefree mood.

In 2006, Karol Radziszewski sets off in Kisiel's footsteps. The young Polish artist has yet to meet his older colleague, but his desire to build international queer contacts and collect material for a self-published magazine, *DIK Fagazine*, spurs him toward Kyiv.[7] Radziszewski meets people, talks about LGBTQ rights, goes searching for queer predecessors, explores differences and similarities, goes to gay clubs, takes photos of nude boys. Between life and death, the body and the archive. All (or maybe not all?) of his Ukrainian adventures are immortalized in the second issue of *DIK Fagazine*. Over the following ten years more issues are released, some focused on Romania, Croatia, Belarus,

and Czechoslovakia, others collecting notes from the author's trips to Serbia, Slovenia, Bulgaria, Hungary, Estonia, and Latvia. It becomes evident that his work method is the affective journey.

Radziszewski is an interdisciplinary artist; he works in painting, photography, film, and installations. His methodology, founded on work with archives, is packed with cultural, historical, religious, social, and gender references. Radziszewski has frequently reinterpreted the work of other artists, mainly of the Eastern European neo-avant-garde, culling queer motifs or looking at the work from a queer or feminist perspective. His research and accompanying artistic renditions of the themes he explores reach their fullest expression in an anti-ethnographic travel-performance: the Queer Archives Institute. The QAI is a nonprofit organization established and created by Radziszewski whose aim is to study, collect, digitize, present, analyze, and artistically interpret queer archives, with a special focus on Central-Eastern Europe and other "peripheral regions."[8] Founded in 2015, it is a long-term project that invites curators, artists, activists, and academic scholars to collaborate.

To describe his archival activities, Radziszewski uses a term associated with complex official structures, or at least with institutionalized teams of people. "Institute" suggests that the knowledge the artist explores and produces is only part of boundless resources worth tracking down and studying.[9] The QAI is not a formalized organization, nor does it have a permanent headquarters. Rather, it annexes the places where it is invited. It can take the form of a single film screening, a lecture, a temporary office, or a performance of a few dozen hours. Most often it is a display resembling a museum exhibition, with the collections in vitrines. Yet

despite the serious form in which the information is presented, the artist's archive evades unequivocal academic classifications. It traffics in truth and fiction; it is fragmentary and nonlinear; and it raises everyday, sometimes vulgar objects to the status of relics, giving the collection a nonnormative, queer, and even, as scholar Magda Szcześniak has phrased it, a way-bent quality.[10] We cannot overlook the fact that this curious archive, despite its official-sounding title, is also driven by the passions of a collector. The QAI expresses a longing for shared queer roots, coming less from a single gender or sexual identity than from the shared experience of being excluded by the norm. These archives are a longing for a community, one where the promise of a free future is alive not only in a political sense, but also as pleasure, friendship, and care.

Journeys to the Center of the Earth

One of the Minsk residents Radziszewski meets in 2006 is Sergey Shabohin, a Belarusian artist and curator, an artivist[11] and art critic more interested in a certain visual aspect of the pickup than in cruising choreography. His installation *Zones of Repression* (2014–ongoing) is made of walls of white tiles imitating the interiors of public lavatories in which, as in other countries, men meet to have sex: "They leave their contacts and offers of sexual nature in the form of inscriptions on the walls of toilet stalls. But in Belarus all public spaces are cleaned until they shine. Cities are almost sterile. Even in public toilets, cleaning services quickly erase any inscriptions and graffiti. Therefore, visitors began to write messages

to each other in a small inconspicuous font on the grout between the tiles."[12] Among the original inscriptions copied out by Shabohin are requests for help that reveal the homophobic climate in Belarus ("Мне 16 лет и мне нравятся парни, как сменить ориентацию?" / I'm sixteen and I like guys. How can I change my sexual orientation?) and fanatical threats with a biblical flavor ("Бог таких как вы сжег в Садоме и Гоморре не дожидаясь страшного суда!" / God burned people like Sodom and Gomorrah without waiting for Judgment Day!). The majority, however, are offering sex ("Хочу волосатого грузина" / I want a hairy Georgian) or ("тут в каждую вторую субботу месяца с 15:30 до 16:00" / Right here on every second Saturday of the month from 3:30 to 4:00 pm).

The frames between the tiles on men's public toilet stalls, like the corridors of an underground city, build endless labyrinths for undercover residents. As soon as they are viewed by an insider, the atmosphere and function of the stalls imperceptibly changes. Their performativity also changes. What is the choreography of cruising? Orbiting around the object (and the subject) until sexual proximity is achieved? Or perhaps the reverse—orbiting around the object and subject so that sexual proximity is *never* achieved? So that the sexual adrenaline never runs dry? This pseudo-readymade, practically pulled straight out of the bathroom universe of Duchamp and transferred to the art gallery by Shabohin, says less about sex than about its absence. The installation is a set that would seem ready for cruising, though it more reminds us of a castrated monument. What has been cut out? A protagonist? A urinal? Maybe a penis? This artistic castration serves to focus our full attention on the text that is at the heart of the installation.

The tiny sex want ads, confessions of love, and epithets meld into the glistening wall, becoming a microcosm of Belarusian (and also Polish) society—its homophobia, closeted gay culture, desires, and fears. Toilet-stall cruising holds the ambivalence of a fun fair, as it is a haunted house and a tunnel of love in one. The artist says, "It is a symbol of freedom for absolutely any utterance. And let all the tiles be cleaned until they shine, let all the abnormal statements be pushed to the seams between them—in the end we see the grid as an image of direct social ties, and as a skeleton of society."[13] "Квир спасет мир" (Queer will save the world) promises one inscription in Shabohin's installation.

Descending deeper, into the depths of the Earth and time, we must pause at one more cruising artist. In 1999, Katarzyna Kozyra confirmed the hopes and fears of the Polish public, leaving the 47th Venice Biennale with an honorary mention for a true bit of espionage in which the penis, like a map, leads to a treasure. But we are getting ahead of ourselves. "I was . . . at an exhibition in Budapest [in 1997] and I went to a Turkish bath for the first time in my life. The place utterly enthralled me. Dark, murky interiors with incredible atmosphere. Strange women moving about and behaving in ways quite unlike what we are accustomed to seeing from day to day. There was everything except for the erotic."[14] Six months later, the artist returned to the Budapest bathhouses to record footage with a hidden camera for her *Bath House* video installation, where she spied on women behaving naturally in an intimate environment. Naked and focused on themselves, they helped the artist formulate statements on the female body's visual strictures in its everyday social performance. Only without an oppressive viewer (at least overtly) can we perceive the beauty of the diversity of bodies

and intimate choreographies. At this same time, the mystery and eroticism of the Turkish baths attracted other artists— Tacita Dean made the video *Gellért* (1998) at the Budapest bathhouses, and Matthew Barney used them as a setting for several episodes in *Cremaster 5* (1997). Small wonder, then, that Kozyra returned to Budapest to continue spying. This time, however, the artist's journey was also across gender (at least ostensibly).

"It's a boy!" Judith Butler might have exclaimed, using one of the incantations she describes in *Notes toward a Performative History of Assembly* (2015), in response to Kozyra done up as a man.[15] "In a hotel room, the make-up artist made her a beard and mustache, enlarged her eyebrows, pasted hair onto her body, and, most crucially, planted an artificial penis between her legs, a pass to the world of men."[16] Armed with her "masculinity" and a small waterproof camera (small for 1990s Poland, anyway), she filmed unsuspecting men for *Male Bath House* (1999). One watches Kozyra's video like a combination of body horror and erotic thriller, two cinematic genres that were particularly popular in the 1990s. The monster receives a new body right before our eyes, but "the monsters and the monstrances in cinema are our own eyes."[17] I am thinking above all of the tension that the artist's work generates. It may be a far cry from David Cronenberg, yet this peculiar pseudo-biological transformation (and the demonstration of the process) is a key part of the work and, in addition to the footage from the bathhouse itself, an important part of the video installation. The viewer is invited to witness practically every stage of the deception, forging a bond with the disguised protagonist. We do not want Kozyra to be caught, so we keep a nervous eye out for her in the frame, fearing the worst. We cheer her on in her undercover work.

Apart from these thrills, we sense another kind of tension that thickens around the male bodies shrouded in steam—an erotic tension. While the women in *Bath House* seem not to notice one another and tend to themselves, the men appear to go to the baths to check one another out. We see their lazy bodies lope across the tiles, their gazes hovering at crotch level, their manspreading. We even see them flirt. Kozyra had not suspected that, having entered this male sanctuary with a camera and a penis, she would be an object of desire.

"And why should only women be spied on? In ads, in porn mags, it's always women. Why shouldn't we peek in on guys without their 'protective layers,' without their outer shell, without their status symbols, their brand-name suits, their cars—in a bath house with just their bare asses. The girls would surely go wild for their dark, withered scrotums and their flaccid dicks."[18] Kozyra reduces male attributes to theatrical props or features, passports to a male world. She points the camera at the men, who are normally the ones holding it. And, defying the traditions of the nude, she does not ask them to undress. It is they who undress for her. "I need the identity as a weapon, to match the weapon that society has against me."[19] Impossible not to see this work through the lens of the Women's Strike, the Polish women's struggle for the right to abortion and to decide about their own bodies in general. In this sense, both Kozyra's work and the street protests speak of the relations between the female body and patriarchal institutions, of the male gaze and male pawing. Of encroaching into the male world and toppling its walls. Of the fact that you have to be a vixen and a lioness. ***** *** .[20]

Ania Nowak also rolls out some penis jokes in her work, which in a way links her to Kozyra's practice. Nowak works in choreography in its broadest sense, speculating on what body and language can do in our day. She makes performances that shift their boundaries toward other formats: text, video, exhibition. She is interested in the material side of the body, but also its nonmaterial aspects—affects, feelings, intuitions—as starting points for developing embodied practices of care and communality.[21] Nowak speaks of care and community as a Polish immigrant who has lived in Berlin for eleven years and as a queer cis woman living for thirty-odd years on patriarchal planet Earth. Like Kozyra in *Male Bath House*, Nowak often adopts male traits, but on different grounds. Kozyra was interested in mimicry, total resemblance, while Nowak is often a drag king in her performances, making a show out of masculinity, parodying it to reveal the oppressive structures and tools of the institution. So it is in *Untitled* (2016), in which a penis, or in fact a dildo hung on a strap, reduces masculinity (biological and cultural) to a toy, a costume, pure symbol. In her static, mainly text-based performance, Nowak explores the structure of an institution generally acknowledged to be gender neutral, pointing out vast spaces of oppression, exploitation, and appropriation. From the material aspects of the "contract, papers, archive, dust" set, to the abstract components of the state, governments, and the church ("tradition, structure, stabilization, administration"), she finally arrives at a harsh and revealing synopsis: "Parliament, parlia-men, pen-men, penises." You could get motion sickness following that logic. Nowak's work is not solely about critiquing the present because, to quote José Esteban Muñoz, "The here and now is a prison house."[22] She contrasts the structures of the state,

86

for instance, with the functions of bodies, which feel, desire, and live.

In another piece, *Untitled 3* (2018), Nowak performs as Karl Marx in drag—in a wig and full makeup, a rock-'n'-roll leather jacket and exposed pussy wig—to reflect on "the possibility of disattaching from prescribed categories and binary oppositions of thought/feeling, fact/fiction, work/leisure, communism/capitalism."[23] These oppositions, pale frames within which we still live, are tools of control and supervision, of outward solicitude, which as a society we blindly trust, allowing ourselves to be embroiled in this imposed performance of gender, exploitation, religious divisions. "To police gender is a criminal act, an act by which the police become the criminal, and those who are exposed to violence are without protection."[24] In one scene from *Untitled 3*, Nowak, still playing Karl Marx, does male breastfeeding on Jason Petterson/Max Göran performing alongside her, feeding him the poisoned milk of capitalism and masculinity.

Journeys to the Edge of the Night

Kozyra's path crosses with Nowak in one other place: where they explore the body from the experience of sickness and mourning. "Everyone who is born holds dual citizenship, in the kingdom of the well and in the kingdom of the sick."[25] Migration from the world of the afflicted to the world of the healthy is generally depicted via metaphors of triumph, victory, and success. This vocabulary links the convalescent and their experience of a capitalist understanding of a duel or rivalry—in short, the work the body must perform.

"Your body is an overheated factory. As you perspire, you stave off the inflammation and remain in good health," says Natalia Sielewicz in her video lecture *Teoria Stanów Zapalnych* (Theory of States of Inflammation, 2020), in which, like Susan Sontag before her, she surveys illness as a metaphor, brought up to date with the COVID-19 pandemic, new technologies, and post-truth. The words, which initially sound like glitching motivational speeches, touch on the kingdom of wellness and a museum of industrialization, and prompt another question from the curator: "When I ask you what you do with your heat, I join Audre Lorde in asking, what is the point of your anger?"[26]

Since the early 1990s, Kozyra has grappled with Hodgkin's lymphoma. The onset of the disease in 1996 coincided with the creation of her *Olympia* installation, which speaks of this experience. In one photograph, Kozyra lies on a hospital bed, quite naked and bald, while a nurse in the background attaches a drip. In the second photograph we again see a nude and bald Kozyra, yet this time the allusion to Édouard Manet's painting is clearer, albeit parodic: there are props, a dark-skinned serving woman, and a stuffed cat. In the third photograph, seemingly taken from the future, an older, naked woman is staring at us. All three "Kozyras" have velvet bands around their necks. They are ill and proud, staring straight at us. The hardest to look at, however, is the video accompanying the piece, showing the preparations for the first photograph. As in *Male Bath House*, the artist takes us behind the scenes. The illness and nakedness of the body, though inextricably linked, put the viewer in a state of inflammation. In *Olympia*, the nudity is contrasted not only with the clothed people, but above all with the medical personnel in their uniforms, making Kozyra seem doubly naked, and doubly ill as well.

There is something worse than the body's state of affliction. It is the fact of turning the gaze away from ailing body, "the trauma of not being seen."[27] The migration from health to illness is normally invisible.

Let's peek into another bed.

"Desire, unite, name," Nowak says to the audience in her poetic manifesto *To the Aching Parts!*, hitting the softest spots of the nonnormative community: internal exclusion, lack of solidarity, lack of agency. The performance she made for HAU, Berlin, in 2018 has taken on a new resonance in the time of COVID-19, when live performances are practically impossible.[28] Nowak performs from her bed in Berlin, shouting through an S&M mask that inhibits her breathing that we need an "ally, ally, ally." Using a micro-choreography and her trademark wordplay, she calls out for mutual support and for making difficult alliances. Yet her work goes beyond lamenting a lack of community, to the greatest dangers posed to queer society. In moments like this, the individual demonstration becomes a collective voice. For some time Nowak has been exploring chronic diseases—lifelong maladies whose special invisibility, misdiagnosis, and above all incurability make them a burden to society, and which are trivialized, marginalized, and ultimately denied.[29]

In her artistic and research practice, Johanna Hedva explores illness as a creative and liberated state, particularly in the manifesto "Sick Woman Theory," where she writes: "Because to stay alive, capitalism cannot be responsible for our care—its logic of exploitation requires that some

of us die. 'Sickness' as we speak of it today is a capitalist construct, as is its perceived binary opposite, 'wellness.' The 'well' person is the person well enough to go to work. The 'sick' person is the one who can't. What is so destructive about conceiving of wellness as the default, as the standard mode of existence, is that it invents illness as temporary. When being sick is an abhorrence to the norm, it allows us to conceive of care and support in the same way."[30]

The beds of Kozyra, Nowak, and Hedva (and of many others: Frida Kahlo, Tracey Emin, Felix Gonzalez-Torres) are prisons and places of rapture all at once. In *Olympia*, Kozyra takes charge of the image of her own ailing body. In *To the Aching Parts!* Nowak seeks help in the ties between suffering and desire. In "Sick Woman Theory," Hedva demonstrates the agency of illness, which can turn into resistance and protest. As the curator and art historian Ruth Noack puts it: "The representation of a desiring subject is one of the possibilities that the artist has to reawaken another view of everyday life. Yet, within patriarchy, the freedom to express central aspects of desire—its incredible capacity to make a subject and its equally fascinating ability to dissolve the same—is seldom accessible to non-male artists."[31]

I would add the map of Yugoslavia to those of vanished countries. This was the birthplace, in 1945, of Sanja Iveković, a leading representative of feminist art in Central and Eastern Europe. To the battlefields of the parks, toilet stalls, and beds, I would add private balconies, and Iveković's eighteen-minute performance *Trokut* (Triangle) on May 10, 1979. On a balcony under which the convoy of President Josip Broz Tito was passing, the artist simulated masturbation and read a book at the same time. There are perhaps no more subversive activities than these, which is why, after

90

eighteen minutes, a policeman rang the performer's doorbell and ordered her to go inside. *I always put my pussy* where I shouldn't.[32] This is how the queer revolution might look—mixing business with pleasure.

A protagonist is always on the move, driven by anxiety. According to Carl Jung, a journey is a picture of an aspiration, an insatiable desire, one that never finds the object of its quest.[33] Journeys in art, between media and bodies, in cruising and affect, come from rejecting oppression, from a desire to reread or redraw the map. These performative queer expeditions are not, perhaps, moon landings, but that does not make them less significant. "The contemporary queer performance, apart from its historical roots and genealogy which can be beautifully expounded, can have profound political potential, which involves writing queer culture into a political and social context that is broader than ever. In this sense, 'queer' itself ceases to be an alternative subject and an aesthetic disruption, becoming something far more complex—an alternative method of raising topics crucial to contemporary life, providing insight into a situation far stranger than the performer's gender and sexual identities."[34]

I do confess that, as a metaphor for artistic practice, the journey is a fairly lame stylistic trope. Even worse would be to compare a person's life to a journey (feel yourself cringe?). Yet being on the road, more than anything else, has dominated today's existence. The very concept of the road has to be updated by the space we cover as we are trapped in our apartments and our beds, the path we take to reach someone on the internet. By the streets of the cities we collectively march in political protests, taking on a new dimension. By the guides in museums that embrace decolonization. By

accessibility itself—a road once blocked can be made accessible to all. By rest, which is only very slow movement. And by travel inside the head—a fantasy in which all these roads can be conquered.

Translated by Soren Gauger

1 A slogan of Polish nationalists who reject immigrants and refugees.

2 LGBT-free zones (Polish: *strefy wolne od ideologii LGBT*) are municipalities and regions of Poland that have declared themselves unwelcoming to an alleged "LGBT ideology" in order to ban equality marches and other such events. As of June 2020, some one hundred municipalities (including five voivodeships), encompassing about a third of the country, have adopted resolutions that have led to them being designated such. See https://en.wikipedia.org/wiki/LGBT-free_zone.

3 Operation Hyacinth was a mass operation conducted in 1985–87, collecting information on Polish homosexuals. Among the many official reasons for this operation: counteracting the AIDS epidemic, fighting prostitution, protecting the public from criminals, and the desire to amass compromising materials that could later be of use in agent collaboration. Today, the multiaspectual nature of the operation is increasingly highlighted, as the "suspects" were not oppressed in every Polish city. See Ewa Majewska, "Public against Our Will? The Caring Gaze of Leviathan, 'Pink Files' from 1980s Poland and the Issue of Privacy," *Interalia Journal of Queer Theory* (2017), available at https://www.academia.edu/35439400/Public_against_our_will_The_caring_gaze_of_Leviathan_pink_files_from_1980s_Poland_and_the_issue_of_privacy.

4 In the following parts of this article I use "homosexual" and "gay" interchangeably with regard to Kisiel's work and interests, although the term "gay" only took root in Poland after 1989. I thus use "homosexual" and "gay" to pertain to sexual male-to-male contact prior to 1989, though today we could recognize a wider spectrum of identities (bisexual, queer, et cetera).

5 Kisiel's research covered twenty-four Polish towns and cities. By comparison, Warsaw presently has 1.7 million inhabitants, and Kutno, 44,000.

6 A gay man who is ostentatiously effeminate and queer.

7 http://www.dikfagazine.com.

8 The QAI has had editions at Videobrasil, São Paulo; Y Gallery of Contemporary Art, Minsk, Belarus; Fundación Gilberto Alzate Avendaño, Bogotá; Centrala, Birmingham, England; Museum of Contemporary Art, Zagreb; and Schwules Museum, Berlin.

9 Much of the collection under the creative control of the QAI was transferred to Radziszewski by Ryszard Kisiel, whom the artist met in 2009. Kisiel became not only a partial founder of the QAI, but also a friend and many-year creative partner to Radziszewski. See http://artmuseum.pl/pl/filmoteka/praca radziszewski-karol-kisieland-2?age18=true.

10 Magda Szcześniak did an in-depth analysis of the Karol Radziszewski archives even before the QAI was established: Magda Szcześniak, "Queerowanie historii, czyli dlaczego współcześni geje nie są niczyimi dziećmi," *Teksty Drugie: teoria literatury, krytyka, interpretacja* 137, no. 5 (2012): 205–23.

11 Shabohin is the editor in chief of a website exploring Belarusian artivism: http://artaktivist.org.

12 Sergey Shabohin, "A White Culture Is Afraid of Looking into a Black Hole" (interview with Karol Radziszewski), *DIK Fagazine*, no. 12 (2016), 15.

13 Shabohin, "A White Culture Is Afraid of Looking into a Black Hole", 15.

14 Katarzyna Kozyra, "Łaźnia męska," in *Łaźnia* (Warsaw: Zamek Ujazdowski Centre for Contemporary Arts, Zachęta Contemporary Art Gallery, 1999), 113.

15 Judith Butler, *Notes toward a Performative History of Assembly* (Cambridge, MA: Harvard University Press, 2015), 29..

16 Karol Sienkiewicz, *Zatańczą ci co drżeli. Polska sztuka krytyczna* (Krakow and Warsaw: Karakter, Muzeum Sztuki Nowoczesnej w Warszawie, 2014), 282.

17 Ute Holl, *Cinema, Trace and Cybernetics*, trans. Daniel Hendrickson (Amsterdam: Amsterdam University Press, 2017), 23.

18 Kozyra, "Łaźnia męska," 78.

19 Susan Sontag, *Reborn: Early Diaries*, vol. 1, *1947-63* (London and New York: Penguin, 2012), 219.

20 The asterisks stand in for "Jebać PiS" (Fuck PiS). This is a coded message to the party presently ruling in Poland, Prawo i Sprawiedliwość—society's response to the numerous cases of neglect, abuse of power, polarization of the people, attempts to make anti-abortion laws more stringent, and many, many other things. It was the symbol of the Women's Strike protests in Poland in 2020–21.

21 See https://www.anianowakanianowak.com.

22 José Esteban Muñoz, *Cruising Utopia: The Then and There of Queer Futurity* (New York: New York University Press, 2009), 1.

23 See https://u-jazdowski.pl/en/programme/wystawy/inne-tance/inne-tance-amp-sprzeze-nia-zwrotne-rezydencje-performatywne/ania-nowak.

24 Butler, *Notes toward a Performative History of Assembly*, 56.

25 Susan Sontag, *Illness as Metaphor* (New York: Picador, 2001), 3.

26 See the museum's page devoted to the exhibition, https://artmuseum.pl/pl/wydarzenia/teoria-stanow-zapalnych-wideowyklad-natal-ii-sielewicz-i-eternal.

27 Johanna Hedva, "Sick Woman Theory" (2016), available at https://johannahedva.com/SickWomanTheory_Hedva_2020.pdf.

28 Commissioned by HAU (Hebbel am Ufer) for "Manifestos for Queer Futures," supported as part of the Alliance of International Production Houses by the Commissioner for Culture and Media of the Federal Government in Berlin.

29 See for instance Ania Nowak, *Inflammations*, premiered September 19–22, 2019, Sophiensæle, Berlin.

30 Hedva, "Sick Woman Theory."

31 Ruth Noack, "Performing Horizontally: On a Meeting of Performance Polemics and Performance Anxiety," in *Is the Living Body the Last Thing Left Alive? The New Performance Turn,*

Its Histories and Its Institutions (Berlin: Para Site and Sternberg Press, 2017), 168.

32 The quote is from Eileen Myles, "Maxfield Parrish," reproduced at https://www.eileenmyles.com/books/Maxfield-Parrish/.

33 C. G. Jung, *The Collected Works of C. G. Jung*, vol. 5, *Symbols of Transformation* (Princeton, NJ: Princeton University Press, 1977).

34 Joanna Krakowska, *Odmieńcza re-wolucja. Performans na cudzej ziemi* (Krakow: Wydawnictwo Karakter; Warsaw: Muzeum Sztuki Nowoczesnej w Warszawie, 2020), 25.

Aleksei Borisionok and Olia Sosnovskaya

The Futures of the "East"

Characters:

* The Librarian at the National Library, who silently went on strike during the massive uprising against Alexander Lukashenko's regime in 2020. The National Library is a controversial architectural project, built in 2006. Part of the money for its construction was forcibly collected from the population.

* Four mosaic panels, "City Warrior," "City of Sciences," "City of Culture," and City-Builder" by Alexander Kishchenko, a painter and mosaicist (1933–1997), on the front facades of a row of apartment blocks in Minsk's East neighborhood (1978). They face Independence Avenue, the main street that dissects the city and transforms into a highway leading to Moscow.

* The Karich brothers, Serbian oligarchs and politicians responsible for several controversial development projects in Minsk. According to some investigations, their companies

were used for laundering personal funds of Lukashenko's family.

* <u>Liudmila</u>, a shop assistant in the "Happiness" shopping mall, a small and dying Soviet-style trading house. Her mother received a flat in the district as the mother of many children and an honorary award for workers recipient.

* <u>The Swamps</u>, prehistoric and modern wetlands that witnessed the "Minsk phenomenon"—rapid urbanization of the city after World War II—and became the "water and green diameter," a water system that dissects, cuts, and trespasses through the industrial districts and ensures the circulation of clean air in the city.

* <u>The anonymous admin of Telegram chat "EAST-1-TOGETHER</u>," which was created in August 2020 to mobilize and organize protesting groups of people. It served as a communication infrastructure for local political activities—organizing concerts and protest marches, and distributing posters and stickers in the neighborhood.

<center>*</center>

If one leaves Minsk, moving east, they follow a farewell passage through a wide avenue, crossing modernist housing ensembles countered by new developments. Or, if one comes from Moscow, it will be the beginning of the city. East-1 and East-2 residential districts, or simply "East," were built starting in 1966 and into the 1970s as exemplary socialist neighborhoods, with modern housing and vast green areas. In recent years, the district became a space where different

temporalities and powers overlap: the socialist utopias of common living, the capitalist developments of Belarusian and Russian state corporations, the deep time of the pre-historic swampy landscapes, and the prefigurative protest energies of district residents.

*

Though marking the end of the city (or its beginning) at the time of its creation, the East neighborhood is well connected to the city center by the main avenue that crosses the district. In this periphery, remoteness is not so much physical, but rather ideological. It is also quite self-sufficient: its well-developed infrastructure includes a library, school, kindergarten, various shops and cafés, and extensive green areas.

The neighborhood was initially built on fields, water, and villages. For a while, these landscapes and temporalities coexisted. The residents of the new developments collected fruits in the nearby garden and fished in the lake. But already in the 1980s the wetlands and rivers were reorganized and incorporated into the twenty-two-kilometer-long Slepyanskaya water system—a system of canals and brutalist cascades. An important element of the socialist planning, part of a so-called water and green diameter, this water system splits industrial districts, supplying enterprises, ensuring the circulation of clean air, and serving as a recreational zone for dwellers.

Since the early 2000s, this utopian socialist project of collective living has been in turn superimposed upon by new models of the future designed by Lukshenko's era: the National Library, Gazprom Tower, and a new residential estate. These projects, however, have been punctuated by a

series of failures. For instance the Gazprom Tower project, a symbol of post-Soviet extractivism that demolished another significant socialist building, the Moscow bus station, is currently stalled.

Advertised as one of Minsk's key landmarks, the National Library is truly one of the most emblematic projects of the current regime. The building, which also hosts the National Archive, has the shape of a rhombicuboctahedron, resembling a diamond, whose glass surfaces glitter and spark with commercial and social advertisements by night. Realized more than twenty years after its initial devising, with numerous mistakes and funding issues along the way, this spectacular architectural project is now out of sync with ideas about the country's progress and prosperity that it was meant to embody. As some local people say, the National Library was built upon the wetland, and one day this spacious and mostly deserted building could be swallowed by the boggy land.

If you face the library, with your back turned toward four monumental mosaic facades and the sealed Gazprom Tower on your right, on your left you will encounter the vast shopping mall, Dana Mall; a business center, Dana Center; and the new housing development, Minsk Lighthouse. All are part of Dana Holdings, a real estate entity of the Karich brothers, Serbian entrepreneurs and politicians and friends of Lukashenko.

Minsk Lighthouse was advertised as a "local Dubai"—a highly ambitious project with canals and gondolas, gardens, a water park, and a three-hundred-meter-tall tower resembling a lighthouse. But these promises were never realized. The "elite" housing turned out to be quite basic and dense, with little public space and overcrowded infrastructure.

Despite multiple complaints about the quality, breach of obligations, and delays and disruptions in construction, Dana Holdings still gets multiple tax benefits and exemptions, and priority to acquire the best spaces in the city. In 2018 the company showed the second highest net profit in the country. The Karich brothers, who also run businesses in several other post-Soviet countries, reached the peak of their financial wealth during Slobodan Milošević's rule, having owned several media conglomerates, a university, and a bank. It has also been reported that Lukashenko uses Karich companies to launder and hide his personal funds.

Through the histories of developments in the East, competing futures manifest themselves: the Soviet modernist future-in-the-past and post-socialist capitalist expansion. Each produces its promises and its own ruins, overlapping in the now-time: the crumbling concrete shores and the weedy waters of the Slepyanskaya water system, the abandoned construction sites, the demolished modernist projects, the unrealized architectural renderings.

*

The summer of 2020 brought some unplanned and unexpected social constellations and activities to the neighborhood.

Anti-government protests in Belarus, triggered by unfair elections and extreme state violence against the protestors, were the most massive and long-standing in the country's contemporary history. In Minsk, their spatial disposition was quite unusual, too. Given the crackdowns on huge demonstrations, mostly in the central parts of the city, people started to self-organize in their neighborhoods.

This included local protest marches, but also the creation of new protest infrastructures. Residents created Telegram chats for communication and organizing and initiated regular meetings and public activities. Apart from partisan protest actions (political graffiti, stickers, flags), the events included outdoor concerts, parties, and other leisure activities in the common open yards. Of course, the police considered these practices part of the protests and implemented regular raids and arrests. At some point, the daily life of the district became almost indistinguishable from the political, and any gathering or even presence in public space could be criminalized. If there was a local protest march in the neighborhood, passersby might well be arrested on their way shopping.

Minsk Lighthouse, like many other new housing estates in the city, was among the most active neighborhoods. Populated as it is mostly by younger and more well-off residents, it might not seem surprising that this was the case. Ambitious professionals and young families overall enjoy greater mobility and more international connections, which in turn allow more flexibility (for instance in case one gets fired for their political views). And their hopes for political change have not yet been crushed by the numerous "failed" protests against the current government and the subsequent repressions, unlike those of older generations. Yet age and class dispositions are not quite so predictable as all this. The residents, deceived by the turbo-capitalist and nepotistic promises of a better life, tricked into the already faulty living, revolt. They reappropriate the spaces of their estate originally planned mostly for consumption, and construct the formerly nonexistent public space through emergent collectivities and protest choreographies.

104

The protest energy is accumulated through the gesture of refusal—refusing to be governed in an authoritarian and patriarchal way. This is the power of negativity, desire, and disobedience that is confronted with a massive wave of repression. Any gesture of refusal could be tracked as dissent against the ruling power. Anything—colors, shapes, glances, songs—could be triggers for an administrative arrest. The diffused energy of revolt becomes more opaque, more agile, more partisan: this is how voices and chants would be amplified from many dark windows instead of in unison as march slogans. The energy of negativity does not produce a single image of a confident and stable future—it forces the future to flicker.

Certainly, Minsk Lighthouse doesn't represent the whole protest. The older socialist neighborhoods of East-1 and East-2 are protesting, too. The open communal yards of the socialist districts seem to serve their very purpose (which was neglected throughout the post-Soviet redevelopments), namely the production of collectivities and politicization of the everyday. But this is not a repetition. They become centers of political life, which is indiscernible from daily life, confusing the policing gaze of the state. They welcome the meetings of residents, who collectively negotiate their political struggles and their collective future. The future, though, is complex, unpredictable, and vague, and not imposed from above. It is already happening, now. Walking through the blocks of flats, along the concrete shores of the canal, one experiences the strange sensation of knowing and not knowing, of not recognizing a familiar landscape. The traces of the ongoing uprising manifest through protest graffiti and information stickers, overwriting the historical surfaces.

Along the avenue are four monumental mosaic panels—
"City Warrior," "City of Sciences," "City of Culture," and
"City-Builder," created in 1978 by the artist Alexander
Kishchenko—installed on the front facades of four residential
houses facing Independence Avenue. Initially they con-
fronted a vast green area of gardens, forests, and swamps, but
these were eventually replaced by a formidable shopping
mall in the 2000s and 2010s, when this rewarding piece of
land started to be developed. The massive facade of the
shopping mall is painted in green and red—colors that repre-
sent the official ideological regime. The building resembles
a cosmic object from the landscapes of Saturn in the paint-
ings of Jazep Drazdovič, a Belarusian Cosmism-inspired
artist active in the 1930s.

The panels by Kishchenko symbolize four historical
strands—the victory in World War II that constitutes the fun-
dament of the nation's independence, according to official
state ideology; the reconstruction force that regenerated the
city from ruins (almost 95 percent of Minsk was destroyed
during World War II); and two driving energies, arts and
sciences, that modeled the future. Kishchenko was famous
for incorporating a specific cosmogony into socialist imagery—
a strange aesthetic mix of realism and symbolism that em-
braced partisans, planets, grids, communists, and esoteric
symbols into one universe. His art reflected a Communist
utopia and the burden of capitalist and imperialist violence,
regeneration from it, the temporality of history and pro-
gress. The four sixteen-story-tall panels work as both monu-
mental historical compositions and a detailed cartography
of time: more than surface, they become the environment.

All of them feature linear progress, from the depth of history to the horizon of the future, through a moment of now. In the smaller spheres or medallions, one can see how the past is defeated by the future through collective negotiation—the moment of now is always collective, represented by a collective will, by a group of partisans, comrades, builders. In this manner, historical fascist violence is overcome by the anti-fascist future through the collective affect of comradeship.

Surprisingly, there is an art gallery. Art Haos in Dana Mall is managed by Lilya Lukashenko, a daughter-in-law of the president of Belarus. According to several journalistic investigations, she is part of the dark economies of Dana Holdings, which are connected to various companies in Cyprus, possibly part of laundering schemes. Perhaps the gallery's name refers both to real estate speculation and to the myth of wild creative energies running through artistic expression. The gallery features works by Belarusian socialist and contemporary artists in mostly realist or impressionistic styles. One of the most expensive pieces available is by the aforementioned Alexander Kishchenko. *Grushevyi* (Pear), from an unknown year (most probably the early 1990s), enacts another utopic space that appeared in a post-socialist time—the image of a "small motherland" that transcends into earthly paradise. These two works by the same maker bring us to very different understandings and mediums of art, of imagery, of utopic temporality. They are also part of different economies. One is always collective, common, both powerful in its statement and fragile, as it is crumbling into pieces; the other is for individual use, a commodity, a decoration, and an expression of a post-Communist appeal to religion.

On the day of remembrance, November 1, 2020, the weekly protest demonstration of many thousands took place. This time, the march route led through the East district to the forest of Kurapaty on the outskirts of Minsk, where the Stalinist repressions included out-and-out massacres. Just before the marchers crossed the district, a huge white-red-white flag was hung over one of the Kishchenko's panels depicting partisan struggle. Over the course of the year, this flag broke the constrained national symbolism and became a popular image of the protest movement. In this instance, its fabric did not overlap the partisan imagery but integrated smoothly into the mosaic composition—the width of the stripes and arrows, color scheme, and other parameters matched up, as if the flag had activated protest energies from the cosmic partisan panels. This imposition reminds us again how protest, popular and horizontal, opens up a flickering moment of futurity in the time of now. This moment of collective assembly organizes the utopic and seemingly non-relevant temporalities: the future is now, the past is now, the now is now.

Authors' Bios

João Laia (1981, Lisbon) is chief curator for exhibitions at Kiasma
 Museum of Contemporary Art, Helsinki. With Valentinas
Klimašauskas, Laia co-curated the 14th Baltic Triennial (2021). Recent exhibitions
include *MASKS* (2020) and *10000 Years Later Between Venus and Mars* (2017–2018), City
Hall Gallery, Porto; *In Free Fall* (2019), CaixaForum, Barcelona; *Vanishing Point* (2019)
Cordoaria Nacional, Lisbon; *Drowning in a Sea of Data* (2019) and *Transmissions from the*
Etherspace (2017), La Casa Encendida, Madrid; *foreign bodies* (2018), P420, Bologna; *H Y*
P E R C O N N E C T E D (2016), MMOMA–Moscow Museum of Modern Art; *Hybridize*
or Disappear (2015), MNAC – National Museum of Contemporary Art, Lisbon. Laia
co-curated the 19th and 20th editions of the biannual Contemporary Art Festival Sesc_
Videobrasil (2014–18), São Paulo. Other exhibitions, performance programs and screenings
were held at Moderna Museet (Stockholm), Kurzfilmtage International Short Film Festival
Oberhausen and Delfina Foundation, South London Gallery and Whitechapel Gallery (all
in London). Laia has published in platforms such as *Art Monthly, Frieze, Mousse, Spike* and
Terremoto and was part of conferences, lectures and panel discussions at ARC Bucharest, Art
Basel Hong Kong, CAC–Centro de Arte Contemporáneo, Quito, Instituto Iberê Camargo,
Porto Alegre, JNU–Jawaharlal Nehru University, Delhi, Kyoto
Art Centre and LIMA, Amsterdam.

Valentinas Klimašauskas (b. 1977, Kaunas, Lithuania) is a curator and writer.
 Together with João Laia he co-curated the 14th Baltic
Triennial at CAC Vilnius (2021). With Inga Lāce he curated *Saules Suns*, a solo exhibition
by Daiga Grantina for the Latvian Pavilion at the Venice Biennale (2019), worked as a
program director at Kim? Contemporary Art Centre, Riga (2017–18), and was a curator at
CAC, Vilnius (2003–13). Since 2020 he is a curator at large at Springs.video. Klimašauskas
has published texts in *A Prior Magazine, Baltic Notebooks of Anthony Blunt, Beyond, Cura*
Magazine, Dailė, Dot Dot Dot, Flash Institut, Flash Art, Kim Docs, Good Times & Nocturnal
News, Šiaurės Atėnai, CAC Interviu, Metropolis M, Mousse Magazine, Paletten, Spike Art
Magazine, and elsewhere.

Michal Novotný is the director of Collection of Modern and
 Contemporary Art at the National Gallery in Prague.
He teaches at the Academy of Arts, Architecture and Design in Prague. He is the former
director of FUTURA Centre for Contemporary Art, Prague (2011–18), and former curator
at PLATO, Ostrava (2016–18). In 2018 he curated *Orient*, a large survey exhibition of art

from Eastern Europe, which appeared at Kim? Contemporary Art Centre, Riga, Lativa; BOZAR, Brussels; and Bunkier Sztuki, Krakow, in 2018, and was followed by *Orient2* at Kunsthalle Bratislava, Slovakia, and *Orient V* at Prague City Gallery in 2019. He curated *School of Pain* (2019), dealing with the legacy of the Marquis de Sade and Leopold Ritter von Sacher-Masoch in contemporary art, at Art in General, New York. *Deux sens du décoratif* at Passerelle Centre d'art contemporain, Brest, France (2019) addressed the question whether the decorative may be taken as a subversive artistic position nowadays. Other recent curatorial projects and residencies have taken place at Delfina Foundation, London (2016); Stroom Den Haag, the Netherlands (2015); Contemporary Arts Center, New Orleans (2014); Contemporary Art Museum, Rijeka, Croatia (2014); and Villa Arson, Nice, France (2013).

Zane Onckule (b. 1982, Latvia) is a curator and Program Director at Kim? Contemporary Art Centre, Riga, Latvia (2010–17 and since 2020). She was co-commissioner of the Baltic Triennial 13 (2018) and co-commissioner of the Latvian Pavilion at the 55th Venice Biennale (2013). Selected curatorial projects include solo exhibitions by Sophie Thun, Kim? (2021); Tobias Kaspar, Kim? (2019); Rodrigo Hernandez, Kim? (2017); Ieva Epnere, Art in General, New York (2017); Ulla von Brandenburg, Kim? (2015); and Ola Vasiljeva, Art in General, New York (2014), and the group exhibitions *Cold Time Out of Joint*, Kim? (2021); *Faktura (For a Nervous Spirit)*, Kim? (2020); *Balticana*, Hessel Museum of Art, New York (2019); *Le Fragole del Baltico* (with Simone Menegoi), CareOf, Milan (2015); and *Vortex*, Garage Museum of Contemporary Art, Moscow (2014). She studied art history at the Art Academy of Latvia, communication science at the University of Latvia, and photography at Zurich University of Arts, and holds a BA from the School of Business and Finance in Latvia (2004) and an MA from the Center for Curatorial Studies at Bard College (2019). Onckule's writings and reviews have appeared in *Artforum*, *MoMA Post*, *Art Monthly*, Echogonewrong.com, *Kulturas Diena*, Arterritory.com, and *Foto Kvartals*, among others.

Borbála Soós (1984, Budapest) is a UK-based curator and an active advocate, participant and organizer of artistic and ecological research. Borbála's practice responds to, disrupts and enriches environmental thinking and related social and political urgencies. She is currently undertaking an MPhil/PhD research at Goldsmiths College in the Art/Visual Cultures Departments. She holds an MA in Curating Contemporary Art, Royal College of Art, London (2012). She has been a visiting lecturer at Goldsmiths College, the Royal College of Art, Central Saint Martins and Edinburgh College of Art among others.

From 2012 to 2019 she was director and curator at Tenderpixel, a contemporary art gallery in central London. As an independent curator she organized projects in collaboration with Rupert, Vilnius; Futura Centre for Contemporary Art/Karlin Studios, Prague; tranzit, Bratislava; Trafó House of Contemporary Arts, Budapest and OFF-Biennale, Budapest; ICA, London and Camden Arts Centre, London. In 2020 she led a Peer Forum on Rewilding at the Horniman Museum and Gardens, London and in

collaboration with Artquest. She often develops projects in environments such as forests, botanical gardens and recently a collective research expedition and exhibition in the Azores Archipelago with Re_Act Contemporary Art Lab.

Michal Grzegorzek is a curator, author of texts on contemporary art and a researcher. He is interested in queer theory in visual and performative arts as well as experimental exhibition formats. Since 2016, he has been associated with the Ujazdowski Castle Centre for Contemporary Art, where he is a curator in the performing arts department. He was the curator of the exhibition series Project Room, an annual competition for young Polish artists, and together with Mateusz Szymanówka, he runs the performative-discursive program To Be Real, exploring the relationship between contemporary performance and club culture. Since 2019, he has been cooperating with Nowy Teatr in Warsaw, where he has established his own visual arts program. Since 2022, he has been co-curating the Kem School–a program of joint learning through experiments and reflection on social choreography, performance, and methods of queer-feminist activities.

Aleksei Borisionok is a curator, writer, and organizer who currently lives and works in Minsk and Vienna. He is a member of the artistic research group Problem Collective and the Work Hard! Play Hard! working group. He writes about art and politics for various magazines, catalogs, and online platforms. His writings have been published in *L'Internationale Online*, *Partisan*, *Moscow Art Magazine*, *Springerin*, *Hjärnstorm*, *Paletten*, and *syg.ma*, among others. His current research focuses on the temporalities of post-socialism.

Olia Sosnovskaya is an artist, researcher, writer, and organizer based in Vienna and Minsk. She works with text, performance, and visual art, and is currently a PhD-in-Practice candidate at the Academy of Fine Arts Vienna. She is a cofounder of Work Hard! Play Hard!, a self-organized platform, and a member of the artistic research group Problem Collective. Her writings have been published in *TQW Magazin*, *Paletten*, *Moscow Art Magazine*, and *pARTisankA*, among others. Recent artistic projects and residences include Centrale Fies, Konstepidemin, Tanzquartier, PACT Zollverein, and the Kyiv International–Kyiv Biennial.

Baltic Triennial 14: The Endless Frontier
4 June–5 September 2021

Contemporary Art Centre, Vilnius

Nada Prlja, *Queue*, 2007

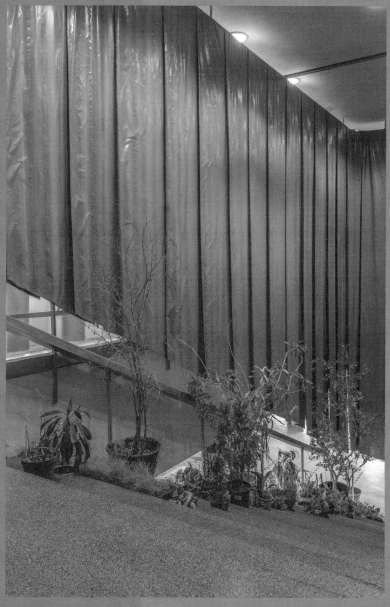

Flo Kasearu, *Violence Grows in Silence*, 2021

Isora x Lozuraityte Studio for Architecture, exhibition architecture, 2021

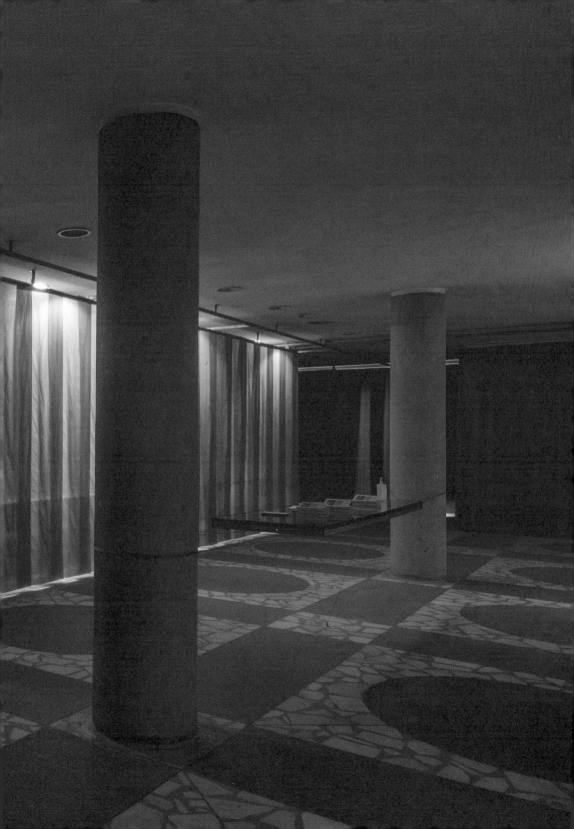

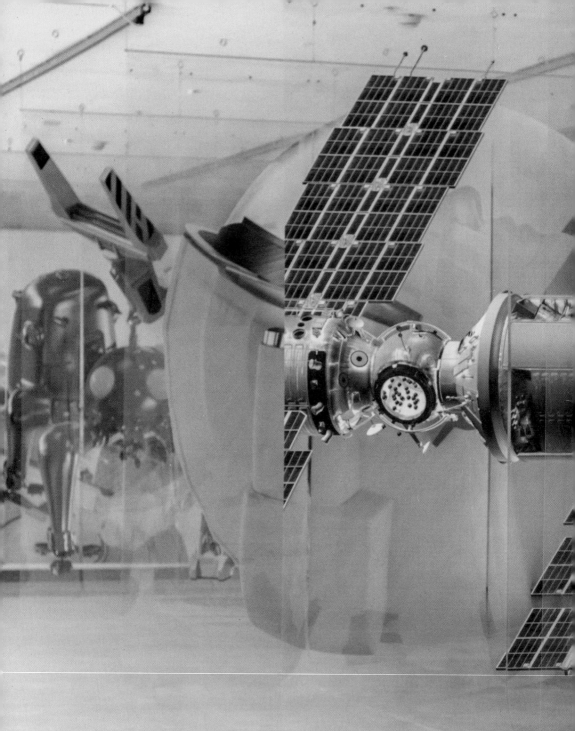

Aleksandra Domanović, *Things to Come*, 2014

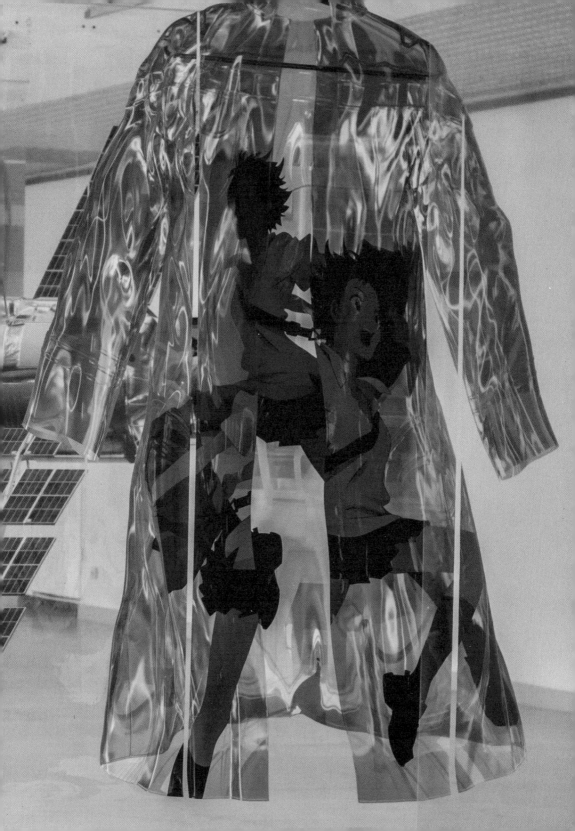

Aleksandra Domanović, *Things to Come*, 2014

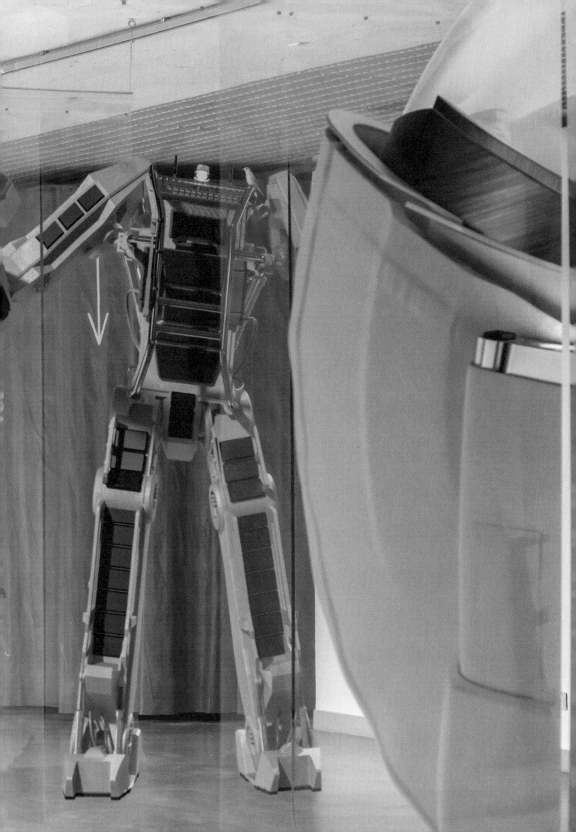

George Maciunas, *Instructions on How to Read the Atlas of Russian History*, c. 1953

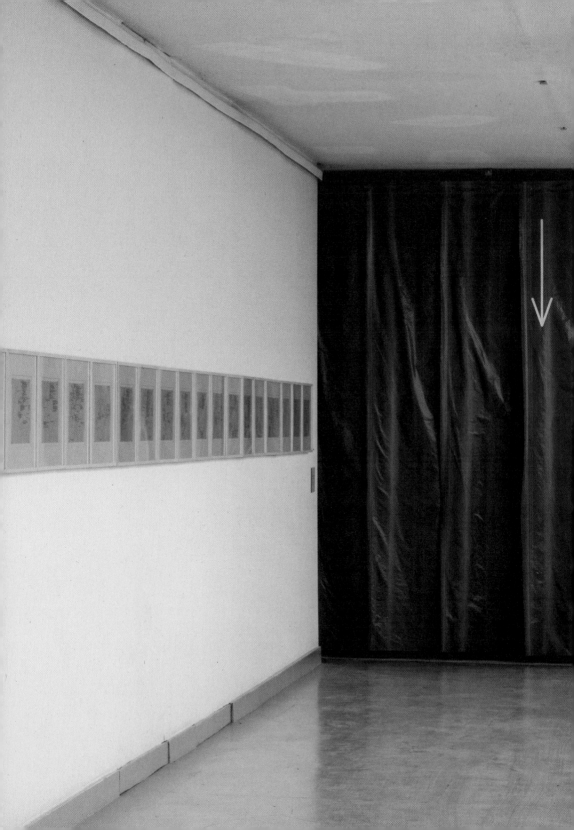

George Maciunas, *Instructions on How to Read the Atlas of Russian History*, c. 1953

George Maciunas, *Instructions on How to Read the Atlas of Russian History*, c. 1953

George Maciunas, *Instructions on how to read the Atlas of Russian History*, c. 1953

Mona Vatamanu & Florin Tudor, *Land Distribution*, 2011

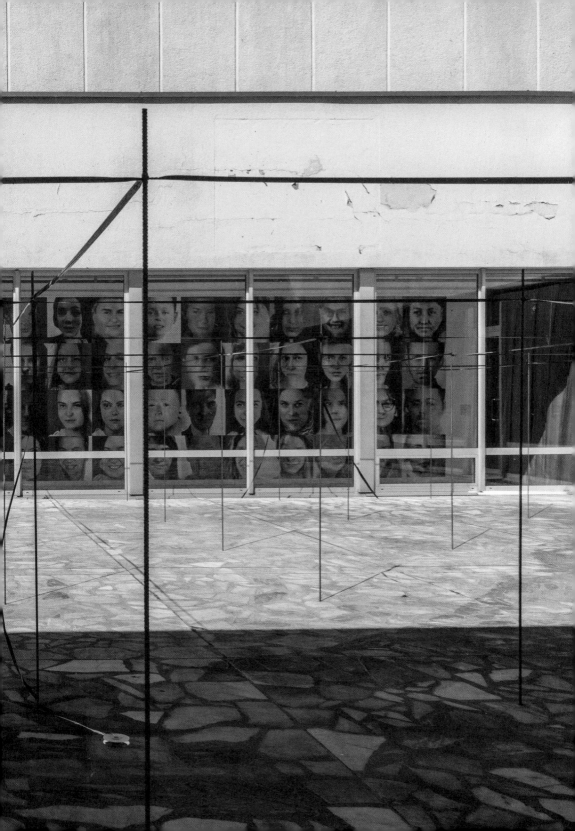

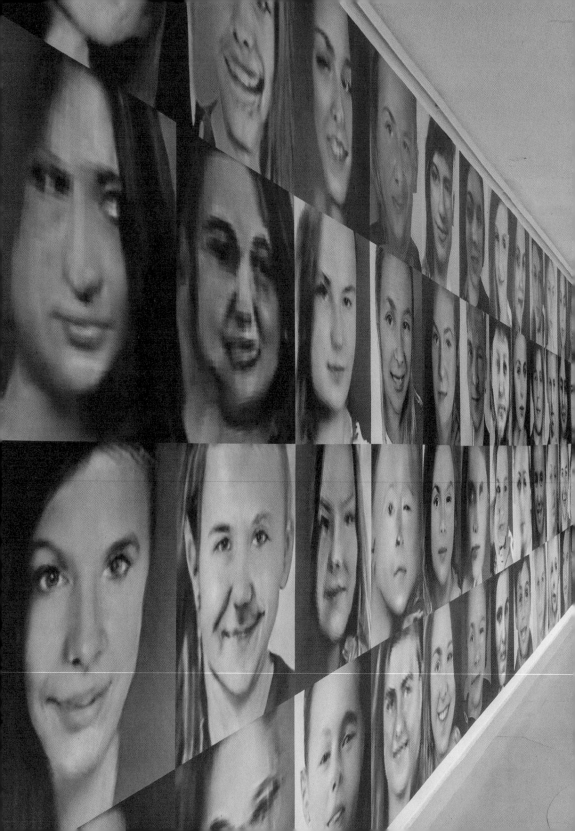

Janek Simon, *Synthetic Poles*, 2019

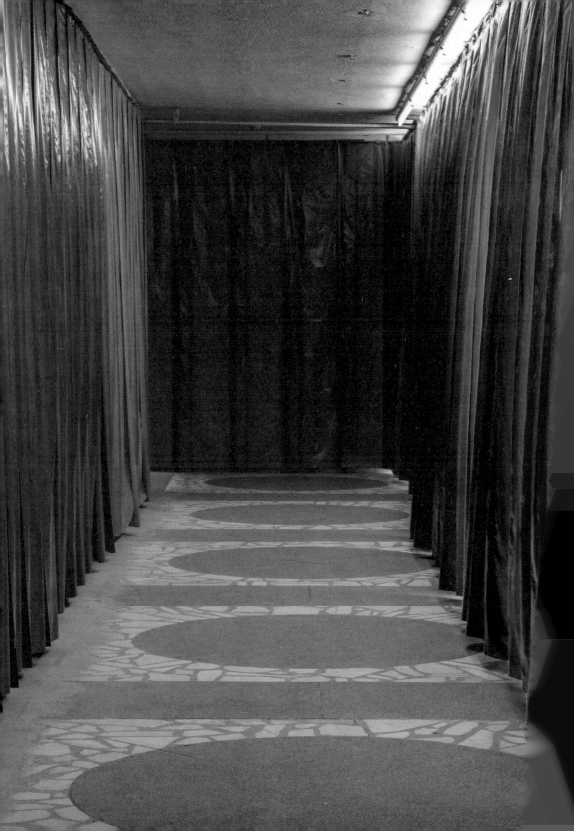

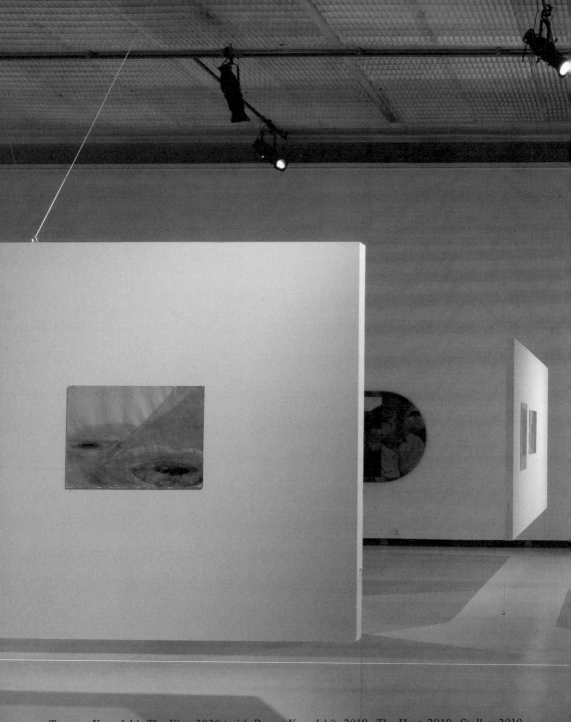

Tomasz Kowalski, *The Kiss, 2020 (with Donat Kowalski)*, 2019; *The Host*, 2019; *Stalker* 2019
Group of 32 works (all untitled), 2020–2021

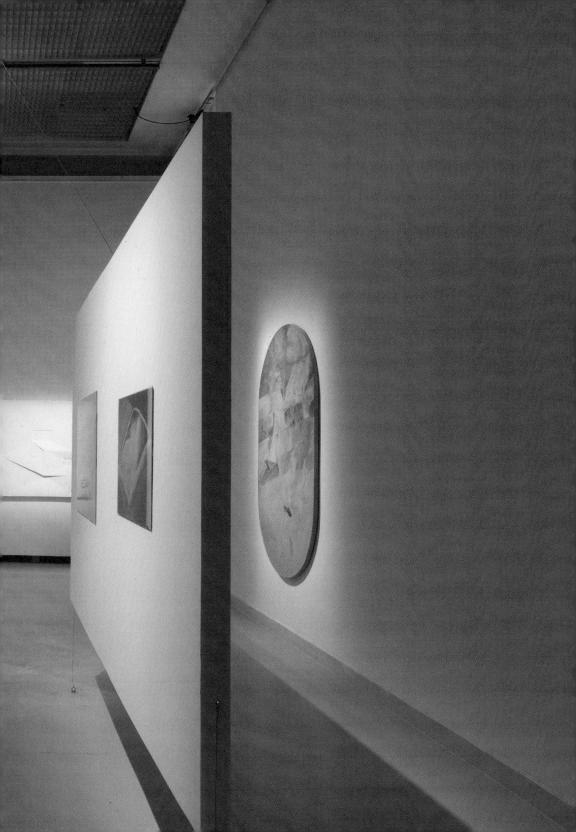

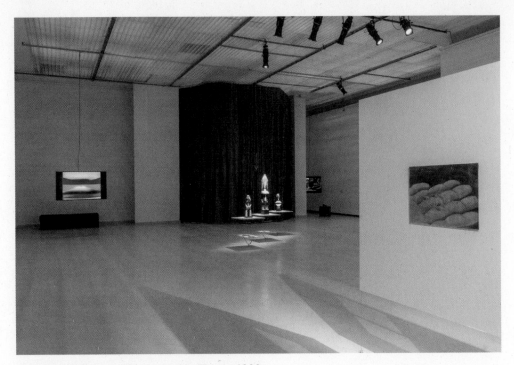

Henrikas Gulbinas, *Unimaginable Things*, 1988
Janek Simon, *Polyethnic 1*, *2*, *3*, 2016, 2019
Uli Golub, *Notes from the Underground*, 2016
Tomasz Kowalski, *Untitled*, 2020

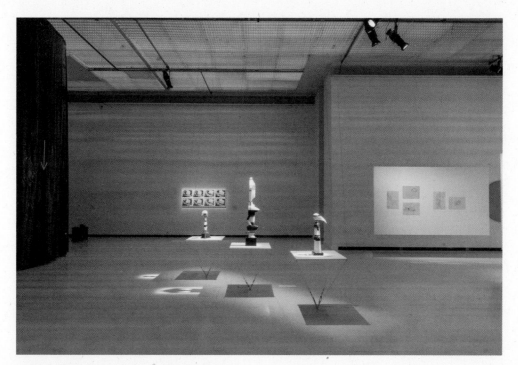

Mladen Stilinović, *Artist at Work*, 1978
Janek Simon, *Polyethnic 1, 2, 3*, 2016, 2019
Tomasz Kowalski, *Untitled*, 2020

Janek Simon, *Polyethnic 1, 2, 3*, 2016, 2019
Tomasz Kowalski, *The Kiss, 2020 (with Donat Kowalski)*, 2019; *The Host*, 2019; *Stalker* 2019
Group of 32 works (all untitled), 2020–2021
Danutė Kvietkevičiūtė, *Grass (Dedicated to M.K. Čiurlionis)*, 1975

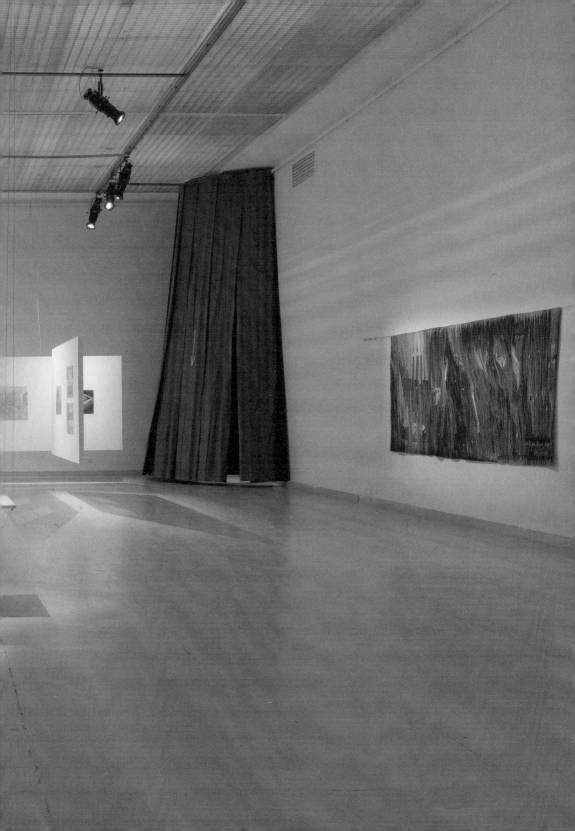

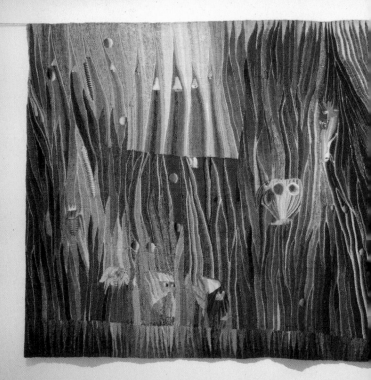

Danutė Kvietkevičiūtė, *Grass (Dedicated to M.K. Čiurlionis)*, 1975

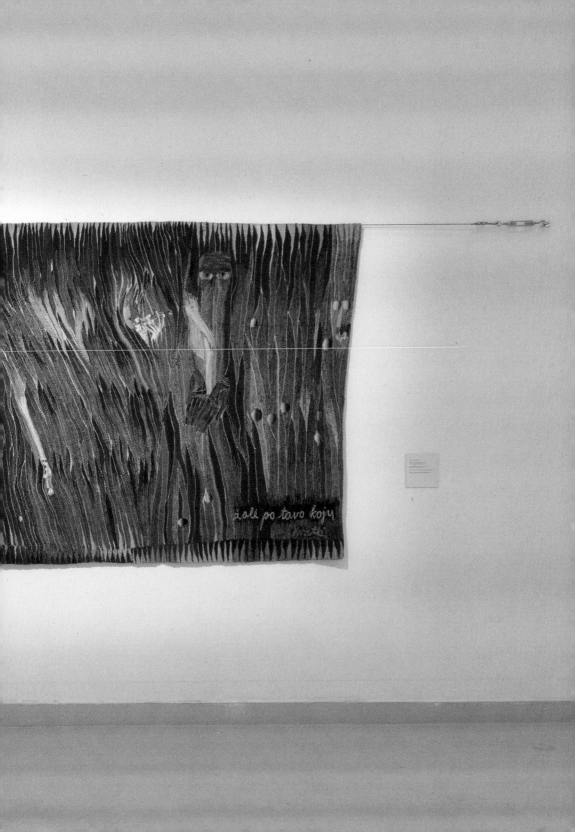

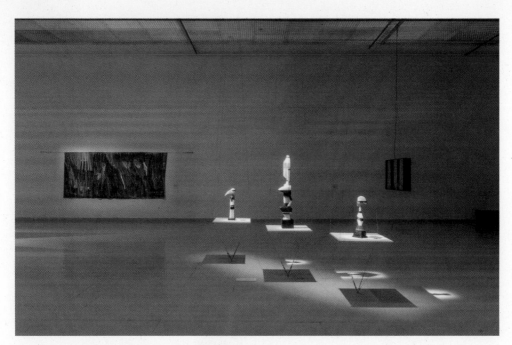

Janek Simon, *Polyethnic 1, 2, 3*, 2016, 2019

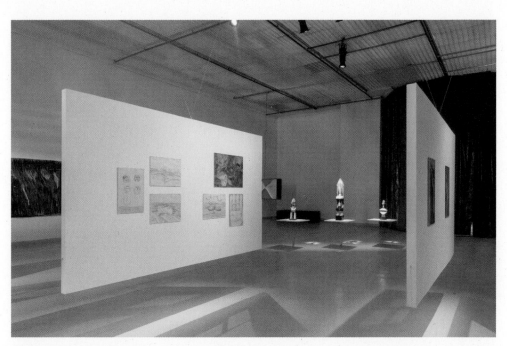

Tomasz Kowalski, *The Kiss, 2020* (*with Donat Kowalski*), 2019; *The Host*, 2019; *Stalker* 2019
Group of 32 works (all untitled), 2020–2021
Janek Simon, *Polyethnic 1*, *2*, *3*, 2016, 2019

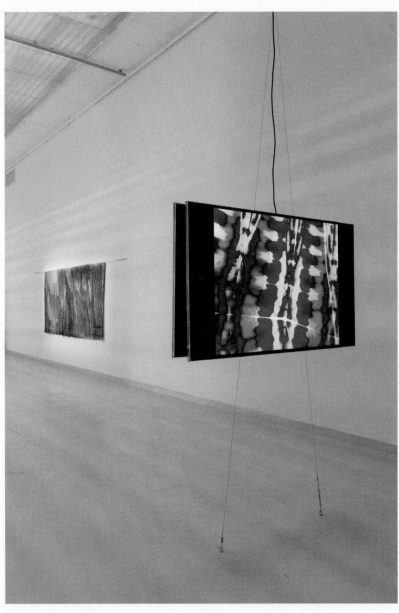

Henrikas Gulbinas, *Journey without a Suitcase*, 1988

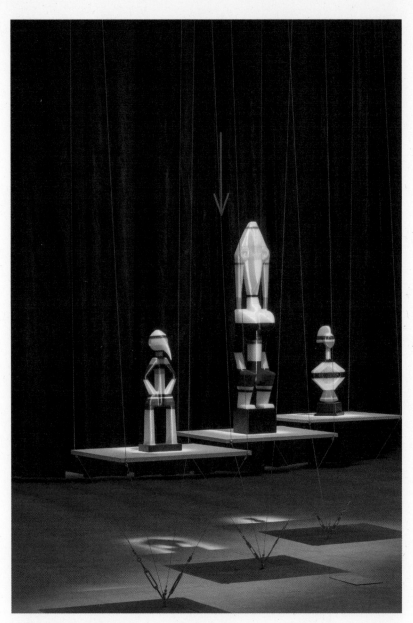

Janek Simon, *Polyethnic 1, 2, 3*, 2016, 2019

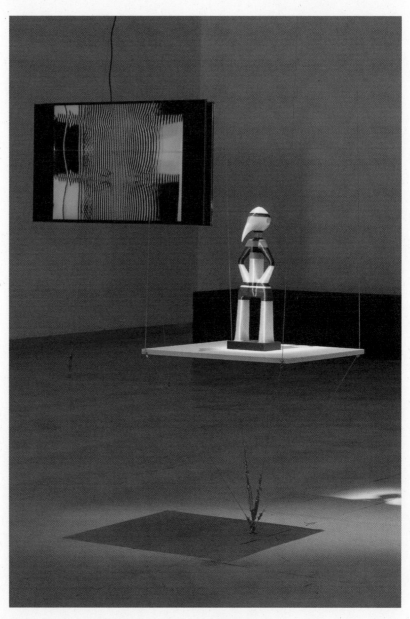

Janek Simon, *Polyethnic 1, 2, 3*, 2016, 2019
Henrikas Gulbinas, *Journey without a Suitcase*, 1988

Zsófia Keresztés, *Inconsolable Presence*, 2019
Klára Hosnedlová, *Untitled* (from the series Nest), 2020
Danutė Kvietkevičiūtė, *At the Speed of Thought*, 1978

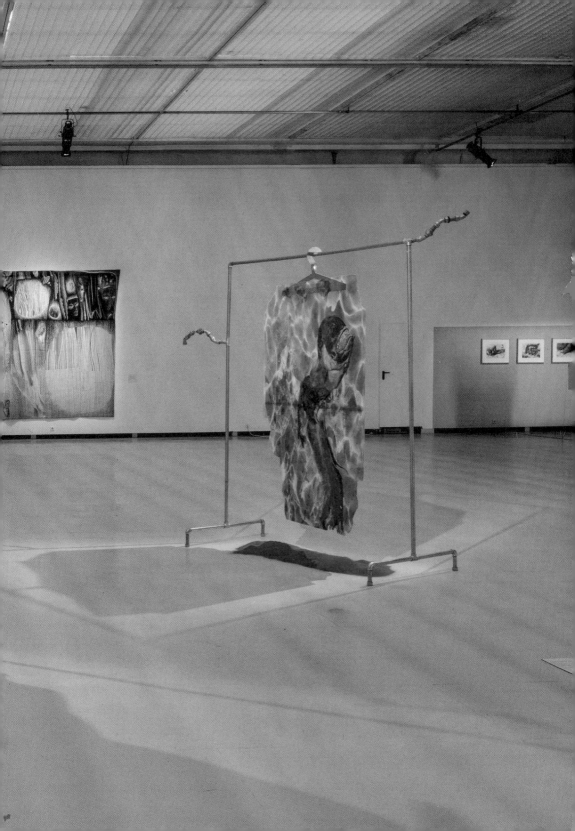

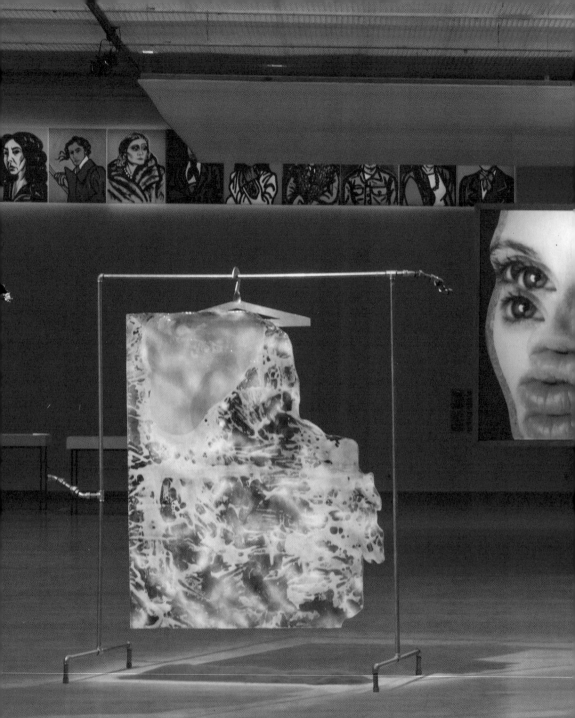

Flaka Haliti, *What Are They Thinking That We Thinking That They Thinking We Going to Do Next?* #1;
What Are They Thinking That We Thinking That They Thinking We Going to Do Next? #2, 2019
Agnieszka Polska, *Ask the Siren*, 2017
Karol Radziszewski, *The Gallery of Portraits*, (2020–ongoing)
Markéta Othová *Her Life*, 1998

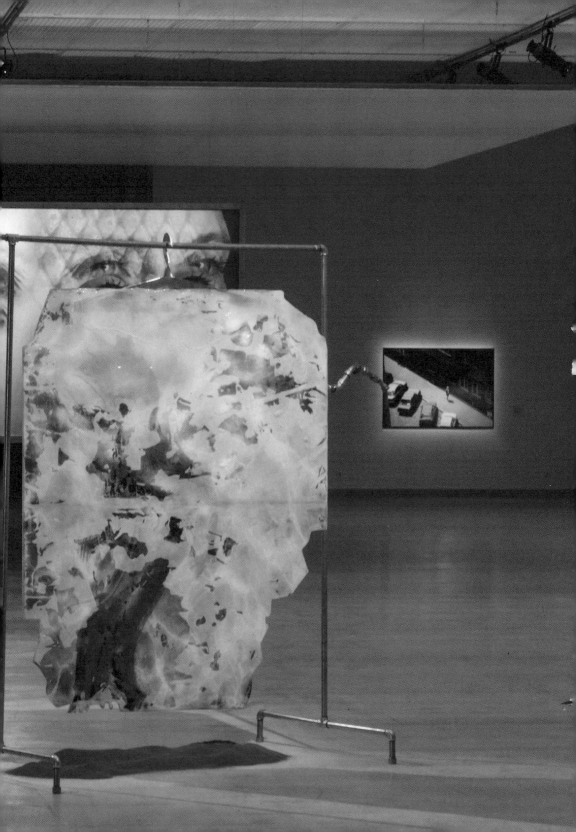

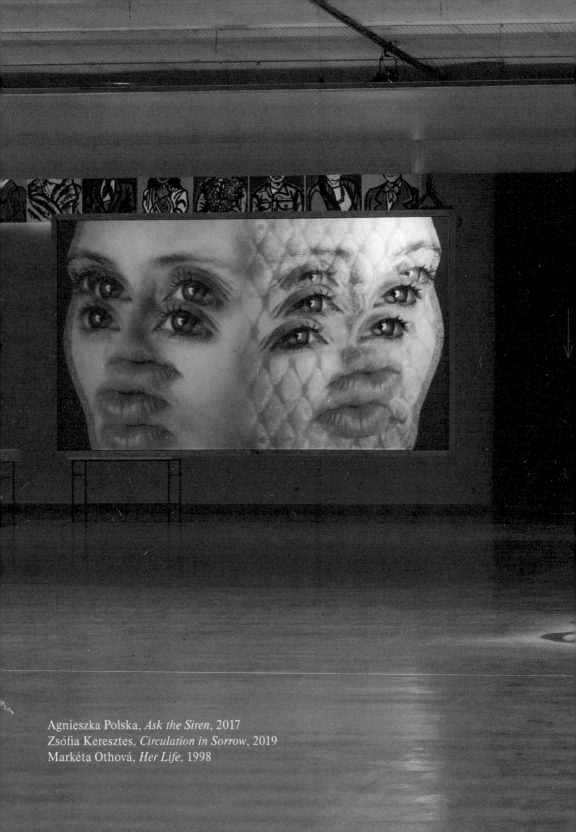

Agnieszka Polska, *Ask the Siren*, 2017
Zsófia Keresztes, *Circulation in Sorrow*, 2019
Markéta Othová, *Her Life*, 1998

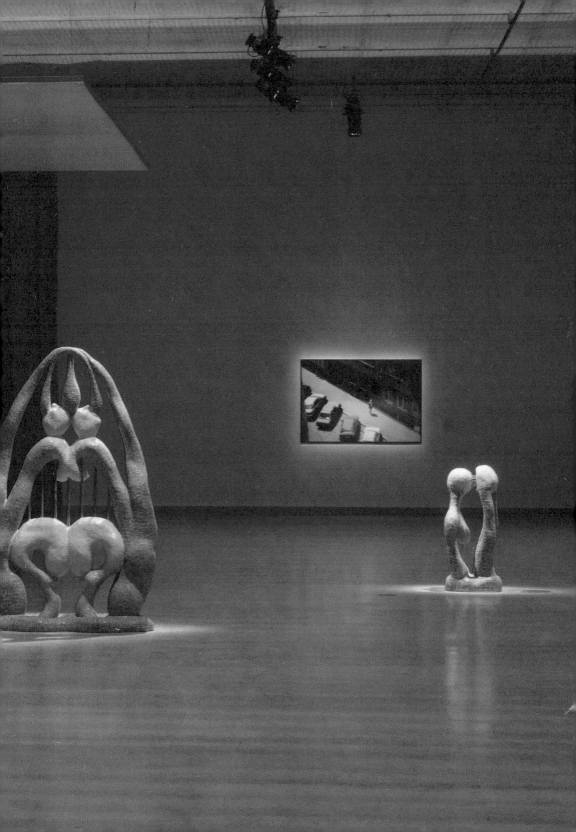

Agnieszka Polska, *Ask the Siren*, 2017
Vojtěch Kovařík, *The Three Fates: Clotho*, 2021; *The Three Fates: Lachesis*, 2021,
Three Fates: Atropos, 2021

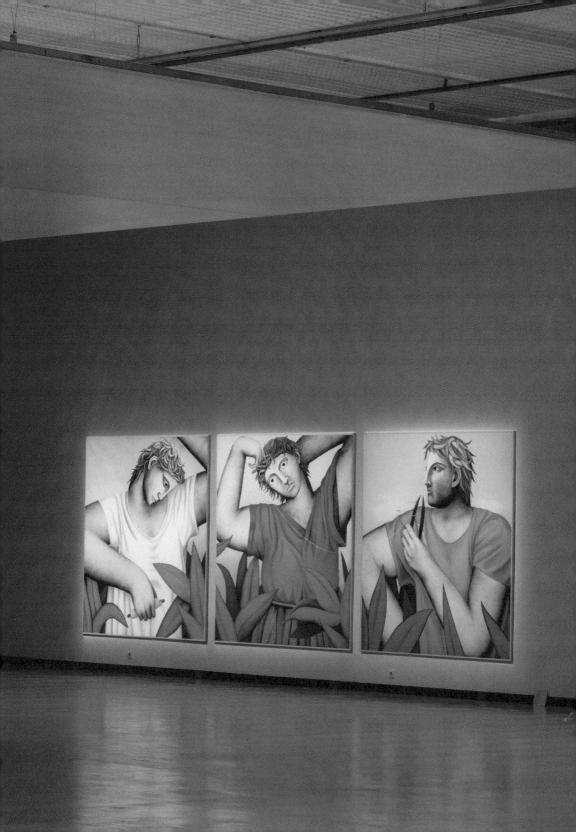

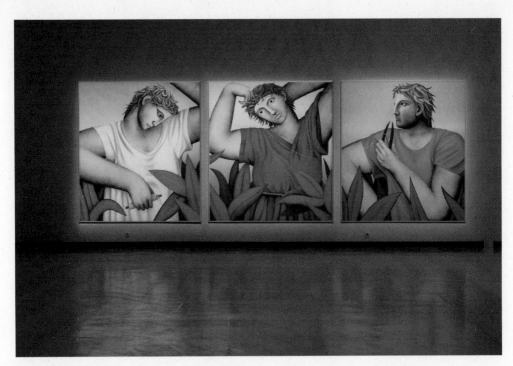

Vojtěch Kovařík, *The Three Fates: Clotho*, 2021; *The Three Fates: Lachesis*, 2021, *Three Fates: Atropos*, 2021

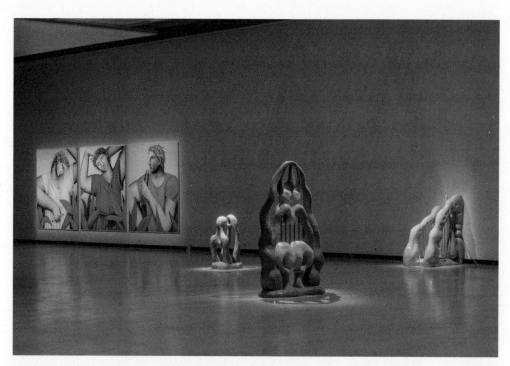

Vojtěch Kovařík, *The Three Fates: Clotho*, 2021; *The Three Fates: Lachesis*, 2021;
Three Fates: Atropos, 2021
Zsófia Keresztes, *Circulation in Sorrow*, 2019, *Inconsolable Presence*, 2019,
Solitary Confinement, 2019

Zsófia Keresztes, *Inconsolable Presence*, 2019

Zsófia Keresztes, *Inconsolable Presence, Solitary Confinement*, 2019
Danutė Kvietkevičiūtė, *At the Speed of Thought*, 1978

Karol Radziszewski, *The Gallery of Portraits* (2020–ongoing). The Queer Archives Institute is a non-profit artist-run organisation, 2021

Karol Radziszewski, *The Gallery of Portraits* (2020–ongoing). Queer Archives Institute, 2021. One of the vitrines is dedicated to Lithuania and was prepared in collaboration with Laima Kreivytė

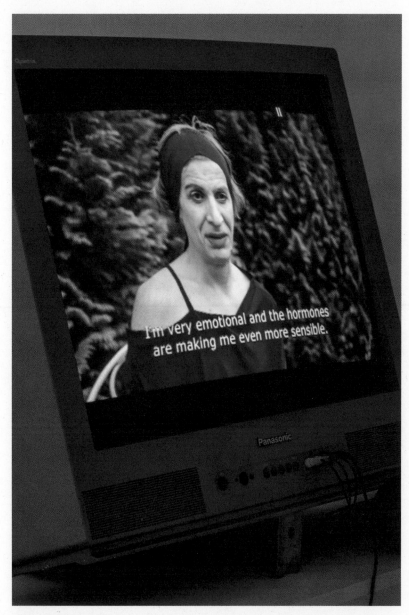

Karol Radziszewski, *The Queer Archives Institute* installation includes
the interview with Croatian fashion designer and transgender activist
Romana Bantić, 2016

STERDAMAS

...bės
...inti

95'1

**Kaip
susirasti
vaikiną**

**Naktis
Amsterdamo
saunoje**

DISKRIMINACIJA

DRĄSA –
KALBĖTI,
AISTRA –
GYVENTI

...aios 3/98

...-8
...000

gėjus

...el mums reikalinga
ANTUOKA

...ROPOS
...ARLAMENTAS
...ugina ginti mūsų teises

...GL
...benkeri metai

5

...opos Sąjunga
...e European Union

ARTIUM
VILNENSIS

VILNIAUS
DAILĖS
AKADEMIJOS
DARBAI

DAILĖ 37

medijos,
masinė kultūra

Gender,
Media, and
Mass Culture

P...
Laisvo...

Kas: Nešvankaus elitešču konkur...
Kur: Baru „Kabaretas" rūsyje grojo...
erotiškos aerobikos projekciją...
Kada: „Flirt-dizigė" diskatekos ma...
šventųjų išvakarese, 2012 spalio 3...
Komitetja: Neringa Dangyvytė, Laim...
Priešai: Rožirdė piktolietas, Dvipa...
Akiniai žurtion, Zvake-žirdu ir Žiedų...
Platintai: Šialtminų...
Maketas: Violeta

Įžanga su nukrypimais
Laima Kreivytė

Poezija nėra tik madingas akses...
raštutas krentančioms į jausm...
užšerikimai. Poezijos rašymas ir...
atrodo kasdienybės pragaro rat...
skaitančiu atsirado ne mažiau e...
det vienu pretekstu pažadinti k...

„Feisbuke" pasirodė skelbimas...
sus rašančius ir nusirašiančius...
Galima kurti originalius ir laisv...
Nugalėtojo/s laukia nešvankus...
būtų šmaikštu, netikėta ir dvipe...

Visi (daugiausia visos) atėję gė...
Buvo ir rašančių plešuku ar par...

Karol Radziszewski, Queer Archives Institute, 2021.
One of the vitrines is dedicated to Lithuania and was prepared in collaboration with Laima Kreivytė

Narcyza Żmichowska

OWAGA
AIDS

Henri de Valois
Roi de Pologne Grand Duc de Lithuanie
né 15-3 à 15-3

Co JEST AIDS?

(Acquired Immune Dificiency Syndrome – zespół
...upośledzenia odporności) to nowa groźna choroba,
...rek dotarł także do Polski. Jej istotą jest bardzo
...niżenie odporności organizmu, który nie jest w
...ić się przed zakażeniami, niegroźnymi przy
...poziomie odporności.

...ST PRZYCZYNA AIDS?

...porności wywołuje wirus, który uszkadza
...ażenie nie u wszystkich jednak powoduje
...jawów choroby, większość nie choruje, choć
...ie znajdują się zarazki. Są to zdrowi nosiciele
...mogą zarażać innych, na równi z tymi, u
...ystąpiły.

...ZARAZIĆ SIĘ AIDS?

...ść zakażeń następuje przez przypadkowe
...(zwłaszcza homoseksualne). Chorują
...tórzy wstrzykują sobie dożylnie narkotyki,
...ø sobą igły i strzykawki używane kolejno
...należy natomiast obawiać się
...y przez podanie ręki, przedmioty
...ub przez powietrze.

...EGÓLNIE NARAŻONY NA AIDS?
...orowania dotyczy:

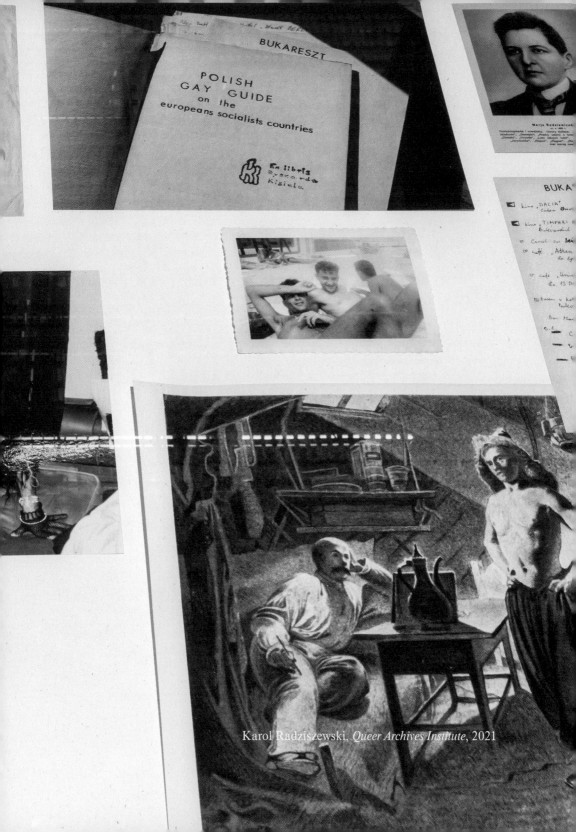

Karol Radziszewski, *Queer Archives Institute*, 2021

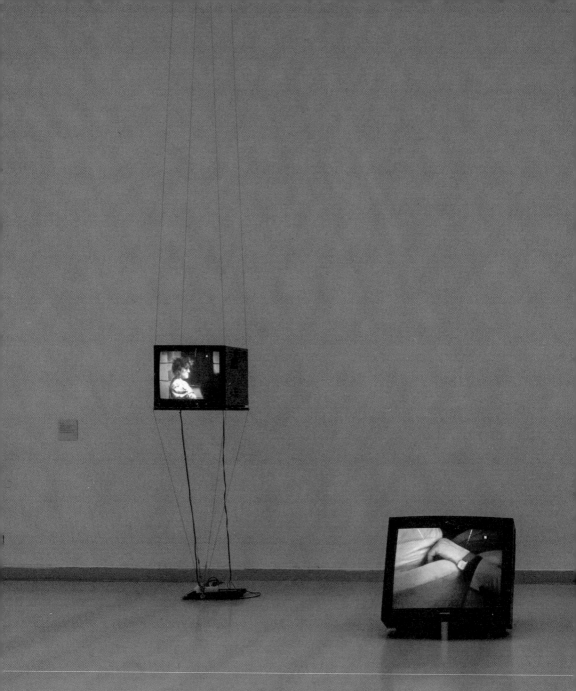

Anna Daučíková, *Ordinary Voyeurism: A Woman, Central Station Lviv*, 1996. *Ordinary Voyeurism – Concert, Florence*, 2006
Mladen Stilinović, *Tijelo (Body)*, 1977
Adam Rzepecki, *Project of the Father Pole memorial*, 1981; *Mother of God with a moustache*, 1983

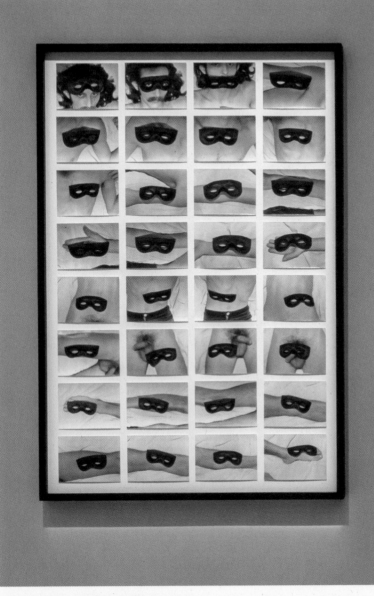

Mladen Stilinović, *Tijelo (Body)*, 1977

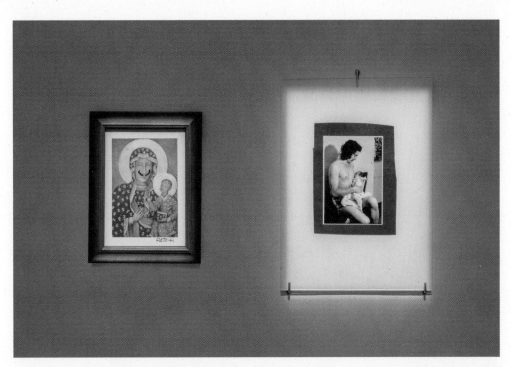

Adam Rzepecki, *Project of the Father Pole Memorial*, 1981; *Mother of God With a Moustache,* 1983

Anna Daučíková, *Ordinary Voyeurism: Concert, Florence*, 2006

Anna Daučíková, *Ordinary Voyeurism: A Woman, Central Station Ľviv*, 1996

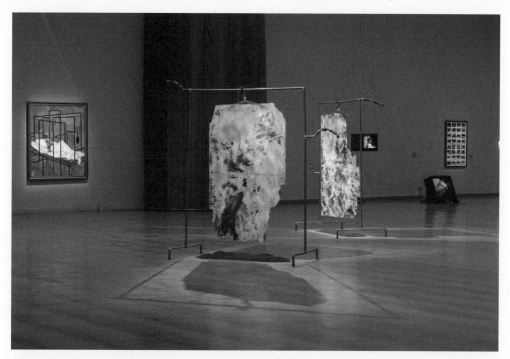

Marija Teresė Rožanskaitė, *Disease*, 1989
Flaka Haliti, *What Are They Thinking That We Thinking That They Thinking We Going to Do Next? #1*; *What Are They Thinking That We Thinking That They Thinking We Going to Do Next? #2*, 2019

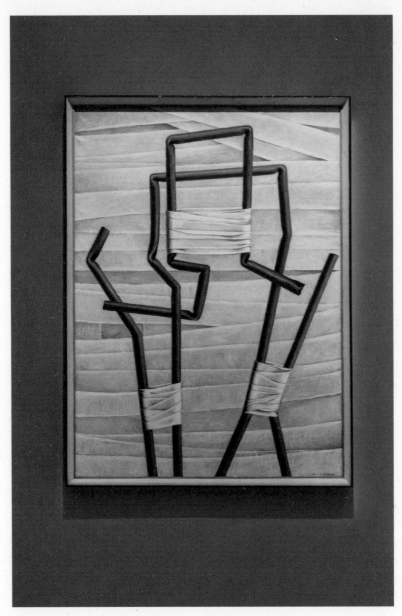

Marija Teresė Rožanskaitė, *Reinforcement Rods*, 1986

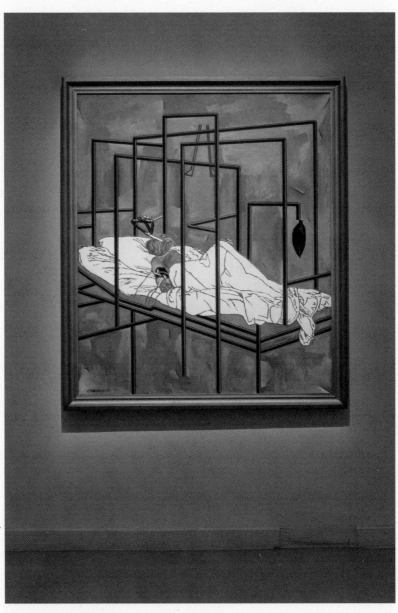

Marija Teresė Rožanskaitė, *Disease*, 1989

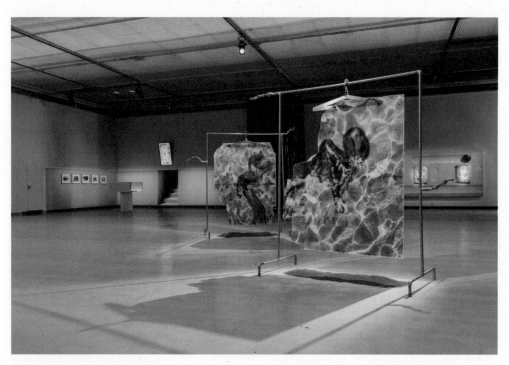

Viktor Timofeev, *DOG*, 2021
Flaka Haliti, *What Are They Thinking That We Thinking That They Thinking We Going to Do Next? #1; What Are They Thinking That We Thinking That They Thinking We Going to Do Next? #2*, 2019

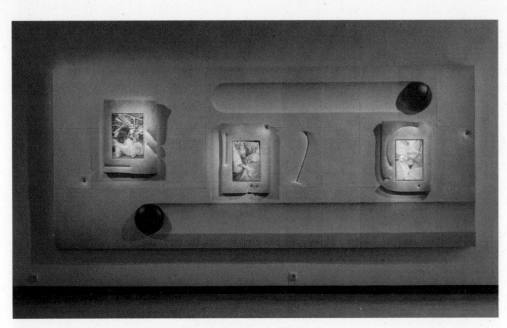

Klára Hosnedlová, *Untitled* (from the series Nest), 2020

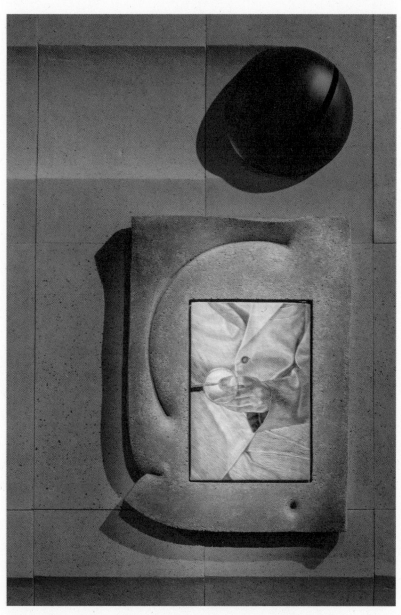

Klára Hosnedlová, *Untitled* (from the series Nest), 2020. Detail

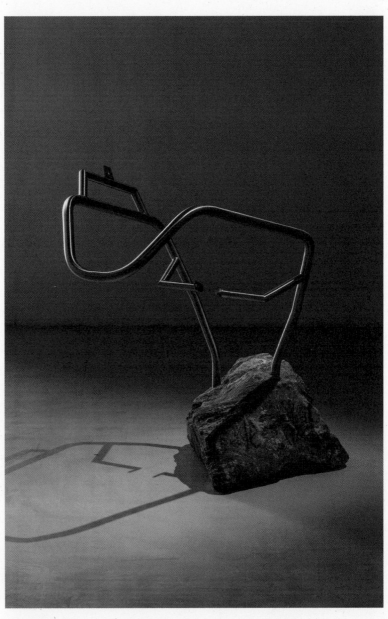

Klára Hosnedlová, *Untitled* (from the series Nest), 2020

Zsófia Keresztes, *Inconsolable Presence*, 2019
Danutė Kvietkevičiūtė, *At the Speed of Thought*, 1978
Zsófia Keresztes, *Circulation in Sorrow*, 2019
Agnieszka Polska, *Ask the Siren*, 2017

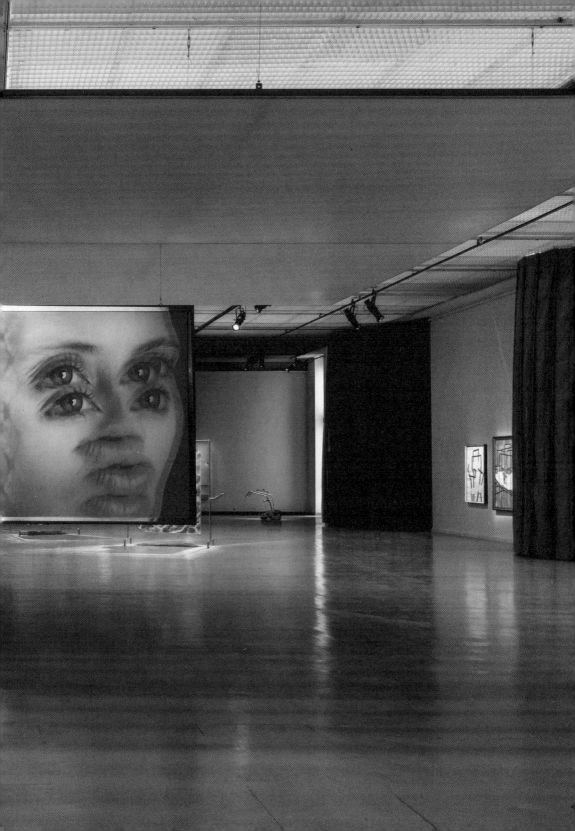

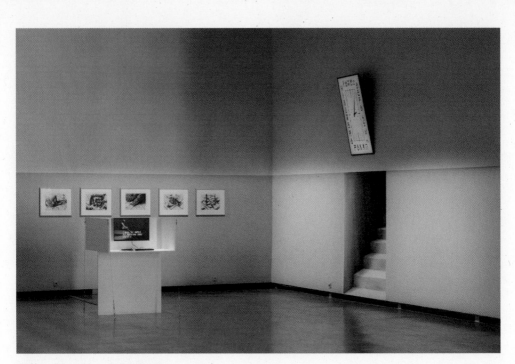

Viktor Timofeev, *DOG*, 2021

Viktor Timofeev, *DOG*, 2021. Detail

Viktor Timofeev, *DOG*, 2021. Detail

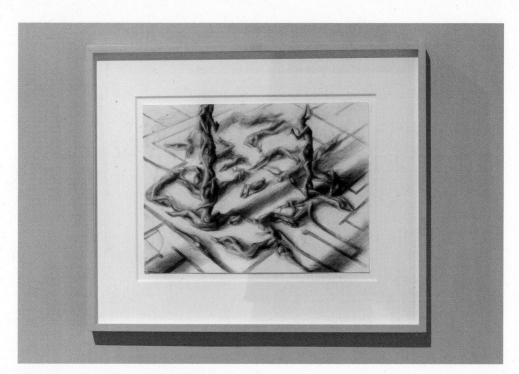

Viktor Timofeev, *DOG*, 2021. Detail

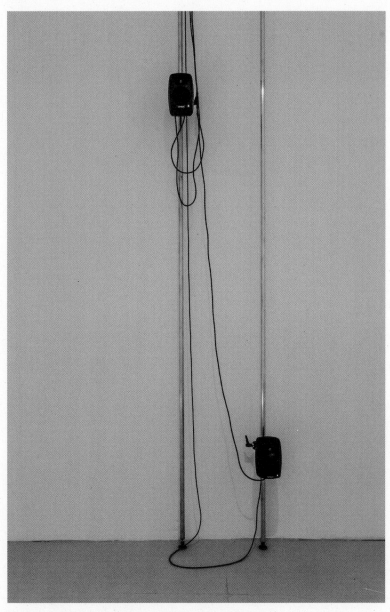

Kirill Savchenkov, *Flat Tiger, Paper Node*, 2021

Emilija Škarnulytė, *Ungrounded Archive*, 2020

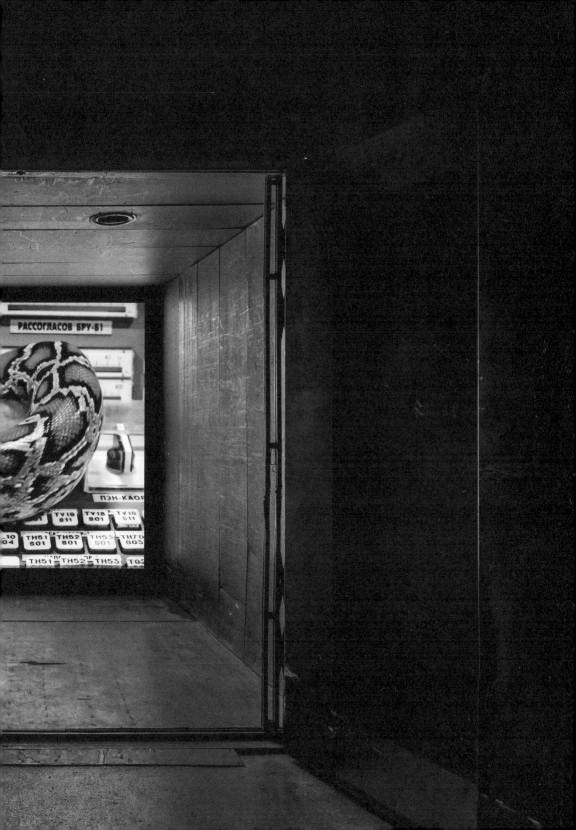

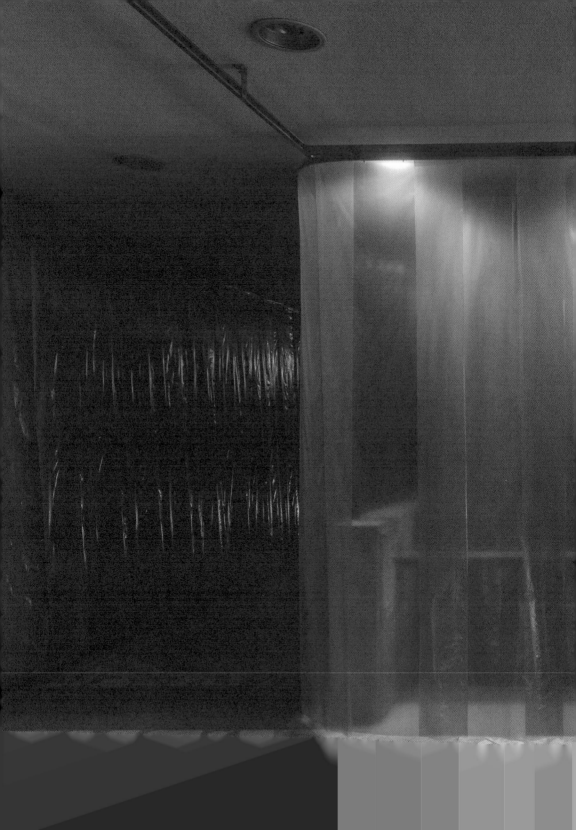

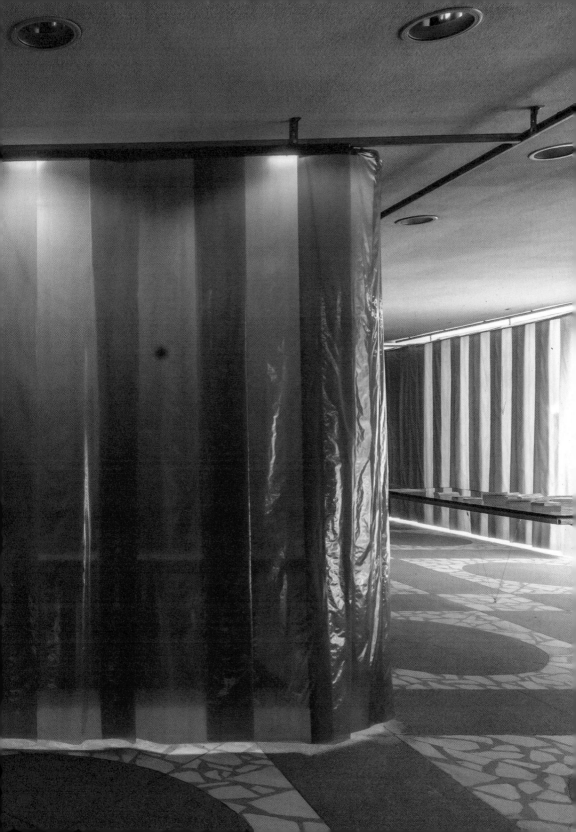

George Maciunas, Four copies of Thomas Kellein's publication *George Maciunas: The Dream of Fluxus*, 2007, containing reproduction photographs of George Maciunas' self-portrait *George Maciunas Performing Cross-Dressing Ballet for a Self-Exposing Camera*, c. 1966

aciunas performing for camera with a self-timer function, New York, c. 1966

George Maciunas, *George Maciunas Performing Cross-Dressing Ballet for a Self-Exposing Camera*, c. 1966

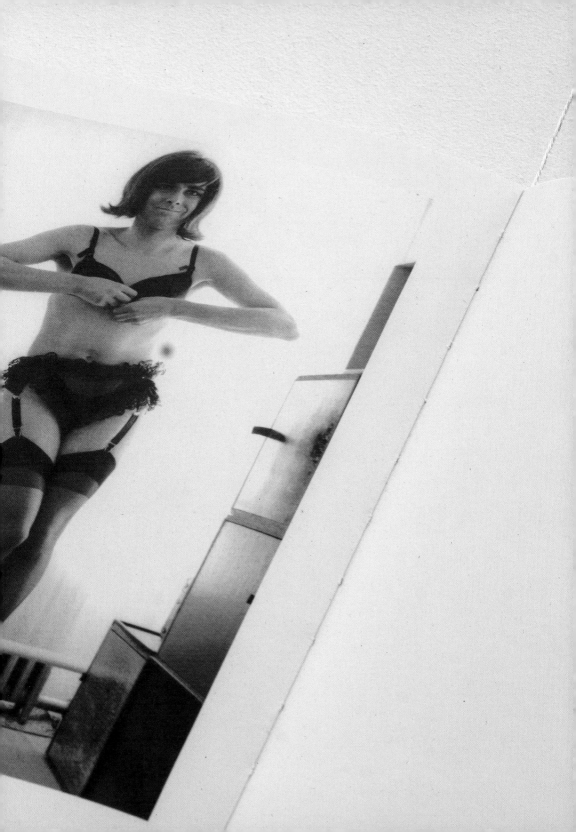

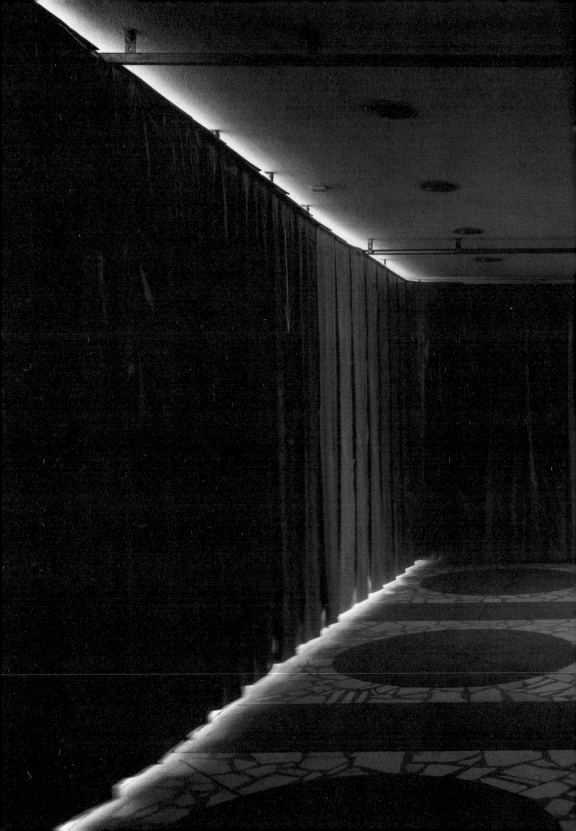

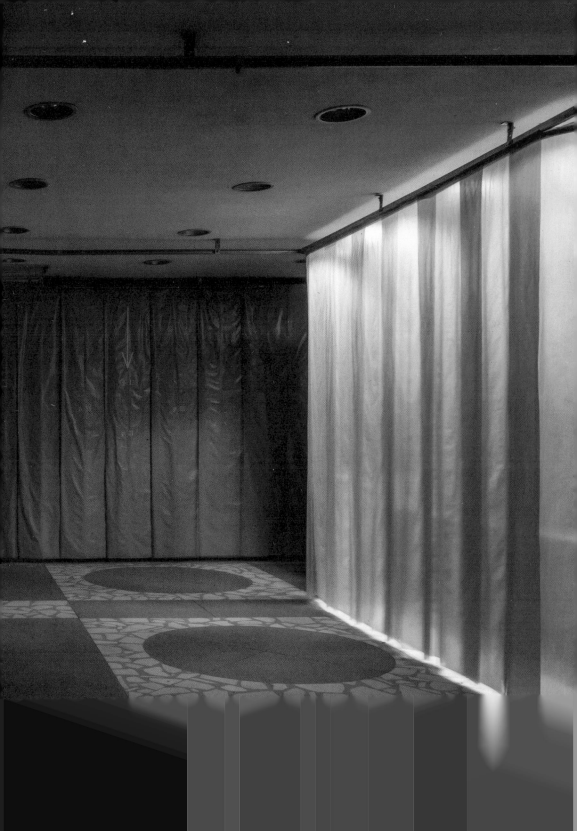

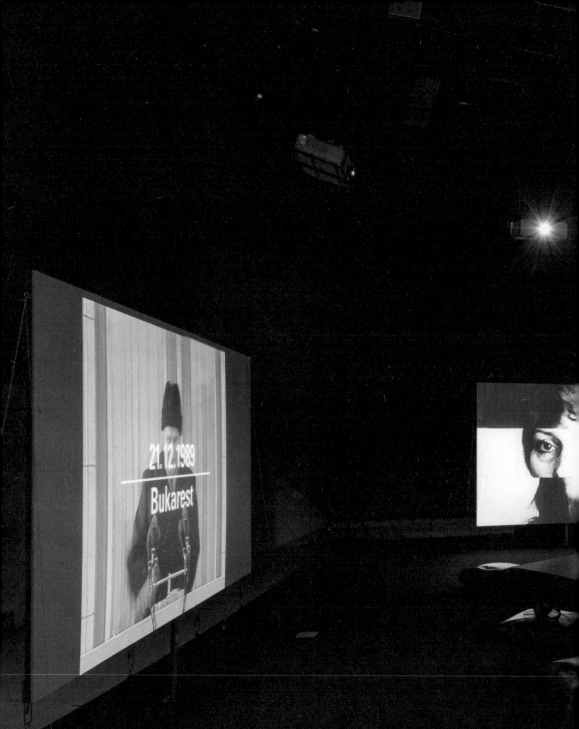

Harun Farocki & Andrei Ujică, *Videograms of a Revolution*, 1992
Dóra Maurer, *Triolets*, 1981
Roman Himey & Yarema Malashchuk, *Dedicated to the Youth of the World II*, 2019

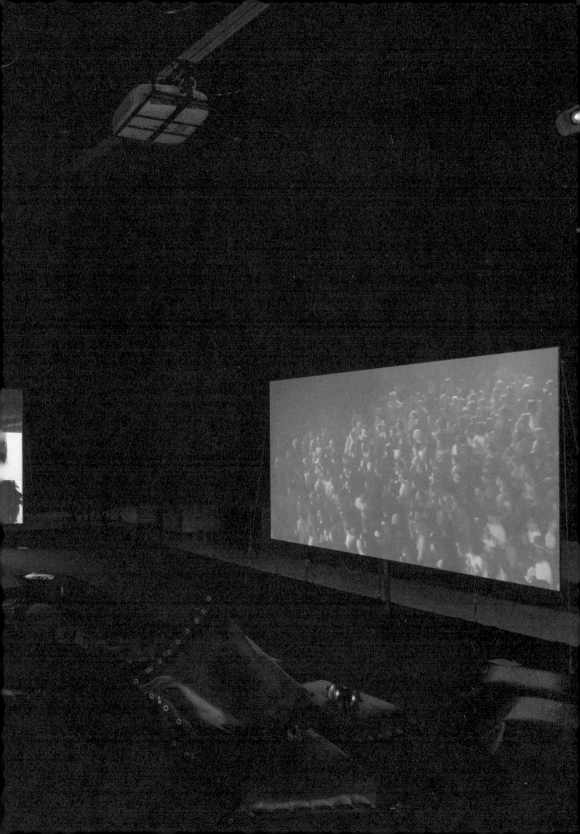

Agnė Jokšė, *Unconditional Love*, 2021

Harun Farocki & Andrei Ujică, *Videograms of a Revolution*, 1992
Dóra Maurer, *Triolets*, 1981
Roman Himey & Yarema Malashchuk, *Dedicated to the Youth of the World II*, 2019

Flo Kasearu, *Violence Grows in Silence*, 2021

Flo Kasearu, *Violence Grows in Silence*, 2021

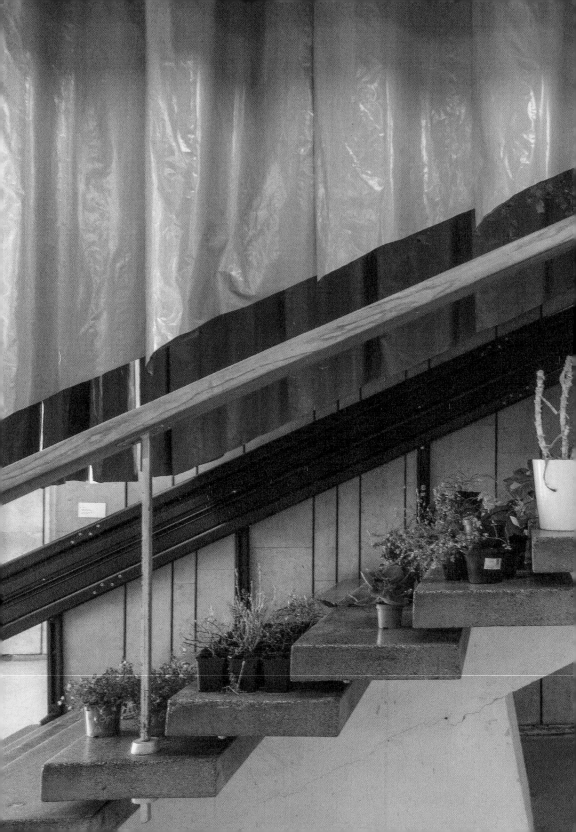

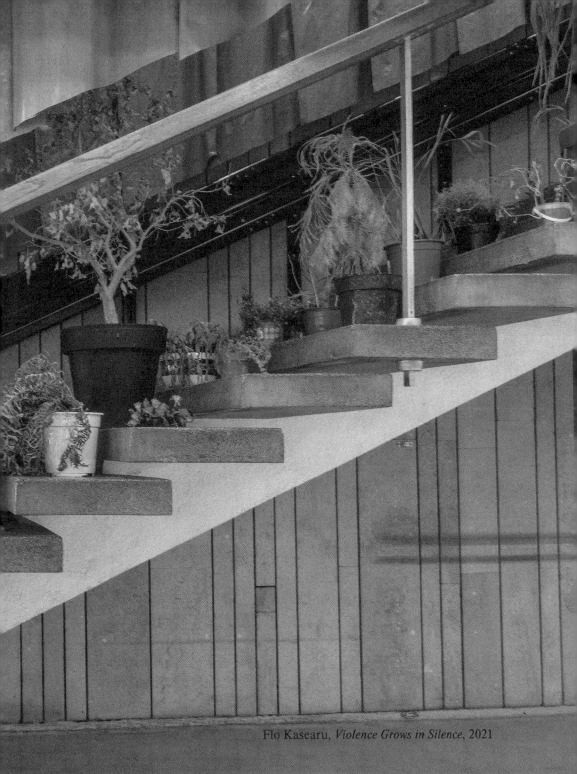

Flo Kasearu, *Violence Grows in Silence*, 2021

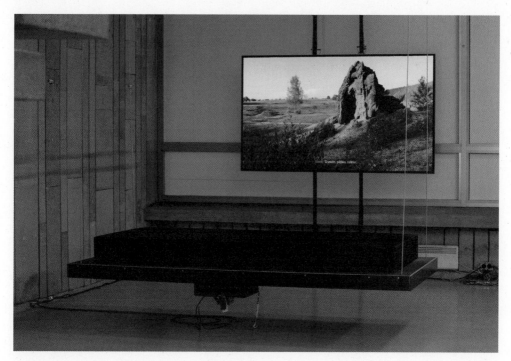
Monika Janulevičiūtė & Antanas Lučiūnas, *Water Striders*, 2019

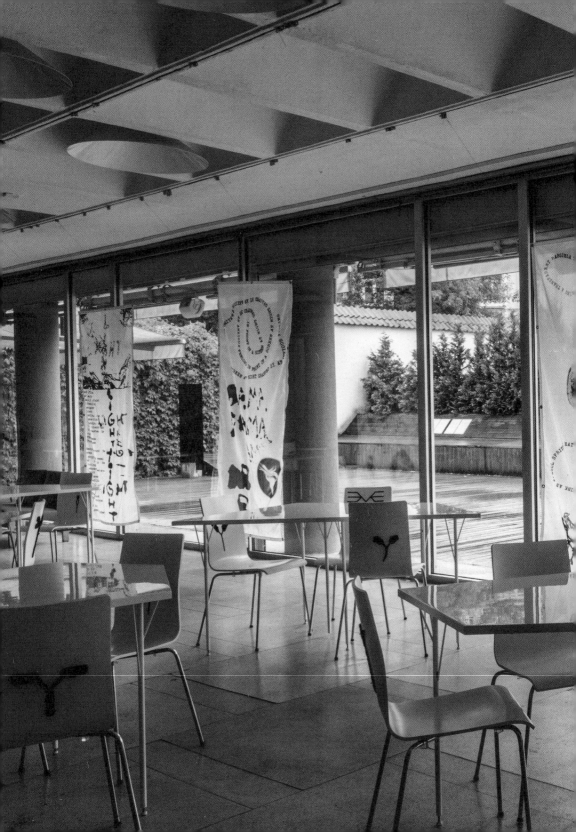

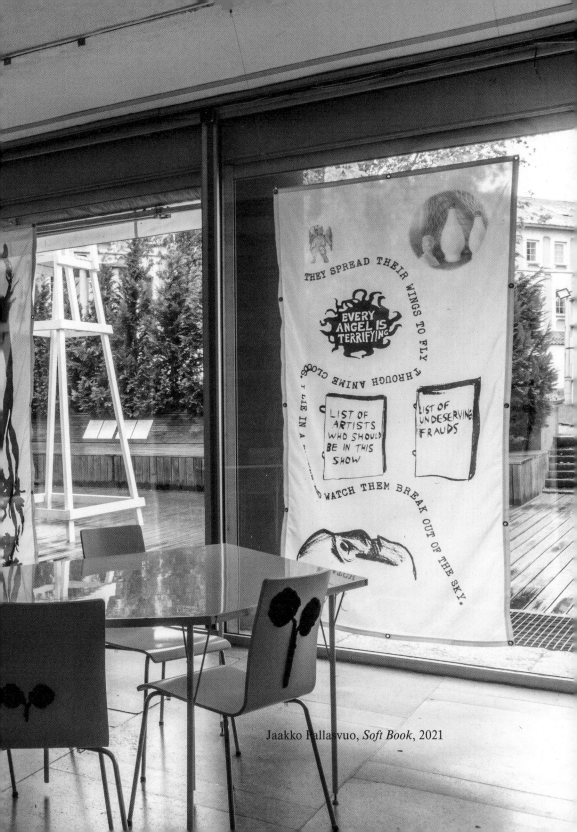

Jaakko Pallasvuo, *Soft Book*, 2021

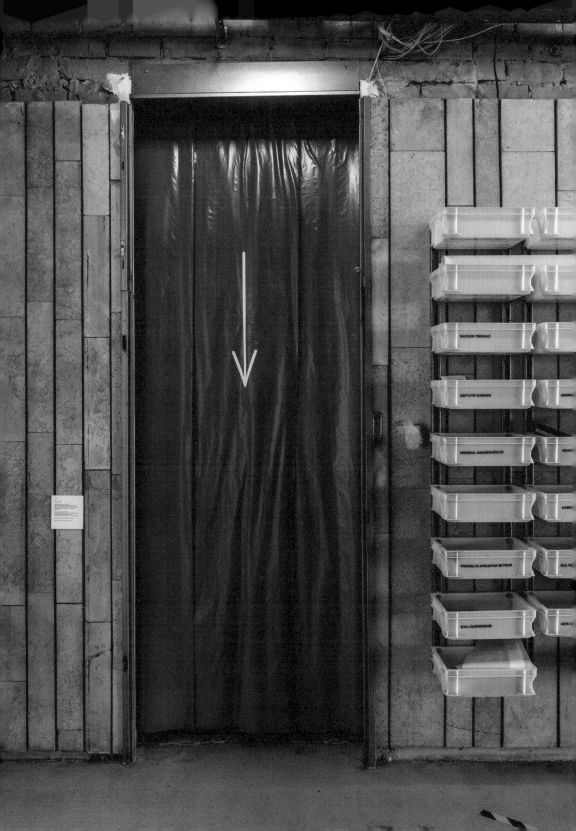

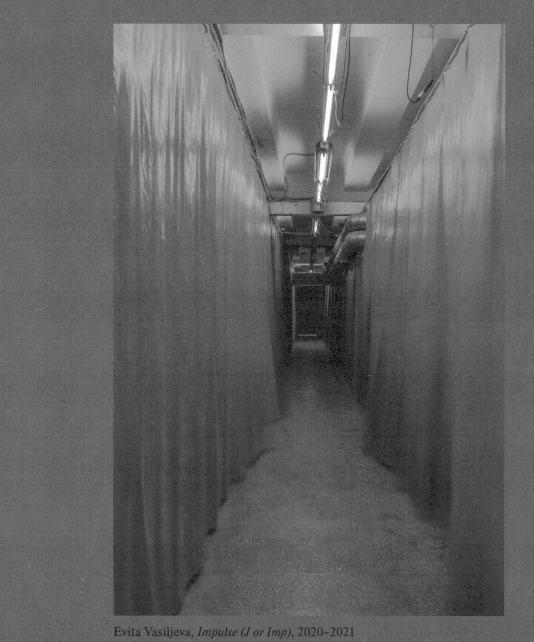

Evita Vasiljeva, *Impulse (J or Imp)*, 2020–2021

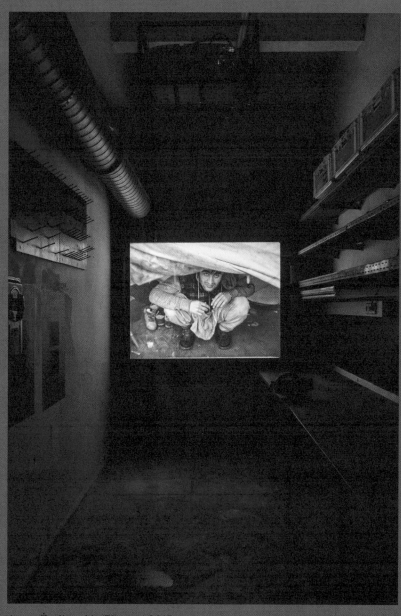

Artur Żmijewski, *Glimpse*, 2017

Anni Puolakka, *From the Heart*, 2021

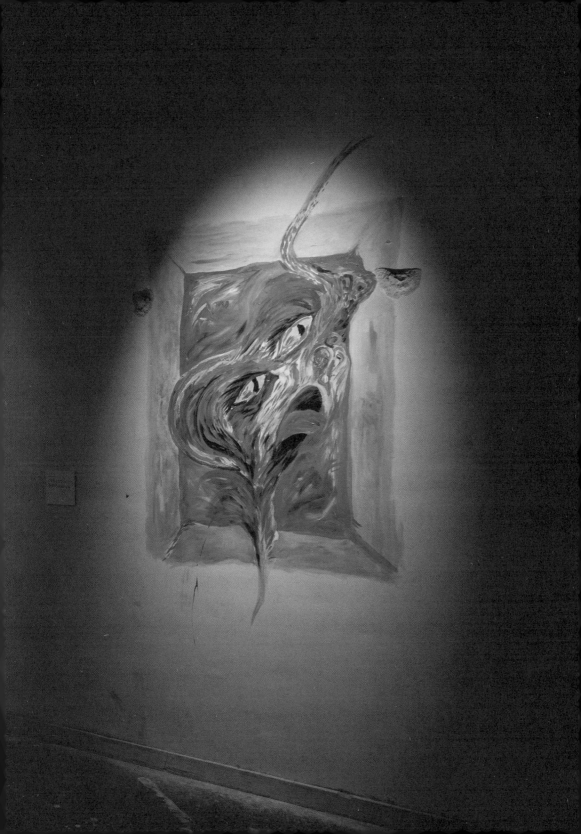

I'm

Anni Puolakka, *From the Heart*, 2021

Evita Vasiljeva, *Impulse (J or Imp)*, 2020–2021

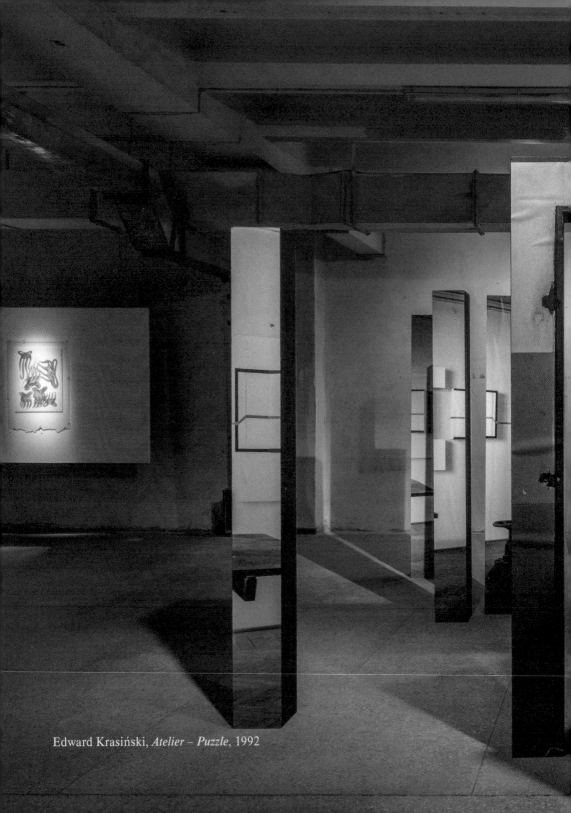

Edward Krasiński, *Atelier – Puzzle*, 1992

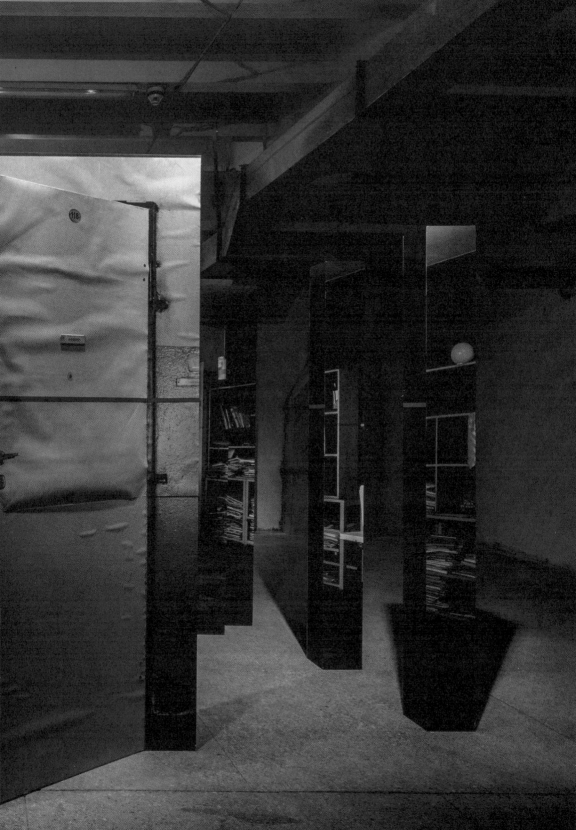

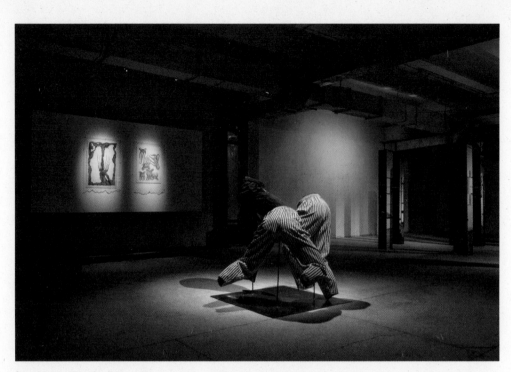

Dominika Trapp, *Unio Plastica (an ongoing series reflecting the union of the organic and the inorganic by borrowing the religious concept of unio mystica)*, 2019
Zuzanna Czebatul, *Tristan, Kewin, Joss*, 2015

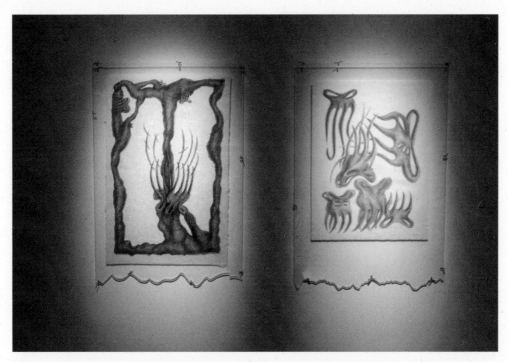

Dominika Trapp, *Unio Plastica (an ongoing series reflecting the union of the organic and the inorganic by borrowing the religious concept of unio mystica)*, 2019

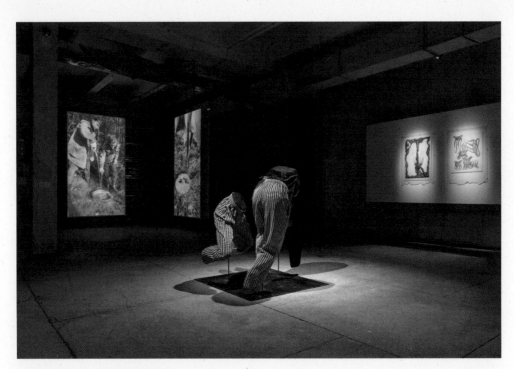

Jura Shust, *Neophyte II*, 2021
Zuzanna Czebatul, *Tristan, Kewin, Joss*, 2015
Dominika Trapp, *Unio Plastica (an ongoing series reflecting the union of the organic and the inorganic by borrowing the religious concept of unio mystica)*, 2019

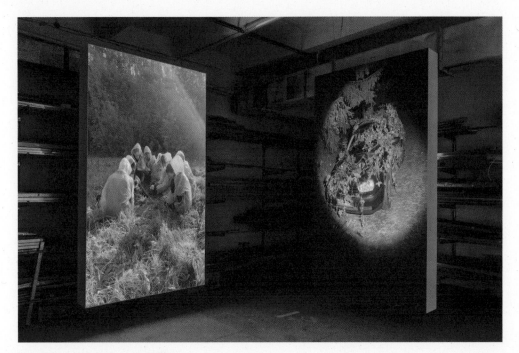

Jura Shust, *Neophyte II*, 2021

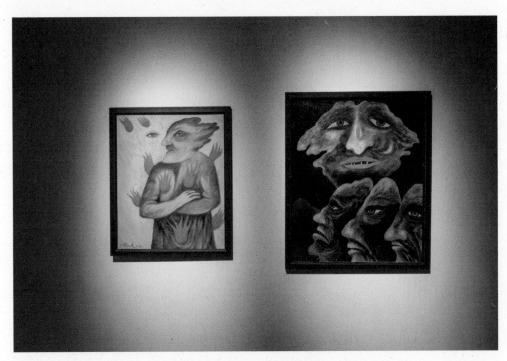

Jüri Arrak, *Flames of Passion*, 2016; *People with Bubo*, 2005 / 2018

Edward Krasiński, *Atelier – Puzzle*, 1992
Zuzanna Czebatul, *Tristan, Kewin, Joss*, 2015
Jura Shust, *Neophyte II*, 2021

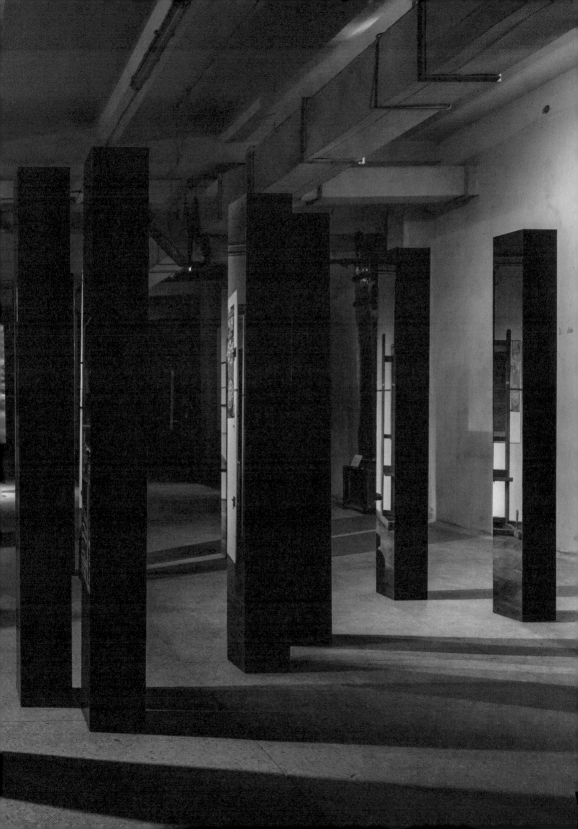

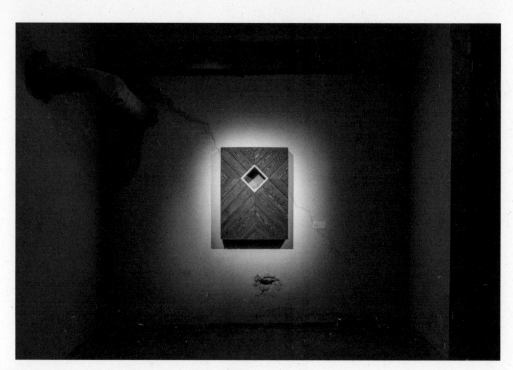

Marija Teresė Rožanskaitė, *Assemblage*, 1992

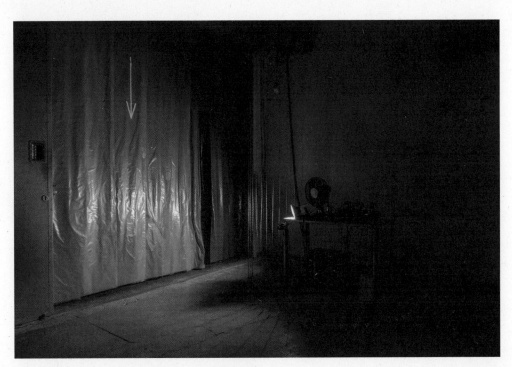

Evita Vasiljeva, *Impulse (J or Imp)*, 2020–2021

The

Alex Baczyński-Jenkins, *Faggots, Friends*, 2019–ongoing

Jonas Mekas, *Lithuania and the Collapse of the USSR*, 2009

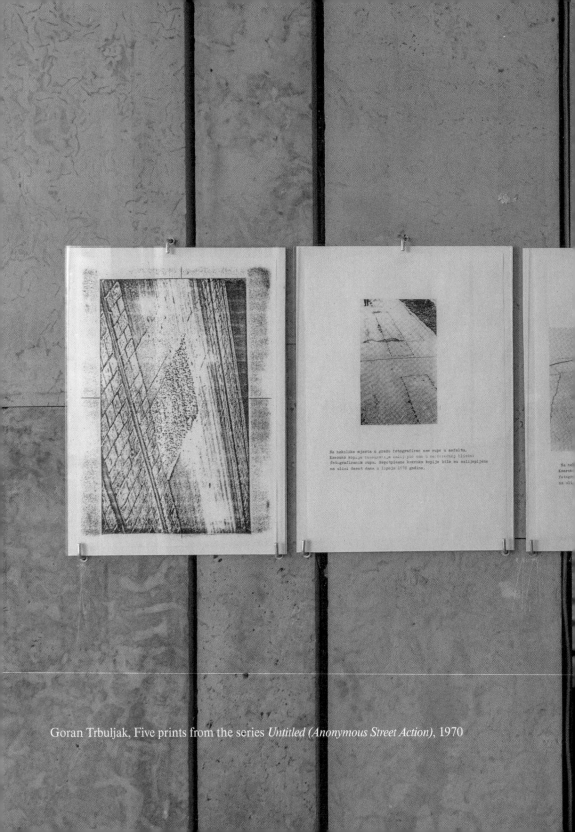

Goran Trbuljak, Five prints from the series *Untitled (Anonymous Street Action)*, 1970

...yao sam rupe u asfaltu.
...sam u neposrednoj blizini;
...oke kopije bile su zalijepljene
...dine.

U moru kod Rijeke i Dubrovnika bušeno je nekoliko slikarskih okvira "marina"
formata

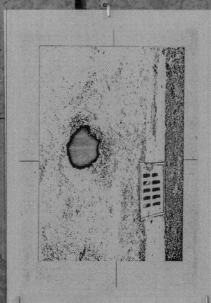

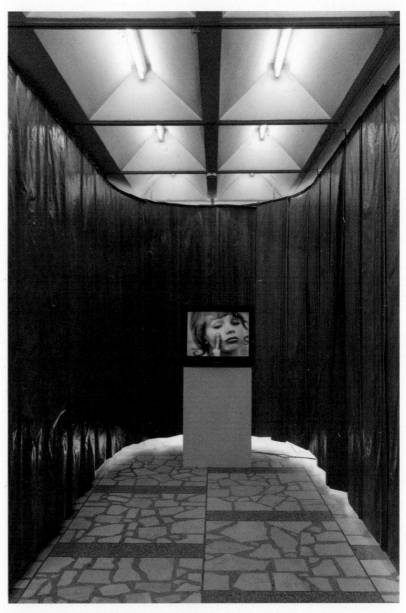

Natalia LL, *Consumer Art*, 1972–1975

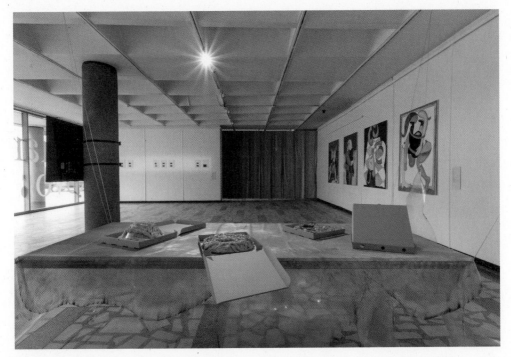

Goran Trbuljak, Five prints from the series *Untitled (Anonymous Street Action)*, 1970
Anastasia Sosunova, *Another Dinner Ruined*, 2021
Martina Smutná, *Mother*, 2019; *Feast*, 2019; *Cuddle*, 2020; *Tighten*, 2020

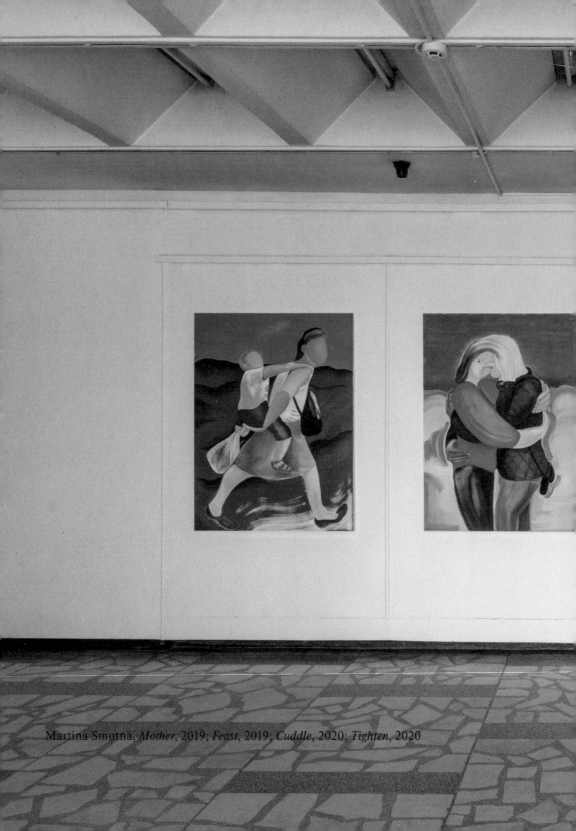

Martina Smutná, *Mother*, 2019; *Feast*, 2019; *Cuddle*, 2020; *Tighten*, 2020

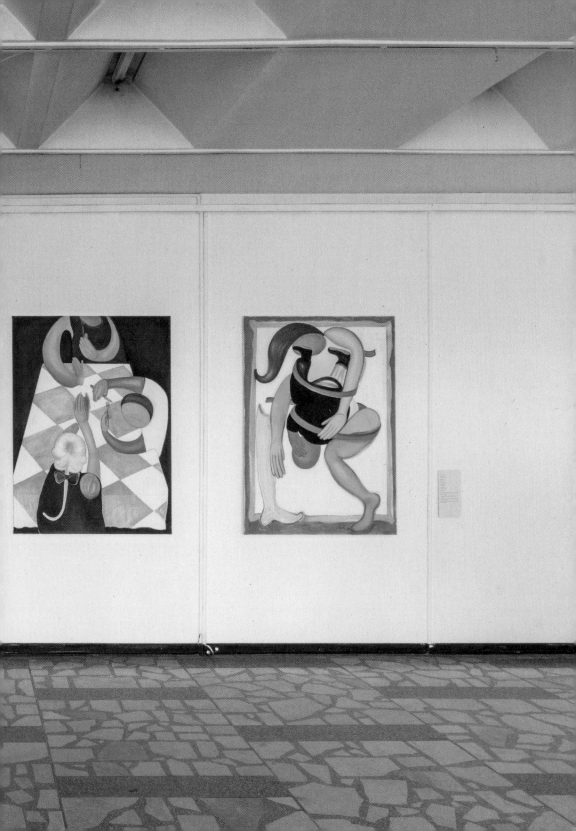

Anastasia Sosunova, *Another Dinner Ruined*, 2021

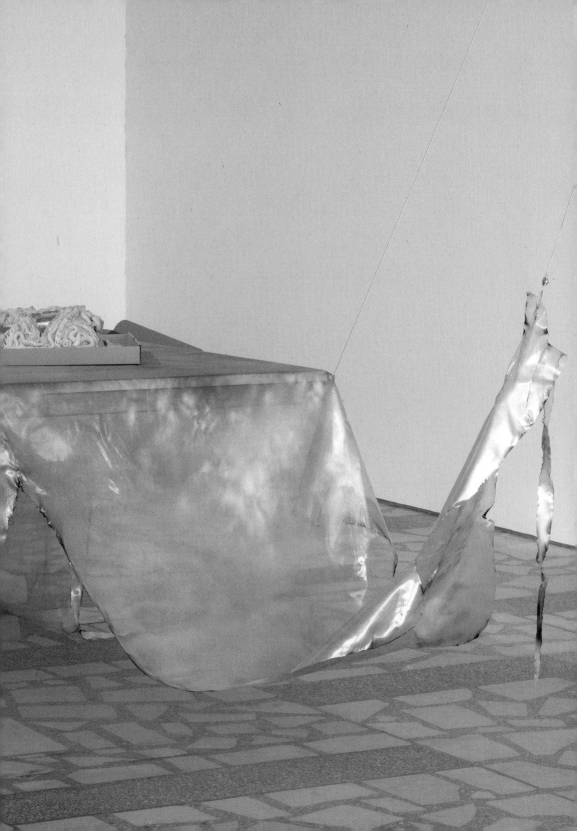

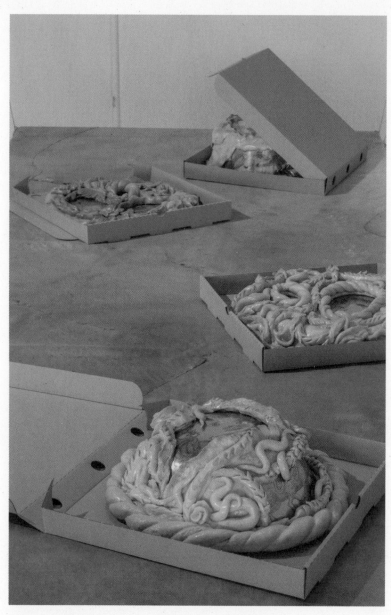

Anastasia Sosunova, *Another Dinner Ruined*, 2021

Anastasia Sosunova, *Another Dinner Ruined*, 2021

x x x
3. září 1977
Praha, Václavské náměstí

Na eskalátoru... otočen, hledím do očí člověku,
který stojí za mnou...

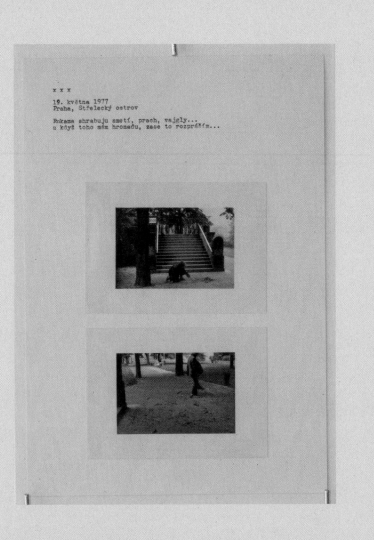

Goran Trbuljak, Five prints from the series *Untitled (Anonymous Street Action)*, 1970

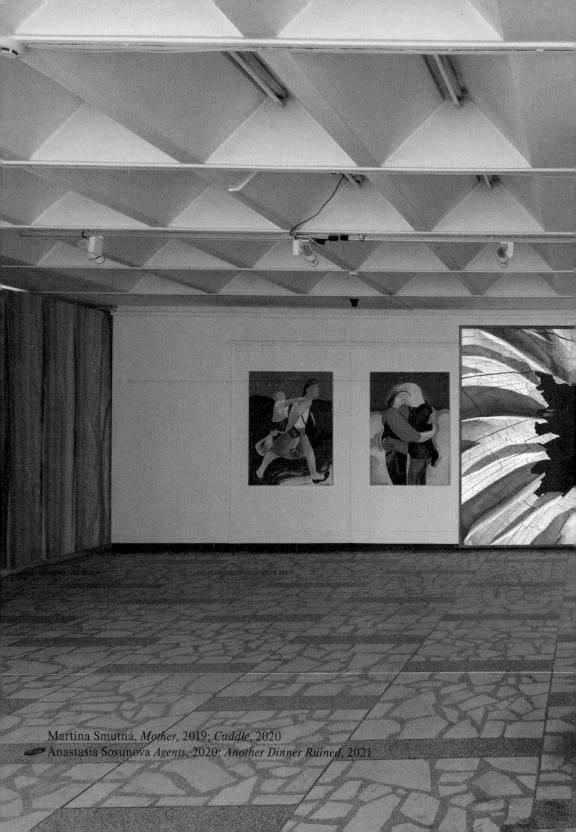

Martina Smutná, *Mother*, 2019; *Cuddle*, 2020
Anastasia Sosunova *Agents*, 2020; *Another Dinner Ruined*, 2021

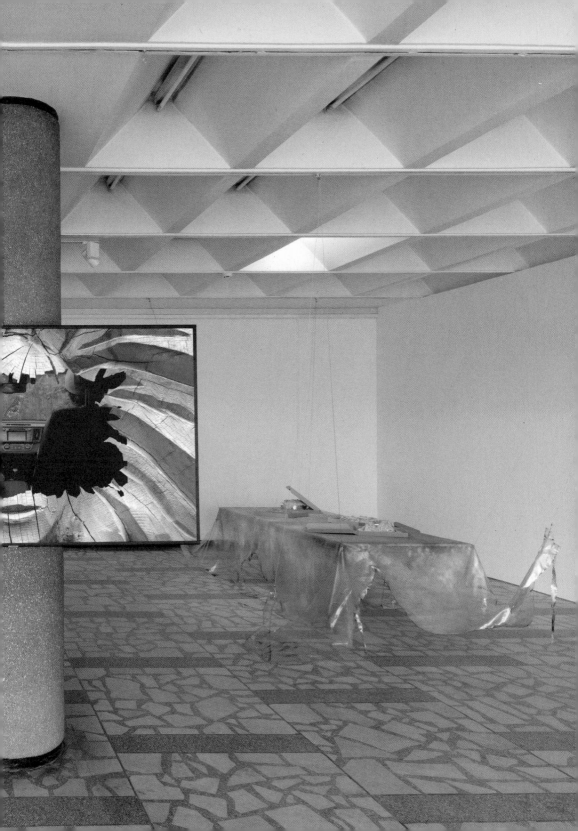

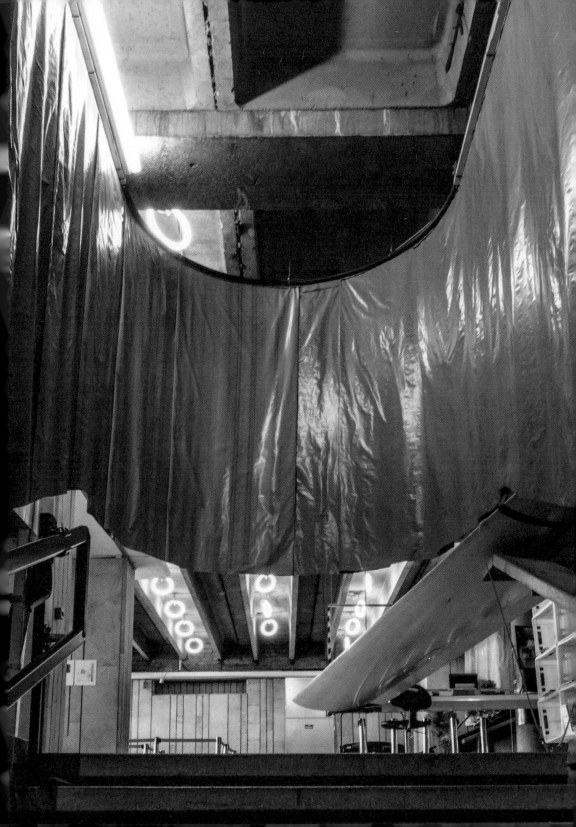

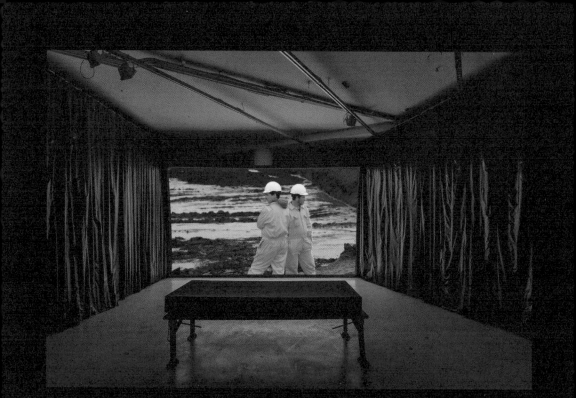

Tekla Aslanishvili, *Scenes from Trial and Error*, 2020

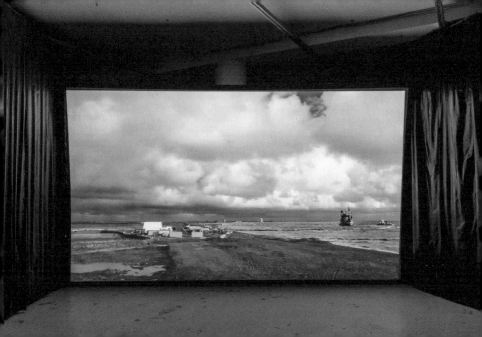

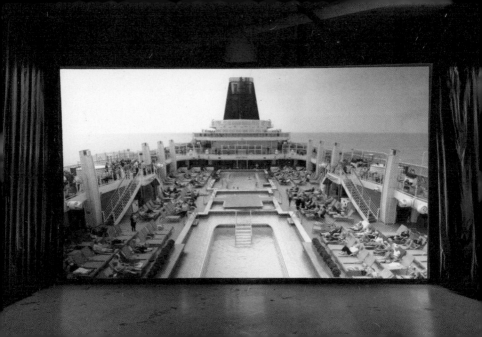

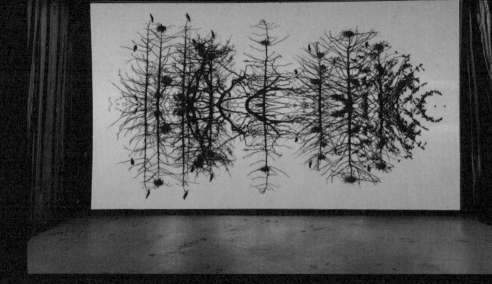

Sasha Litvintseva, *Every Rupture*, 2020

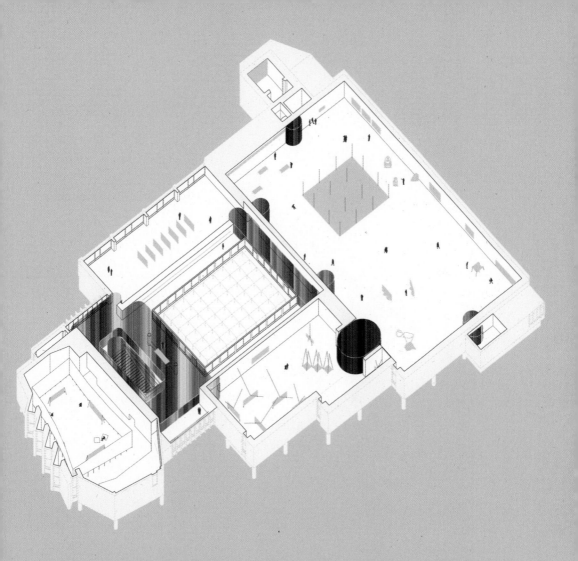

Exhibition architecture by Isora x Lozuraityte Studio for Architecture, first floor, 2021

Exhibition architecture by Isora x Lozuraityte Studio for Architecture, ground floor, 2021

Exhibition architecture by Isora x Lozuraityte Studio for Architecture, basement, 2021

Atletika

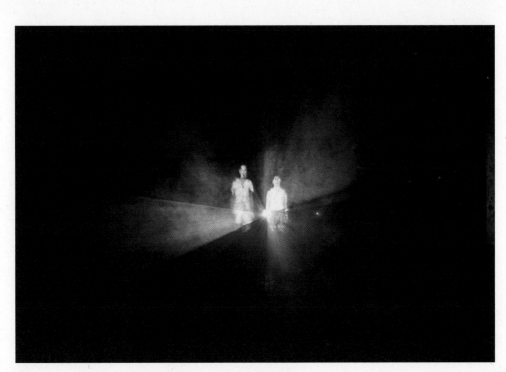

Žygimantas Kudirka and felicita, *Who Are You?*, 2020

Žygimantas Kudirka and felicita, *Who Are You?*, 2020

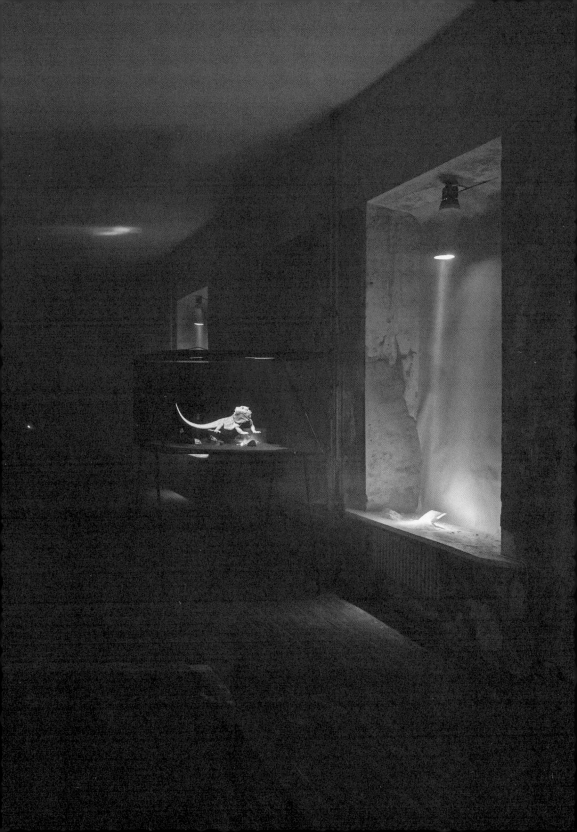

Žygimantas Kudirka and felicita, *Who Are You?*, 2020

Žygimantas Kudirka and felicita, *Who Are You?*, 2020

Autarkia

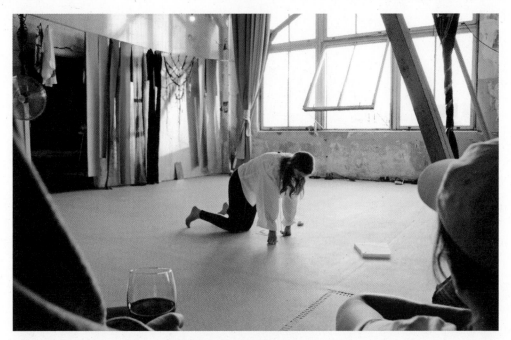

Barbora Vilkaitytė, *Atvanga I (Apartment)*, 2021

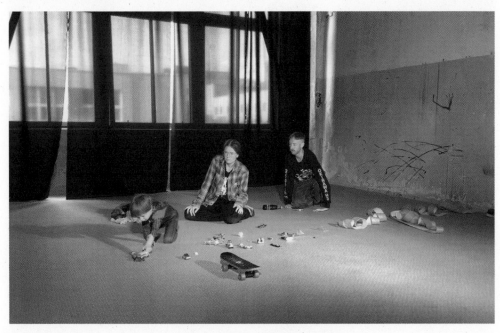

Krõõt Juurak and Alex Bailey, *Codomestication*, 2019–ongoing

Kontakt event, Friday 4 June 2021

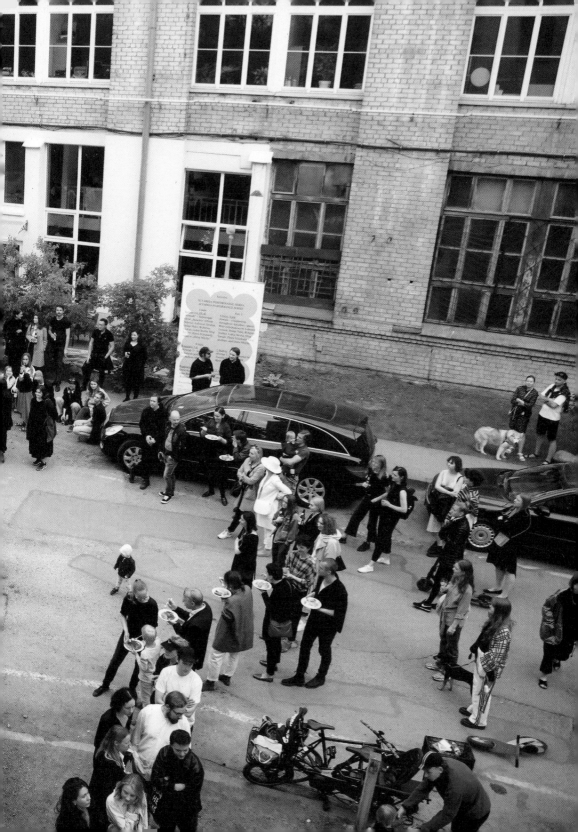

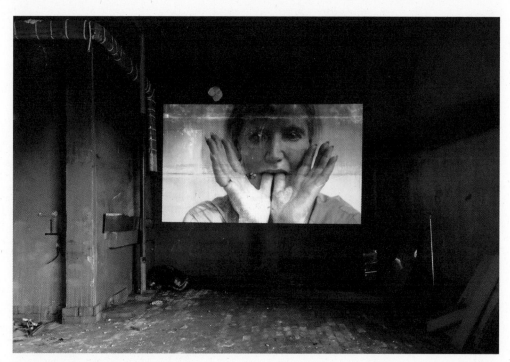

Kontakt event, Friday 4 June 2021

Editorial

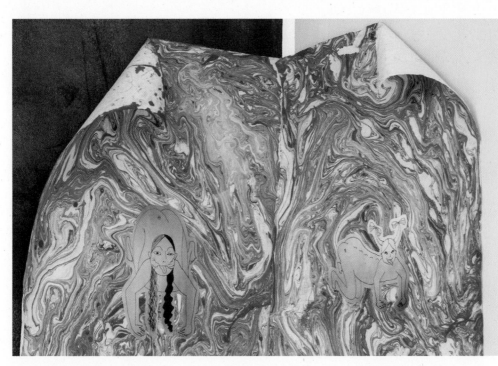

Anni Puolakka, *Feed*, 2021

Anni Puolakka, *Rumina*, 2017

Anni Puolakka, *Timanttimaha (Diamond Belly)*, 2018

Anni Puolakka, *Clown 5*, 2021

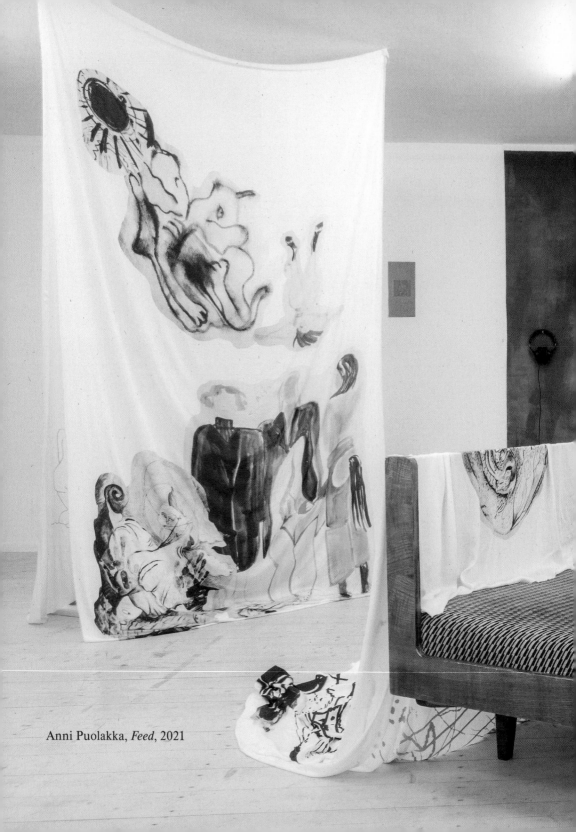

Anni Puolakka, *Feed*, 2021

Rupert Centre for Art, Residencies and Education

Žilvinas Dobilas, Jonas Zagorskas, *I Was Bored*, 2000

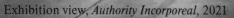

Exhibition view, *Authority Incorporeal*, 2021

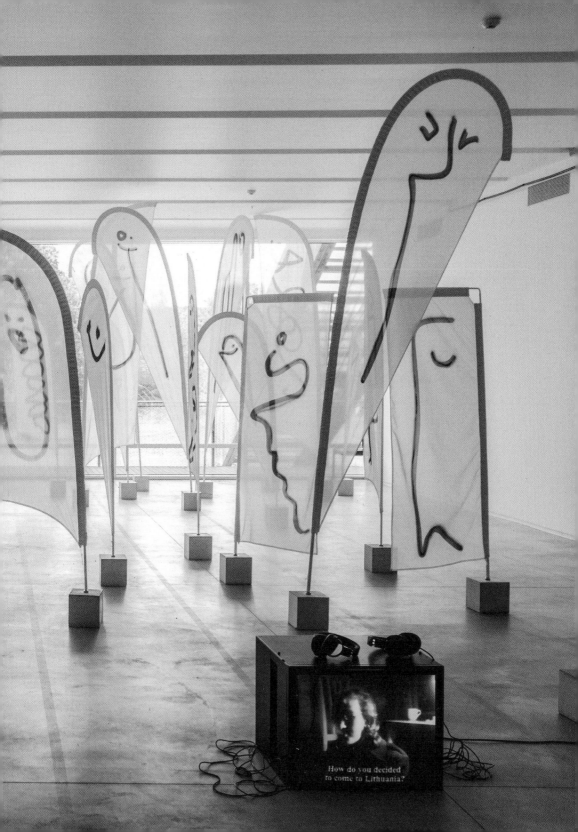

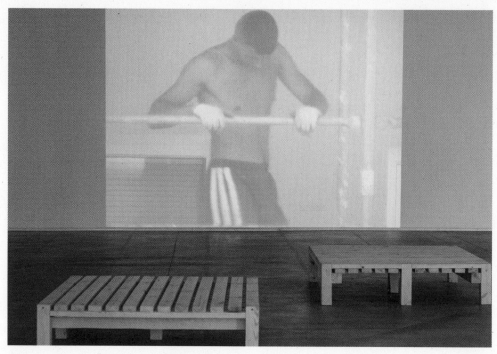

Karol Radziszewski, *Painters*, 2007

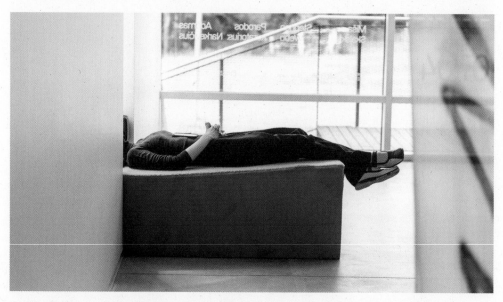

Jaakko Pallasvuo, Miša Skalskis, Rachel McIntosh, Stephen Webb, *Angels Instead*, 2020

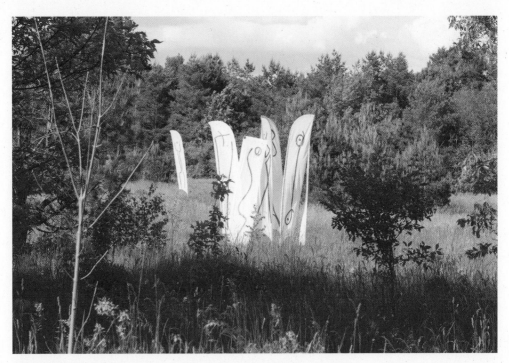

Flaka Haliti, *Concerned by the Ghost without Being Bothered*, 2017

Swallow

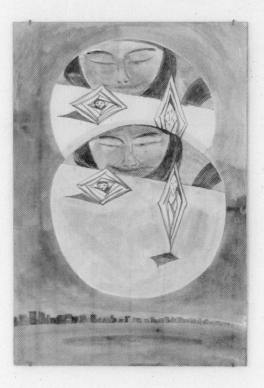

Tomasz Kowalski, *Untitled*, 2021

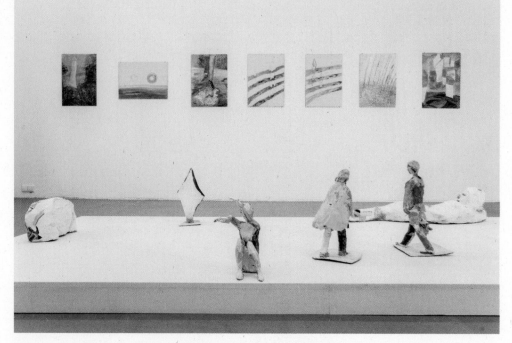

Tomasz Kowalski (with Marta L. Poznanski), *Foam City*, 2021

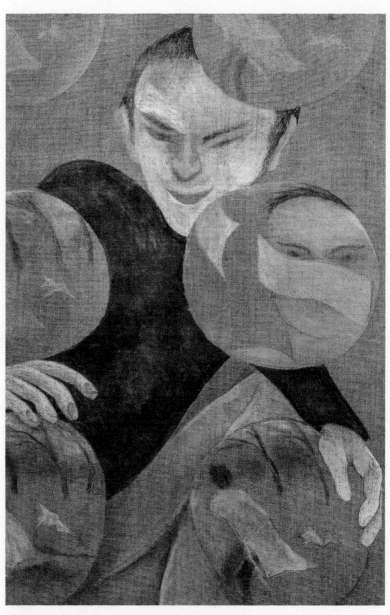

Tomasz Kowalski, *Untitled*, 2021. Detail

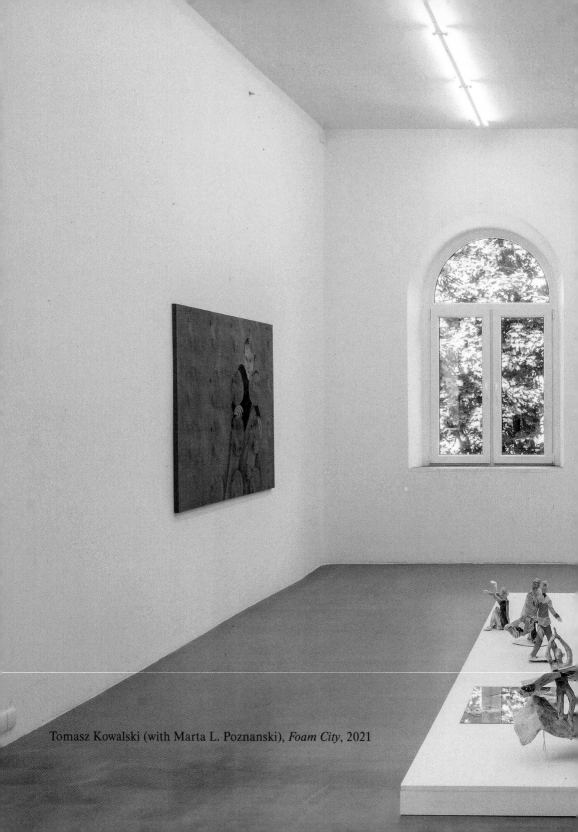

Tomasz Kowalski (with Marta L. Poznanski), *Foam City*, 2021

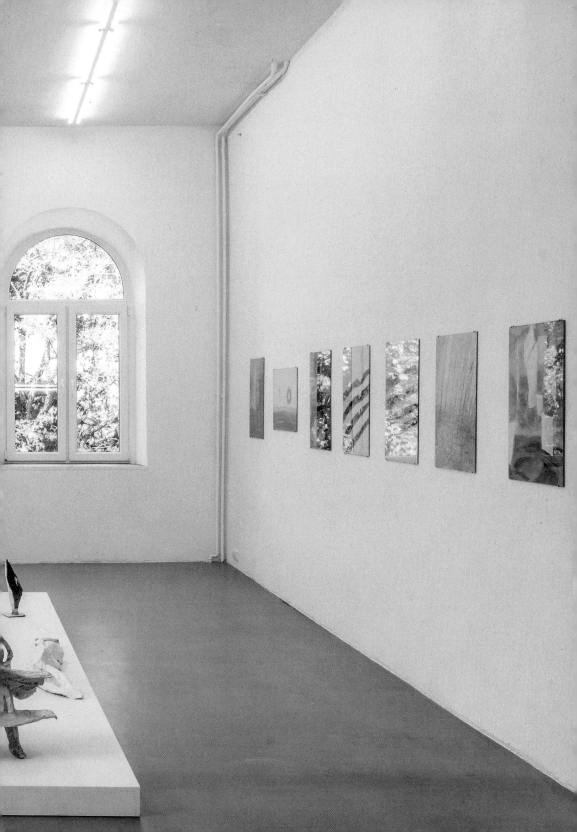

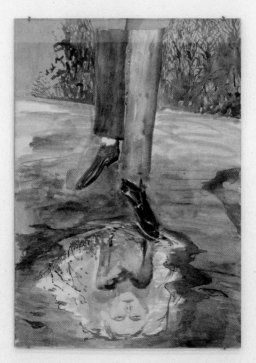

Tomasz Kowalski, *Enchanted Puddle*, 2021

Exhibitions and Events

Baltic Triennial 14: The Endless Frontier
Vokiečių str. 2, Vilnius
June 4–September 5, 2021

Curators:
Valentinas Klimašauskas and João Laia
Architecture:
Isora x Lozuraityte studio (Petras Išora
and Ona Lozuraitytė)
Artists:
Jüri Arrak, Tekla Aslanishvili, Alex
Baczyński-Jenkins, Zuzanna Czebatul,
Anna Daučíková, Aleksandra Domanović,
Harun Farocki and Andrei Ujica, Uli
Golub, Edvinas Grin, Henrikas Gulbinas,
Flaka Haliti, Klára Hosnedlová, Monika
Janulevičiūtė and Antanas Lučiūnas,
Milda Januševičiūtė and Miša Skalskis,
Agnė Jokšė, Dóra Maurer, Flo Kasearu,
Zsófia Keresztes, Jiří Kovanda, Vojtěch
Kovařík, Tomasz Kowalski, Edward
Krasiński, Danutė Kvietkevičiūtė, Sasha
Litvintseva, Natalia LL, George Maciunas,
Yarema Malashchuk and Roman Himey,
Jonas Mekas, Ania Nowak, Markéta
Othová, Jaakko Pallasvuo, Agnieszka
Polska, Nada Prlja, Anni Puolakka, Karol
Radziszewski, Marija Teresė Rožanskaitė,
Adam Rzepecki, Kirill Savchenkov, Sergey
Shabohin, Jura Shust, Janek Simon, Emilija
Škarnulytė, Martina Smutná, Anastasija
Sosunova, Mladen Stilinović, Viktor
Timofeev, Dominika Trapp, Goran Trbuljak,
Evita Vasiljeva, Mona Vatamanu and Florin
Tudor, Artur Żmijewski, and others
Photography:
Ugnius Gelguda

The 14th edition of the Baltic Triennial
was premised on the conviction that in
a paradoxical time of fragmented integration,
addressing the local is, simultaneously, to
question the global. Consequently, and for
the first time since the Triennial was es-
tablished in 1979, BT14 focused on the ge-
opolitical territory of Central and Eastern
Europe and included historical as well as
contemporary artistic practices. BT14's take
on the region engaged with its composite
constitution, highlighting transnational
connections. The inclusion of some artists
from locations such as the Balkans, the
Caucasus, and Finland underlined Central
and Eastern Europe's porous boundaries
as well as its belonging to a global and
multilayered network of systems. Regularly
experiencing abrupt shifts, Central and
Eastern Europe is a key crossroads for social
issues related to ideology, ecology, and
economy. The region's gravitational pull is
further highlighted by the introduction
or anticipation of numerous tensions that
later also emerged elsewhere, such as
disinformation, human-made industrial
disasters, nativist nationalism, and the
oppression of nonnormative identities.

BT14 interconnected the rich artist-
led Vilnius scene. As the organizing
institution, the Contemporary Art Centre
(CAC) invited the project spaces Atletika,
Autarkia, Editorial, Rupert, and Swallow
to join as partners. Each platform autono-
mously developed a project while including
some of the artists presented at the CAC's
exhibition. Another ally, the Lithuanian

Artists' Association, shared its spaces and its archive, which holds key documents about the early iterations of the Baltic Triennial.

BT14 was presented across the city of Vilnius, with exhibitions and events at the CAC and the Lithuanian Artists' Association Gallery (curated by Valentinas Klimašauskas and João Laia), Atletika (the exhibition-performance *Who Are You?*, presenting artists Žygimantas Kudirka and felicita), Autarkia (three different evening events curated by Robertas Narkus and JL Murtaugh), Editorial (the exhibition *Feed*, presenting artist Anni Puolakka, curated by Neringa Černiauskaitė and Vitalija Jasaitė), Rupert hosted by Tech Arts (the exhibition *Authority Incorporeal*, curated by Adomas Narkevičius), and Swallow (a solo exhibition by Tomasz Kowalski).

BT14's architecture project by Isora x Lozuraityte studio proposed a radical reshaping of the CAC's iconic city-center building, re-choreographing its spaces through a number of interventions that centered ecological sustainability and un-covered the layered history of the site.

Together, these voices grounded BT14 to map Central and Eastern Europe as a kaleidoscopic, queer space-time of strange realism whose extraordinary polyphonic juxtapositions echo the complexity of the world at large.

Žygimantas Kudirka and felicita
Who Are You?

Exhibition dates: June 5–July 30, 2021
Performance dates: June 5 and July 1, 2021
Location: Atletika, Vitebsko str. 21, Vilnius,
atletikaprojects.lt

Deprive your senses and camouflage yourself
in darkness.

Trust the voices coming from inside the
head.

Explore the flexibility of your spine, the
sensation of your skin, the curves of your
tongue.

Explore your own self, explore your
sexuality.
Don't be scared of who you are.

Regenerate all that was lost and dream on!
So many spectacular things await you.

Trust me. Glide with me.

Your dreams will be clarified.
Your reality will vapour away.

Don't blink, instead –
lick your eyeballs and enter
the holographic terrarium.

Who Are You? is a multimedia performance-
installation created by Žygimantas Kudirka
and felicita. Using the gallery space as a
canvas for narrative, this interactive work
stimulates visitors using immersive audio,
binaural voice recordings, light effects, and
multiple types of handcrafted holograms.
It questions our human nature with a hope
to build lasting bonds between different life
forms, promoting interspecies communica-
tion. Yet in another sense, the creatures are
simply mediators helping us explore our
own selves.

Žygimantas Kudirka is a Lithuanian writer,
artist, and performer in the fields of
interactive poetry, artificial languages, and
avant-garde rap, devoted to seeking a
universal dialect understandable by plants
and animals and babies and future evolu-
tionary links. His works range from music
performances to readings to DJ sets to
interactive installations, often exploring
unexpected forms such as alternate-reality
audio guides, radio plays created for the
modified car interior, or a takeover of
public communication channels. Kudirka
has published an interactive poetry book,
released seven music albums, and makes
frequent appearances in contemporary art
shows such as the Baltic Triennial and the
Venice Biennale. He has won multiple
awards in the fields of music (Alternative
Music Artist of the Year), advertising (Cannes
Lions Silver), visuals (Music Video of the
Year), and literature (Best European
Performative Poet). He has participated

in hundreds of local events in his native tongue, and has performed abroad in English and artificial languages from Latvia to Estonia, Finland, Iceland, Belgium, Germany, Netherlands, Ireland, UK, France, Sweden, Denmark, Norway, Israel, and Hong Kong. Kudirka has collaborated with Eglė Kulbokaitė and Dorota Gaweda, Robertas Narkus, Emilija Škarnulytė, Styrmir Örn Guðmundsson, Martin Kohout, J. G. Biberkopf, David Bernstein, Valentinas Klimašauskas, and Laura Kaminskaitė.

felicita is an Anglo-Polish electronic producer and multidisciplinary artist, and part of the label collective PC Music, launched by A. G. Cook in 2013. felicita uses software and digital tools to explore new possibilities in electronic pop music, absorbing a wide range of influences, from commercial pop to Slavic folk and the various underground dance genres emerging from their home city of London. felicita has collaborated with SOPHIE, Tommy Cash, and Caroline Polachek, and has produced runway music for the Polish label misbhv. Their experimental dance piece *soft power*, created with Unsound Festival, was presented at the Barbican, London, and Knockdown Center, New York. felicita is currently based between Shanghai and London and is developing a new body of music and visual merchandise.

TEAM

Žygimantas Kudirka – concept, texts, ideas
felicita – sound design, ideas
Marija Puipaitė and Vytautas Gečas – furniture design
Rūta Palionytė – ambient lights
Scenos darbai – physical production
Eitvydas Doškus – camera
Lukas Zapereckas – post production

Sima Jundulaitė – video editing
Studio Cryo – graphic design
Ignas Pavliukevičius – technical engineer
Atletika – curating
All photos by Andrej Vasilenko

This event was part of Baltic Triennial 14, *The Endless Frontier*, organized by the Lithuanian Interdisciplinary Artists' Association (LIAA). The activities of LIAA are supported by the Lithuanian Council for Culture and Vilnius City Municipality.

Autarkia Performs

Throughout the summer of 2021, Autarkia participated in the Baltic Triennial 14 with a three-part performance program curated by Robertas Narkus and JL Murtaugh. These related but distinct affairs commenced at a pivotal confluence of political, social, seasonal, and health statuses, where the longer sunlight hours met a renewed sense of collective possibility and appetite for action.

Part I was *Kontakt*, a large, multidimensional happening in all of Autarkia's spaces that included artists working in music, food, comedy, film, and social interaction, re-forging lapsed community bonds. Barbora Vilkaitytė presented *ATVANGA I (Apartment)* in part II, inviting audiences into her new, un-renovated flat, constructed in a floor of our postindustrial building annex. Closing the Triennial, the final part brought Estonian and UK artists and co-parents Krõõt Juurak and Alex Bailey to Autarkia. They staged *Codomestication*, an exploration of understanding with their collaborator, codirector, and young son Albert (also known as Spiderman).

Part I
Kontakt
June 4, 2021, 20:00–midnight

With contributions from Lubomir Grzelak, Robertas Narkus, Lukas Strolia, Oleg Šurajev, Elena Veleckaite, Sniege Naku, Delta Mityba (Kotryna Butautyte, Saule Gerikaite, Jonas Palekas, Dominykas Saliamonas Kaupas, and Maria Tsoy), local children, and others

It is easy to love the ones we like. How can we love others?

The generation of artists who witnessed the fall of the Berlin Wall still wonders how long we must live according to the rules of the old, divided, segregated world. Bricks collapsed so that capital might freely cross the borders, but what about love? Why do we keep on falling into the same pitfalls of hatred and destruction? Autarkia, an artists' day-care center, invited all to celebrate the cease-fire. Do heated international political environments and complicated histories also apply to the supposedly different world of art? Is art a ground to begin building, little by little, an alternative universe of respect, inclusion, and common sense? *Kontakt* was a fluid post-historic event dedicated to re-forging community bonds, incorporating acts of music, food, performance, comedy, and architecture.

Part II
Barbora Vilkaitytė
ATVANGA I (Apartment)
July 30, 2021, 20:00

Set design by Barbora Matonytė, poems by
Vlada Banilytė Kvedarienė, soap sculpture
by Liudvika Sonja Koort, metal sculpture by
Kotryna Butautytė

This immersive dance performance was origi-
nally staged in the Kaunas Chamber Theatre
during the 2020 ConTempo festival. At
Autarkia, the choreography was transformed
to occupy an un-renovated loft space. By
choosing the word *atvanga* (deriving from an
old Lithuanian word meaning pause, stop,
respite, shelter, or opening) and impersonat-
ing a new character (Barbora, Greek for
"foreign woman"), Barbora Vilkaitytė searched
for the meanings beneath the surface, inside
her new but not-quite-livable apartment.

Part III
Codomestication
Krõõt Juurak and Alex Bailey
September 4–5, 2021

Krõõt Juurak and Alex Bailey collaborated
with their son Albert to design, direct, and
perform *Codomestication*. The performance
integrates the fluid labor of creativity,
recreation, and care, finding understanding
between adults and children on common
ground. Adult wishes and artistic ideals often
dissolve when confronted with precarious
children. Krõõt, Alex, and Albert draw
inspiration from the life events many parents
would regard as disruptive. Children are
often considered an economic and emotional
burden, and not permitted participation
or autonomy—by family or society—in affairs
that influence them. Juurak and Bailey con-
sider their child to understand what work
will look like in the future.

Editorial

Anni Puolakka
Feed
June 3–July 3, 2021
Photography: Ugnius Gelguda, Editorial
Curators: Neringa Černiauskaitė and
Vitalija Jasaitė

Look at this poem:

Magic
Strange, I had words for dinner
Stranger, I had words for dinner
Stranger, strange, do you believe me?
Honestly, I had your heart for supper
Honesty has had your heart for supper
Honesty honestly are your pain.
I burned the bones of it
And the letters of it
And the numbers of it
That go 1, 2, 3, 4, 5, 6, 7
And so far.
Stranger, I had bones for dinner
Stranger, I had bones for dinner
Stranger, stranger, strange, did you believe
me?
 —Jack Spicer

The poem paints ambiguous, mealy
relationships between characters such as I,
you, Honesty, Strange, and Stranger. I want
to digest these in my own art. The poem
generates, in me, an experience of connec-
tion—a shared interest in surreal relations
between characters, human or nonhuman.

I grew tired of planning and executing
projects, and started to paint every day
without predetermination. Figures started
to materialize on paper, and I gathered
scraps of older works around them, like
recycled landscapes. The figures are my
companions, and I followed their ways
when making this exhibition. I do feel re-
sponsible for what these characters are like,
what they do, the way they are, naked or
clothed, the way they represent differences
in human bodies.

There are moments when I feel cultural
and societal norms pouring into my paint-
ings, and then other moments when my
paintings seem like manifestations of
another, freer, delish reality. One figure
repeats the convention of a slim femme
posing for the viewer; another one rejects
realism in showing the internal organs
of two people connecting. The third figure
is half-human, half-plant. I'm curious
about what the characters will say to you,
Stranger: Will it be something different
than what they just whispered to me?

Red gouache is a character in these works,
too. Gouache, sometimes called body color,
is paint made with pigment and gum arabic,
also used in icing, fillings, soft candy,
and chewing gum. Red gouache is not blood-
red, even if in my paintings it sometimes rep-
resents blood. Painting with it is like eating a
hearty meal, pizza marinara.

I thought of this exhibition as something
or someone that I am feeding with the
fruits of my daily practice. When you, as a

visitor to the show, step inside, you feed on them, too. That feels stimulating and vivid to me, as if I'm a cow feeding a calf, giving nutrition from my warm body. The parenting cow also needs to eat and ruminate. I've been feeding off spring life in Vilnius, off other people's paintings and writing, off collective and personal dreams and consciousness. Even if I might never meet you, Stranger, in my mind I am feeding on you as well—on your responses to these works.

Whatever the feeding scenario might be, it can never fully satisfy. I keep making, and I keep feeding.

Anni Puolakka (b. 1983, Oulu, Finland) is based in Helsinki and makes performances, videos, installations, drawings, and texts in which situation-specific or documentary materials are incorporated into fictional worlds. They have presented the solo shows *Oestrus*, Polansky Gallery, Prague (2020); *Parasitia*, 427, Riga (2019); and *Degradia*, Sorbus Gallery, Helsinki (2018), among others. Puolakka's works have recently been shown at BOZAR, Brussels; PLATO Ostrava, W139, Amsterdam; Kiasma Museum of Modern Art, Helsinki; Baltic Circle festival, Helsinki; and Performance Space, Sydney. They hold an MFA from the Piet Zwart Institute and teach at Aalto University, among other places. annipuolakka.com

Puolakka's work and travel to Vilnius was supported by Finnish Cultural Foundation and Frame Contemporary Art Finland.

Editorial is supported by Lithuanian Council for Culture and Vilnius City Municipality.

Special thanks to Liinu Grönlund, Karolina Janulevičiūtė, Liucija Skalskaja, Miša Skalskis, Anastasia Sosunova, Monika Valatkaitė Short Pieces That Move! writing group, Swallow, Rupert centre for art, residencies and education, and Antanas Stanislauskas for technical support.

Authority Incorporeal
June 6–July 4, 2021

Artists: Juta Čeičytė (Lithuania), Žilvinas
Dobilas & Jonas Zagorskas (Lithuania),
Flaka Haliti (Kosovo/Germany), Rachel
McIntosh (US/Finland), Jaakko Pallasvuo
(Finland), Karol Radziszewski (Poland),
Miša Skalskis (Lithuania) & Stephen Webb
(US/Finland), Virgilijus Šonta (Lithuania)
Curator: Adomas Narkevičius

Authority Incorporeal was an international
group exhibition focused on several works
of art that have, over recent decades, sensed
and continue to think through the relation-
ship between secular and spiritual agency,
referred to daily as power, and on other occa-
sions as affect or empowerment. Stemming
from the malleable region of Central
Eastern Europe, they are markers of different
traditions, social milieus, and moments in
time as much as the particular forms of
knowing that slip out of them. The corpo-
real, material, or otherwise felt presence of
all these artworks suggests how murky the
inner workings and distinctions between
"justified beliefs," commonly called knowl-
edge, and beliefs lacking such qualifications,
can be. In art history and the art world, as
much as in politics more broadly, the figure
and the idea of authority, supposedly self-
explanatory, are awkward to legitimize using
reason alone. As such, they occupy the
gap between "imaginary"—desiring, paranoid,
hopeful—inclinations and "factual"—neces-
sary, inevitable, accepted—convictions.

The featured artworks dwell in this inter-
stice, making their own particular addresses
through form and color as well as what
and how they elect to represent. They allude
to the continual yet not entirely predictable
relation between art histories of the region
and wider geo- and sociopolitical processes.
Dwelling between the power of belief and
the jurisdiction of knowledge, their aesthetic
structures reorder entrenched historical
and social relationships without issuing
orders, all with the soft authority of some-
thing that has simply been made and
perseveres toward the future.

Authority Incorporeal intended not so much
to once again call the factual into question
or further haphazardly conflate the two
realms, but rather to acknowledge the
existence of this subtle transitional space
between that which was and is quelled
as "irrelevant fantasy," "superstition," or
simply "bad art," and that which was and
is authorized as "the only viable reality,"
joining what Eve Kosofsky Sedgwick called
reparative work. Alongside the artworks
themselves, the exhibition wondered: How
can we address this authoritative forgetful-
ness, an ongoing psychosocial repression—
at times our own, of unreasonable, untimely,
and otherwise illegitimate beliefs, ideas,
and lifeworlds?

Never entirely incorporeal and absent, nor
fully incorporated, the apparition of authority
punctuates past and present in its new
temporary embodiments, poking fun at us

or itself looking silly in the process. In this particular locality, a magisterial apparition in its latest form tells tales of the young who do not remember and thus now live in a way that is "healthy," "wholesome," and entirely "Western." If this holds true, then they, as it were, gave up the ghost. However, as suggested by Flaka Haliti's artwork *Concerned by the ghost without being bothered*, which welcomed visitors, a certain retention—being okay to feel things that are not entirely okay—in time might be more emancipatory than forgetfulness.

Curator: Adomas Narkevičius
Producer: Vitalija Jasaitė
Architecture: Linas Lapinskas
Coordination and mediation: Guoda Šulskytė
Technical team: Tauras Kensminas, Mantvydas Šiška, Vytautas Narbutas
Graphic design: Domantė Nalivaikaitė
Special thanks: Dina Akhmadeeva, Milda Dargužaitė, Romuald Demidenko, Karolis Didžiokas, Lolita Jablonskienė, Elona Lubytė, Monika Kalinauskaitė, Simona Makselienė, Romualdas Požerskis, Julija Reklaitė, Deborah Schamoni, Gabrielė Vasiliauskaitė, Vilnius Auction, Darius Žakaitis

Hosted by Tech Arts in collaboration with Rupert Centre for Art, Residencies and Education

Co-presented with Baltic Triennial 14 (Contemporary Art Centre, Atletika, Autarkia, Editorial, and Swallow)

Supporters: Lithuanian Council for Culture, Vilnius City Municipality, Nordic Culture Point, Tech Zity

Foam City
Tomasz Kowalski (sculptures are made
together with Marta L. Poznanski)
June 5–July 31, 2021

Tomasz Kowalski's exhibition *Foam City*
at Swallow project space marked the first
solo presentation of the artist's work in
Lithuania.

In *Foam City*, Kowalski's frequently used
bubble motif became an allegory of a con-
tinuously produced human environment.
The soapy and only partially transparent
bubble membrane reflected projections
of external realities. Although when viewed
from the inside, these possible worlds seem
to be right in front of us, as soon as we try
to reach them, the bubble bursts. The bub-
bles act like optical devices whose swelling,
vibrating, iridescent surfaces distort and
multiply the reflections of our personal and
communal lives.

The exhibition featured a demon—the pro-
tagonist of a hypothetical situation defying
the second law of thermodynamics devised
in 1867 by Scottish physicist James Clerk
Maxwell. The situation is usually depicted
as a two-room space housing bubbles of two
different colors moving at different speeds
according to their temperature. The door
separating the two rooms is controlled by
a demon, who keeps opening and closing
it, outrunning the moving particles and
thus separating the warmer from the cooler
ones in different rooms. Thus, one room

gradually warms while the other one cools
down, and thermodynamic equilibrium
is never reached. Maxwell's demon is an
articulation of how, within the bounda-
ries of the collision between two separate
systems—both at a molecular and a politi-
cal level—operate eccentric, untrustworthy
forces that are not subject to their rules
and orders. In ways known only to them-
selves, these forces distribute and regulate
invisible flows of information, energy, and
matter circulating between the two envi-
ronments. Moreover, since they are at work
both internally and externally, the
collision with them cannot be represented
on a coordinate plane or in any other
diagram. How we feel their action is rather
"from the inside"—as an inflammation in
the body or an irritated state of conscious-
ness in which our sensorium instinctively
tenses up and begins to react by saturating
the colors of the environment, reducing
all shapes of unclear boundaries into
geometric figures and combining individual
sounds into rhythms.

In *Foam City*, Kowalski's drawings, paintings,
sculptures, and sound works offered a
dreamlike critical image of contemporary
social life, where the invisible boundaries
of our personal security and intimacy
loosely fuse with the material limits of the
city: fences, streets, walls of buildings. The
building material of the foam city—bubbles,
equally fluid and solid, fragile and plastic—
combined to form a growing and renewable
mass with no established distinction between

inside and outside. Maxwell's demon sorting particles into separate rooms was not an allegory of an exception to a physical law, but the only rule of an unpredictably changing social and material order. Kowalski's works cultivate a troubling and enchanting, both atomized and fluid, image of a reality in which life that happens on the fringes of society, culture, or the imagination is brought to the foreground.

Text by Edgaras Gerasimovičius

Tomasz Kowalski (b. 1984, Szczebrzeszyn, Poland) has had solo exhibitions at Ujazdowski Castle Centre for Contemporary Art, Warsaw, and the Contemporary Art Museum St. Louis, and has participated in group exhibitions at Kunsthalle Wien, Vienna; De Appel, Amsterdam; MUMOK, Vienna; Centre Pompidou, Paris; MSN Warsaw; and S.M.A.K., Ghent, among others. His works are in the public collections of the Centre Pompidou; MUMOK; the Museum of Contemporary Art, Krakow; Frac des Pays de la Loire, France; the Pinault Collection, Paris, Venice; Boros, Berlin; and Olbricht, Berlin. He was the winner of the 2014 Guerlain Foundation Drawing Award. He runs Alicja, a music label releasing various artists and his own music and sound plays.

Colophon

Baltic Triennial 14
The Endless Frontier
4 June–5 September 2021

Organizer
Contemporary Art Centre, Vilnius

Director
Kęstutis Kuizinas

Deputy Director and Advisor
Virginija Januškevičiūtė

Curators
Valentinas Klimašauskas and João Laia

BT14 in Vilnius was co-presented with
Atletika, Autarkia, Editorial, Lithuanian
Artists' Association, Rupert (hosted by
Tech Arts) and Swallow

Exhibition architecture
Isora x Lozuraityte Studio for Architecture
(Petras Išora andOna Lozuraitytė)

Graphic design
Nerijus Rimkus

Manager at large
Julija Fomina

Project coordinator
Ieva Tarejeva

Communication
Dovilė Grigaliūnaitė, Anne Maier (Send /
Receive), Eglė Trimailovaitė

Curatorial assistant
Žanete Liekīte

Educational programme
Kamilė Krasauskaitė, Ernesta Šimkutė,
Vilius Vaitiekūnas

Lighting
Eugenijus Sabaliauskas

CAC installation team
Audrius Antanavičius, Paulius
Gasparavičius, Almantas Lukoševičius,
Ivanas Vilkoicas, Ilona Virzinkevič

External technical team
Vladislav Bajaznyj, Denis Dubrovskij,
Antanas Gerlikas, Jurgis Gulbickas,
Gediminas Lekavičius, Teodoras
Malinauskas, Dainius Markevičius, Jurgis
Paškevičius, Dominas Pulokas, Mantas
Rimkus, Darius Sadovskis, Andrius
Sinkevičius, Mykolas Sinkevičius, Antanas
Stanislauskas

Thanks to
All the artists, Maria Arusoo, Alius
Bareckas, Eglė Ganda Bogdanienė and
the Lithuanian Artists' Association,
Aleksei Borisionok and Olia Sosnovskaya,
Boros Collection,Neringa Bumblienė,
BWA Warszawa, BWA Wrocław, Dawid
Radziszewski Gallery, Deborah Schamoni
Galerie, Antanas Dombrovskij, Akvilė
Eglinskaitė, The Film-Makers' Cooperative,
Galerie Martin Janda, Arūnas Gelūnas
and the Lithuanian National Museum
of Art, Goethe-Institut Vilnius, Edgaras
Gerasimovičius, Antanas Gerlikas,
Edvinas Grin, Michał Grzegorzek,
Giedrius Gulbinas, Flaka Haliti, Victoria
Ivanova, Lolita Jablonskienė, Virginija
Januškevičiūtė, Jonas Mekas Visual Arts
Center, Agnė Jokšė, Karolis Klimka,
Kraupa-Tuskany Zeidler, Tomasz Kowalski,
Laima Kreivytė, Kęstutis Kuizinas, Michal
Mánek, Loreta Meškelevičienė, Michael
Müller-Verweyen, Muzeum Sztuki in
Łódź, National Gallery Prague, Michal
Novotný, Ania Nowak, Zane Onckule,
Gerda Paliušytė, Gediminas and Mykolas
Piekurai, Agnieszka Polska, Nada Prlja,

Dawid Radziszewski, Karol Radziszewski,
Raster Gallery, Eglė Rindzevičiūtė, Jurgita
Sakalauskaitė, Kirill Savchenkov, Natalya
Serkova, Borbála Soós, Jaroslaw Suchan,
SVIT Gallery, Tanya Leighton Gallery,
Artūras Tereškinas, Asta Vaičiulytė, Evita
Vasiljeva, Vintage Galéria, X Museum, ZW
Foundation / Natalia LL Archive

Financed by
Lithuanian Council for Culture

 LITHUANIAN
COUNCIL FOR
CULTURE

Main partner
Government of Flanders

 Flanders
State of the Art

Supported by
Baltic Culture Fund, Goethe-Institut
Vilnius, Frame Contemporary Art Finland,
Danish Culture Fund, Czech Ministry of
Culture and Jindrich Chalupecky Society

Media partners
Artnews.lt, Go Vilnius, JCDecaux,
Lithuanian National Radio and Television

More information: www.cac.lt

Baltic Triennial 14: The Endless Frontier
(A Reader)

Publishers

CAC

Contemporary Art Centre (CAC), Vilnius
Mousse Publishing

Publishing Partners
Kim? Contemporary Art Centre, Riga
Estonian Centre for Contemporary Art,
Tallinn

Edited by
Valentinas Klimašauskas and João Laia

Texts by
Aleksei Borisionok and Olia Sosnovskaya,
Michał Grzegorzek, Valentinas Klimašauskas,
Kęstutis Kuizinas, João Laia, Michal
Novotný, Zane Onckule, Borbála Soós

Copy editing and proofreading
Gemma Lloyd, Lindsey Westbrook

Graphic design
Nerijus Rimkus

Typeface: EF Timeless
Timeless was originally developed in 1982
as a substitute for Times New Roman by
VEB Typoart. VEB Typoart was a type
foundry in Dresden created by the govern-
ment of the German Democratic Republic
in 1948. The function of VEB Typoart was
to provide typefaces for Eastern Germany
and other Eastern Bloc countries. Most
of the typefaces they produced were appro-
priations of Western type-faces that local
printing companies could not afford to
license. The company went bankrupt in 1995.

This publication was made possible
with support from

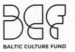

BALTIC CULTURE FUND

Distributed by
Mousse Publishing
Via Decembrio 28
20137, Milan–Italy

Available through
Mousse Publishing, Milan
moussepublishing.com

DAP | Distributed Art Publishers, New York
artbook.com

Idea Books, Amsterdam
ideabooks.nl

Les presses du réel, Dijon
lespressesdureel.com

First edition: 2022

Printed in Lithuania by Kopa

ISBN 978-9986-957-87-4
ISBN 978-8867-495-51-1

€ 18 / $ 20

The publisher would like to thank all those who have kindly given their permission for the reproduction of material for this book. Unless stated otherwise, texts have been provided by the writers and BT14 partners. Every effort has been made to obtain permission to reproduce the images and texts in this catalogue and to credit authors accurately. However, as is standard editorial policy, the publisher is at the disposal of copyright holders and undertakes to correct any omissions or errors in future editions. We apologize for any such cases in advance.